# THE SMART LOFT

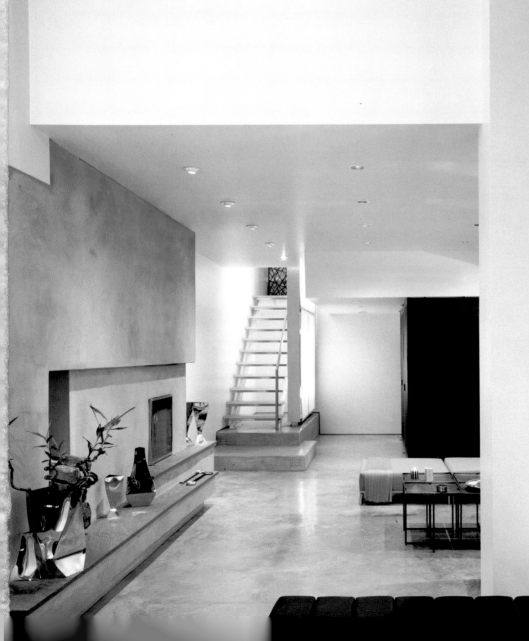

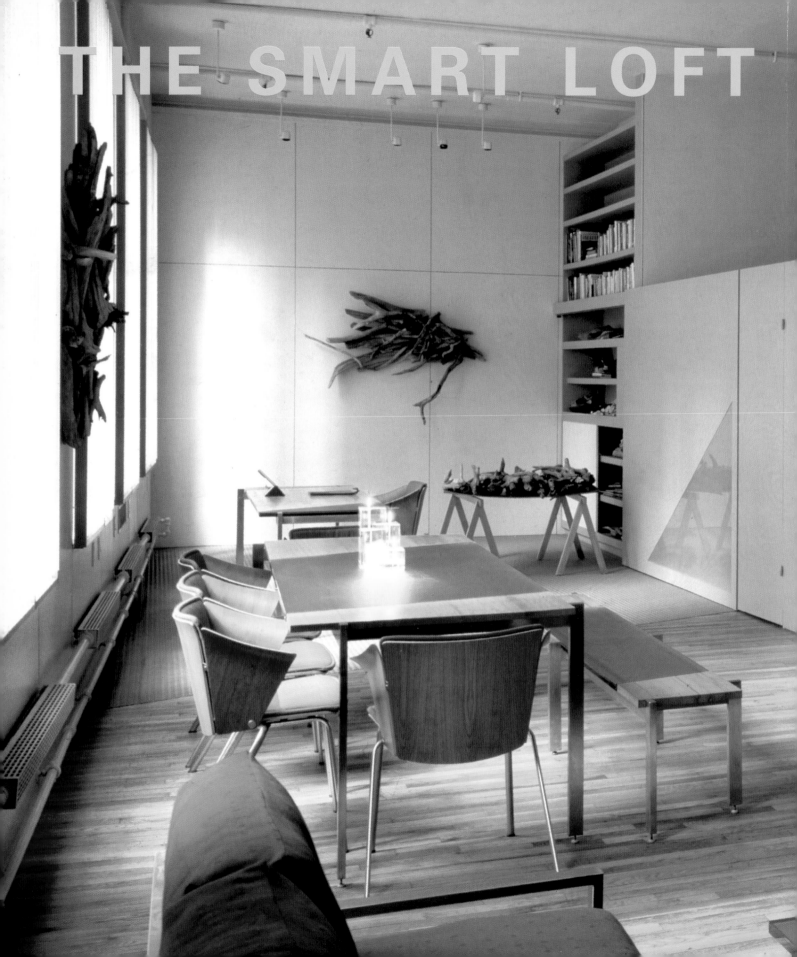

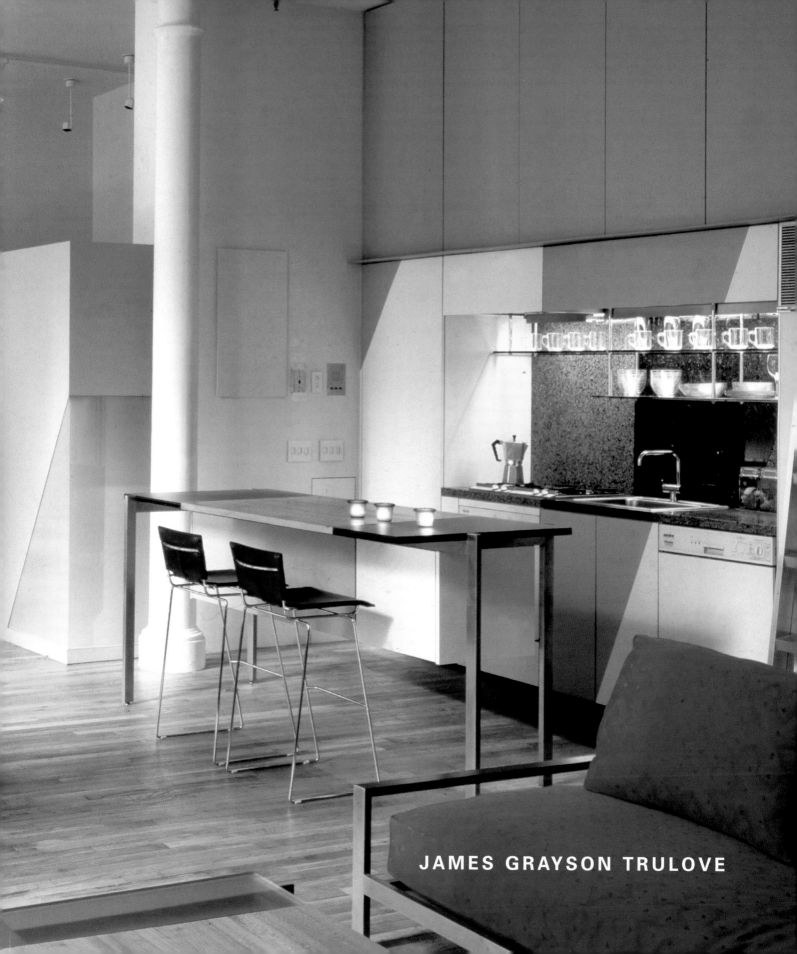

JAMES GRAYSON TRULOVE

THE SMART LOFT

Half title page: Loft of Light, Hariri & Hariri Architecture
Paul Warchol, Photographer
Title Page: Studio Loft, Standing Architecture
Scott Frances, Photographer

Published in 2003 by
Harper Design International, an imprint of
HarperCollins*Publishers*
10 East 53rd Street
New York, New York 10022-5299

Distributed throughout the world by
HarperCollins International
10 East 53rd Street
New York, New York 10022-5299
Fax: (212) 207-7654

ISBN: 0-06-054472-4

Packaged by:
Grayson Publishing
1250 28th Street NW
Washington, D.C. 20007
Tel: (202) 337-1380
Fax: (202) 337-1381

Printed in Hong Kong
First Printing, 2003

1 2 3 4 5 6 7 8 9 /04 03 02

# CONTENTS

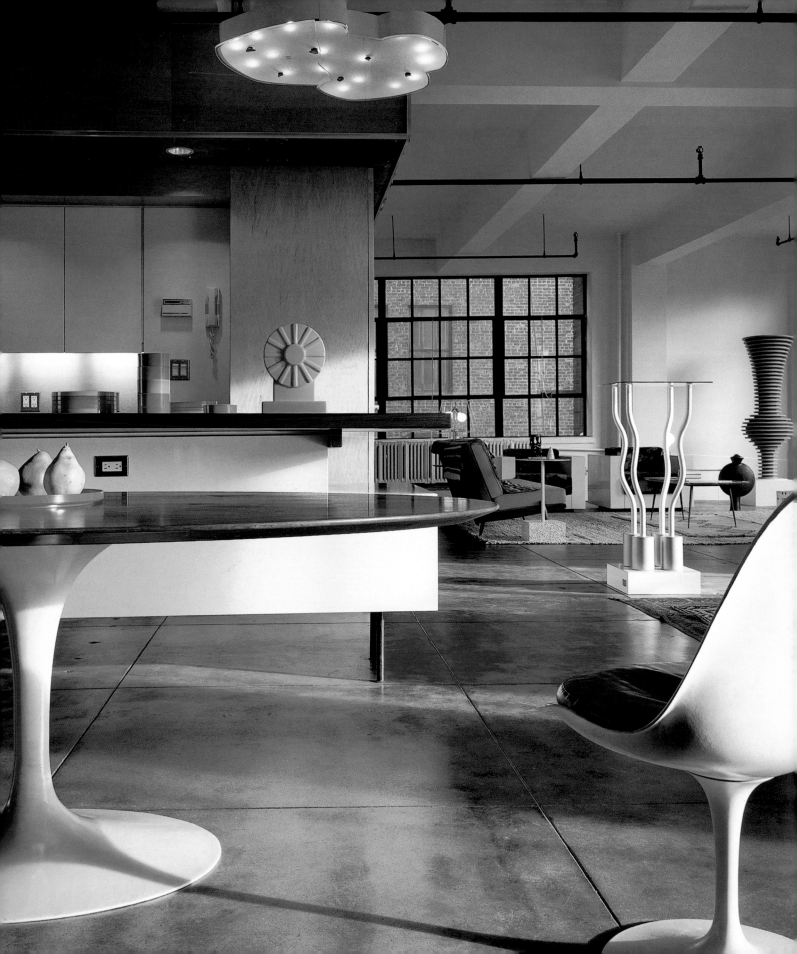

**L**oft living has long been fashionable with artists, architects, and designers needing wide-open spaces with lots of natural light in which to work and live. Inhabiting abandoned factories in parts of cities where no one else would consider calling home, the lofts were cheap but basic amenities were few—heat and plumbing were the exception and steep flights of stairs were common. A freight elevator was a luxury.

Today, everyone wants to live in a "loft," from young executives to empty nesters. Most older cities have the basic ingredients—abandoned factories and warehouses—and developers are converting them at a rapid pace. And, where they do not exist, no problem. New "lofts" are being constructed from the ground up.

Because lofts have always represented an alternative lifestyle, they are fertile ground for experimentation with a variety of new materials, technologies, and design solutions. *THE SMART LOFT* presents 20 such lofts where architects have been given wide latitude to create rich living environments while solving often exceedingly difficult design problems ranging from inadequate natural light to

**Left:** *Frank and Amy's loft; Resolution:*

**This** project was driven by a desire to create a temple for art, a

sanctuary for the soul, and a refuge for the body in a dense, noisy

urban environment.

Architecturally, the loft is organized around light and bringing as

much of it (natural and artificial) into the loft as possible. Entering

the apartment on the upper level, visitors are greeted by a two-

story light-wall embedded with Fluorescent tubes. It serves as a

vertical connector between the two floors of the loft, organizing the

space and circulation while providing soothing illumination.

The space on both floors runs from the street to the garden,

Stair detail

Section

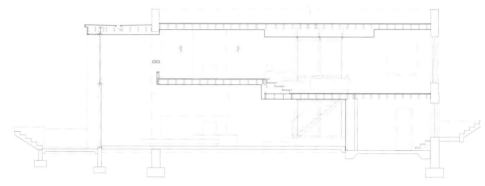

Exterior

First-floor plan

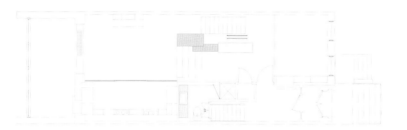

Ground-floor plan

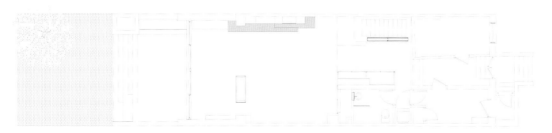

Previous page:
*View of two-
story living room
through rear
glass wall*
**Right:** *Stair
detail*
**Following
pages:** *View of
living area and
light wall adja-
cent to the stairs*

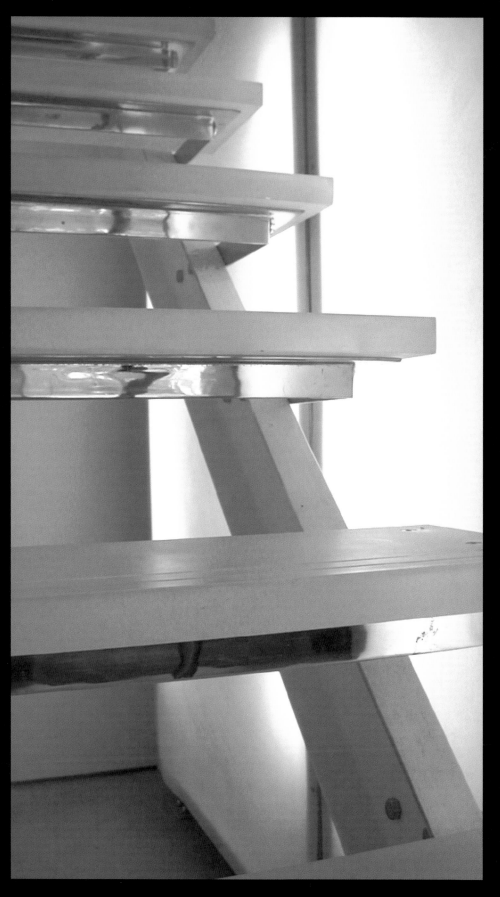

allowing natural light to penetrate and filter throughout the loft. The kitchen and bathrooms are along the east wall behind translucent screens on tracks. These screens conceal the spaces behind and provide privacy while allowing natural light to enter. At the rear of the loft, overlooking the garden, is a double-story living room enclosed by a glass curtain wall. A water channel stretches from the living room out to the garden, terminating in a fountain, effectively uniting the interior and exterior.

*Hariri & Hariri*
*Architecture*
*New York, New York*

*Photography: Paul Warchol*

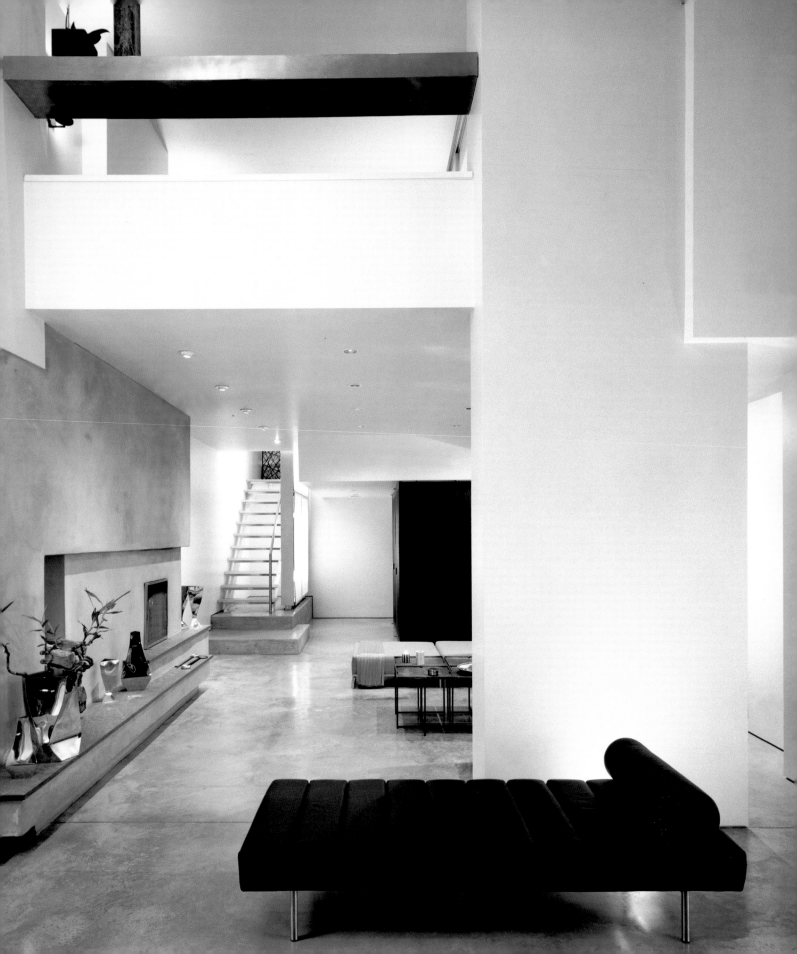

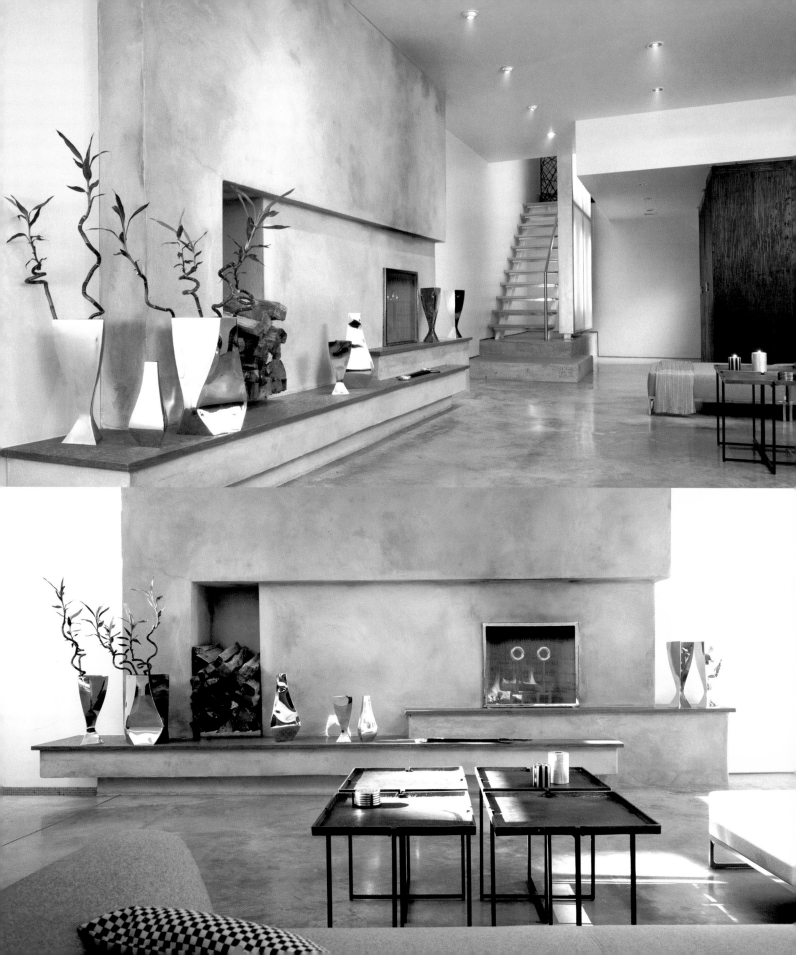

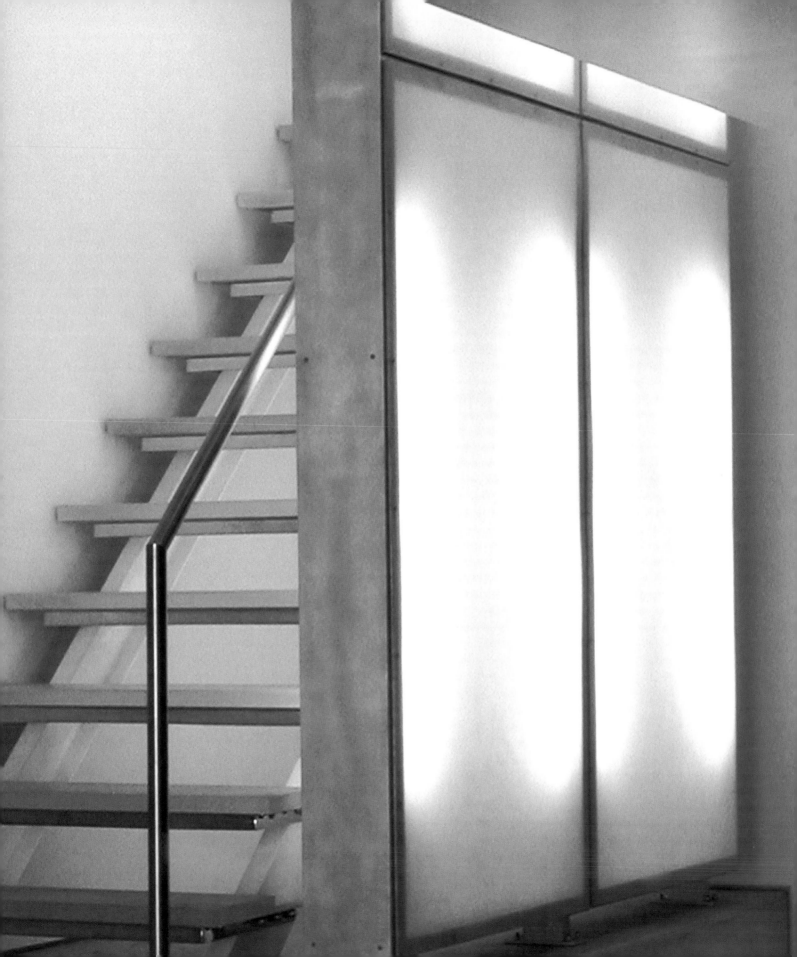

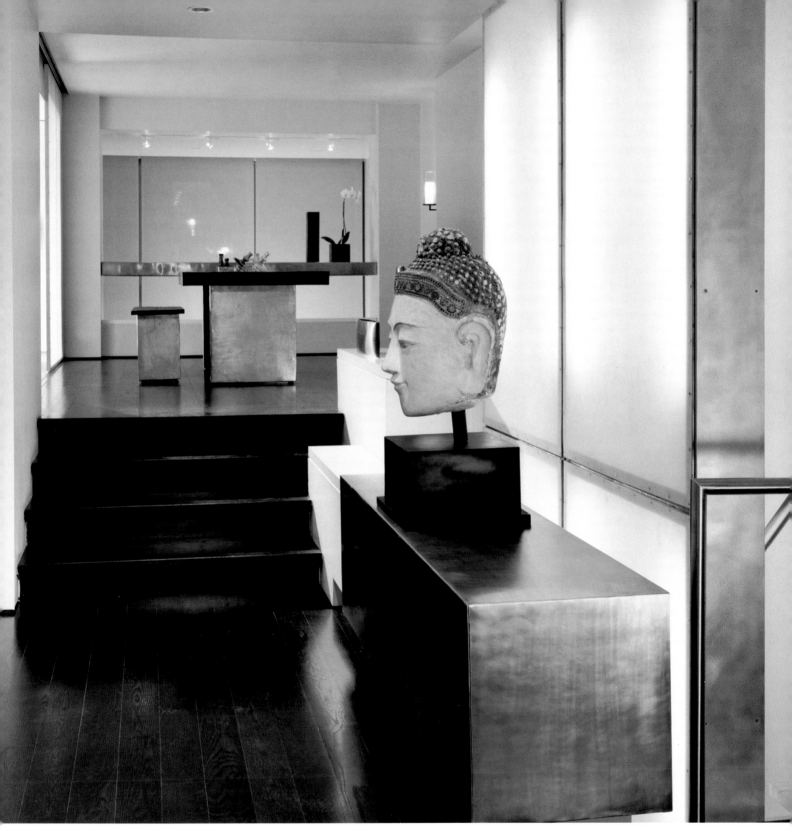

**Above:** *View of light wall at second floor*
**Left:** *View of light wall at entry level*

15

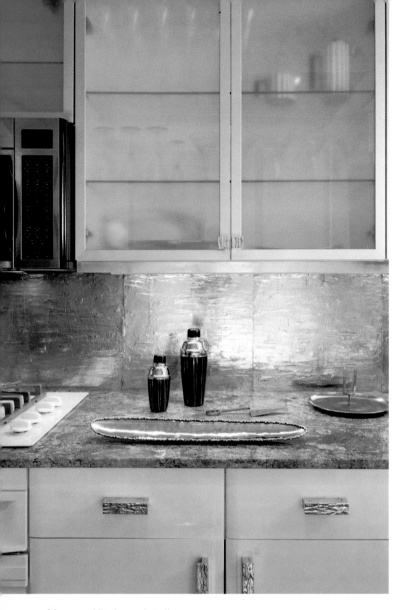

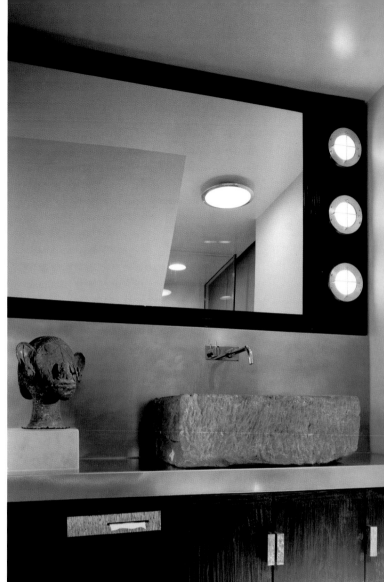

**Above:** *Kitchen detail*
**Above right:** *Bathroom vanity*
**Right:** *View of the garden and exterior water channel*

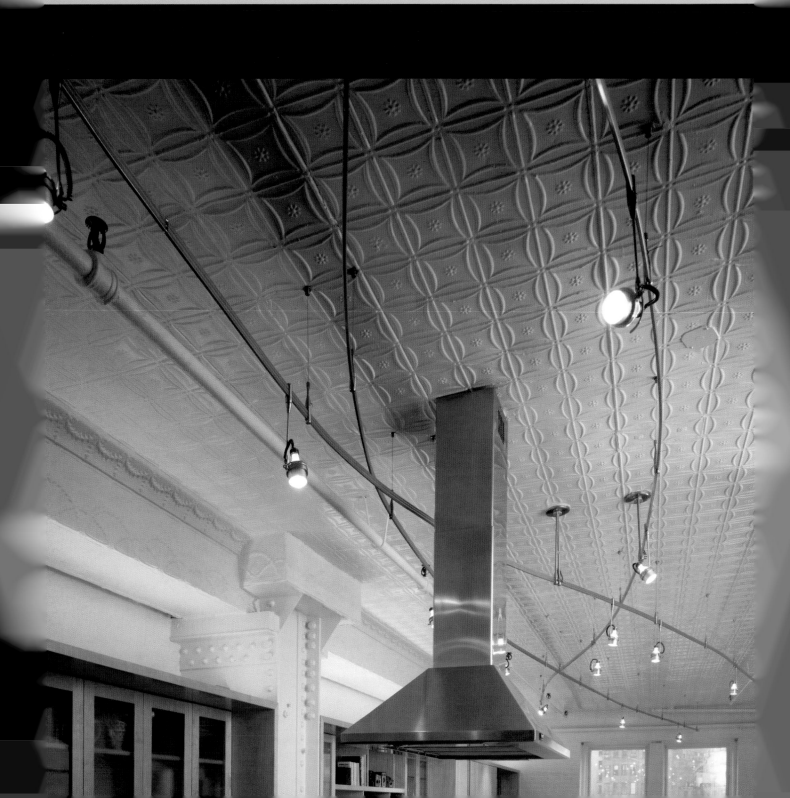

**Located** in a former industrial building, the Hill loft is quite small—750 square feet—as lofts go, and thus became, for the architects, an exercise in the efficient use of space.

Various programmatic elements, ranging from kitchen storage and appliances to wine storage, dining room display cabinets, sleeping and entertaining centers, are all accommodated in gigantic wall units. These units are inserted between the existing massive steel-plate columns along the east wall of the loft.

A sculptural bar element and the combination kitchen island and dining table greets the visitor upon entering the loft. This unit

Bed detail

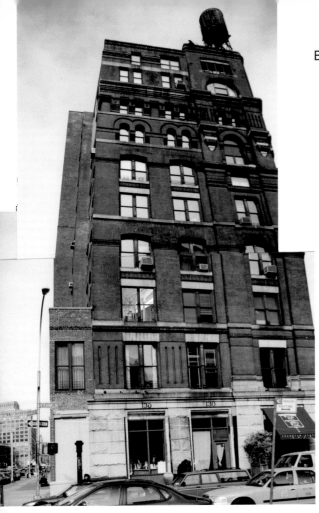

Exterior

**Previous page:** *Ceiling lighting detail*
**Right:** *Computer model of ceiling lighting*

Floor plan

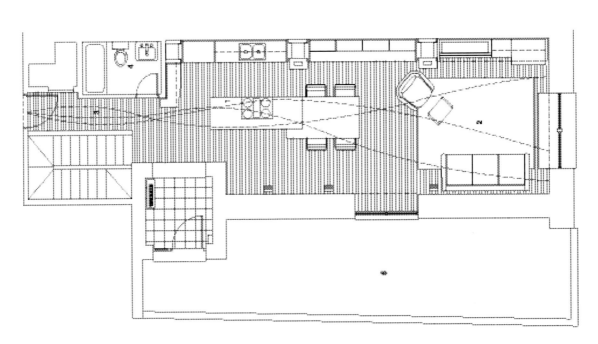

consists of a rectangular prism base on the kitchen side that supports a site-cast, L-shaped concrete countertop and a cantilevered maple plane that extends from the solid portion of the unit to the view at the south end of the loft.

Because of the loft's long, rectangular shape, the ceiling plane is of paramount importance in the design. The open space is unified and the perspective enhanced by playfully woven flexible track lighting that gradually unwinds itself from one end to the other.

*Resolution: 4 Architecture*
*New York, New York*

*Photography: Eduard Hueber*

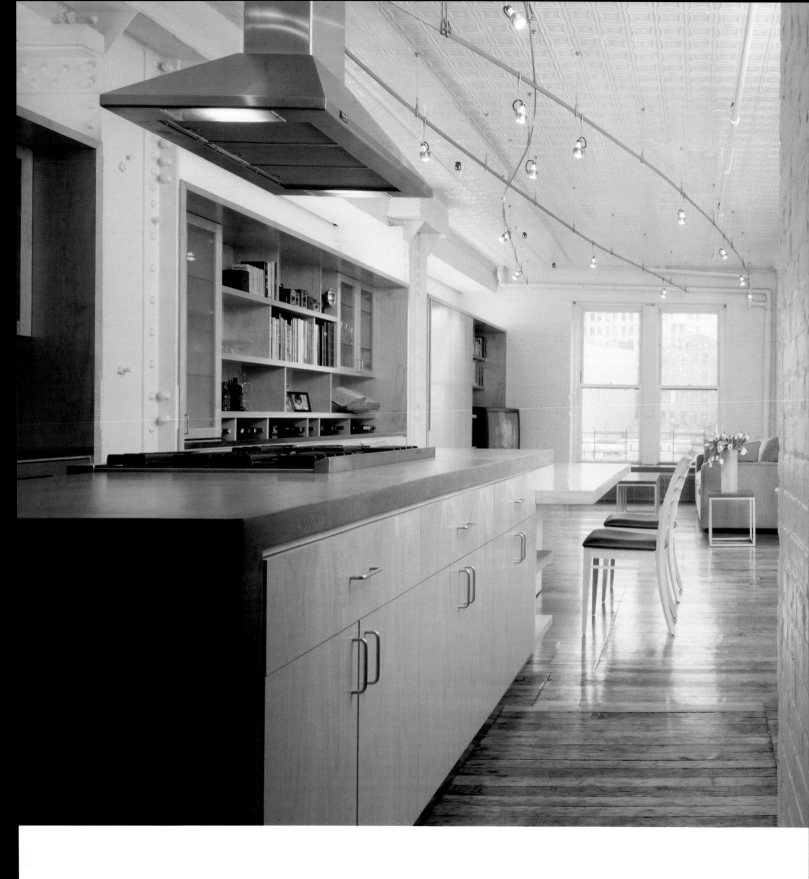

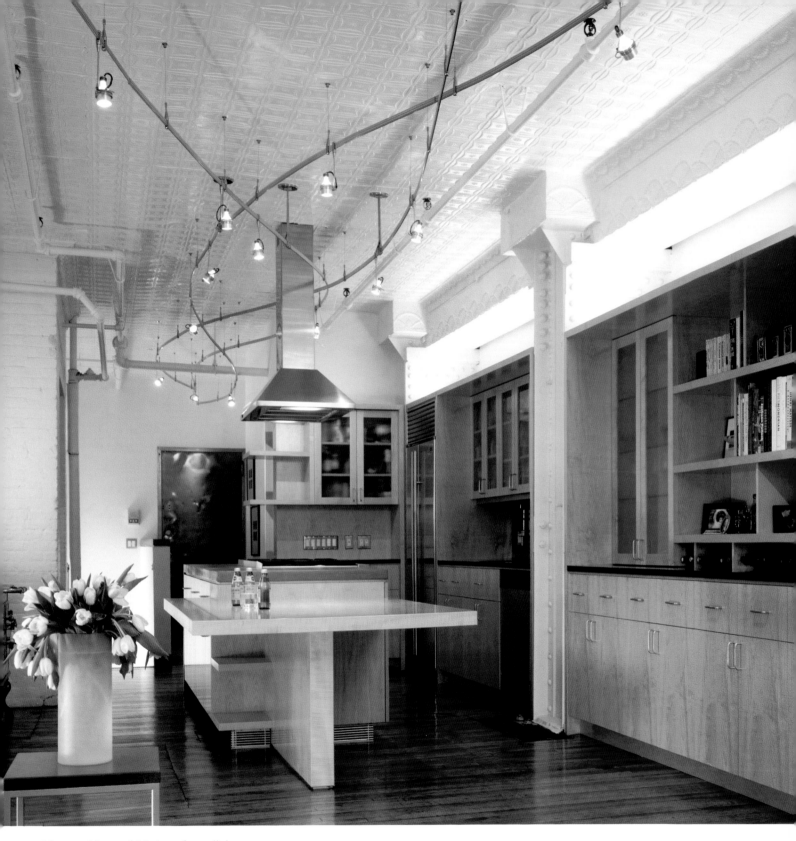

**Above:** *View of kitchen from living area*
**Left:** *View of living/sleeping area from kitchen*

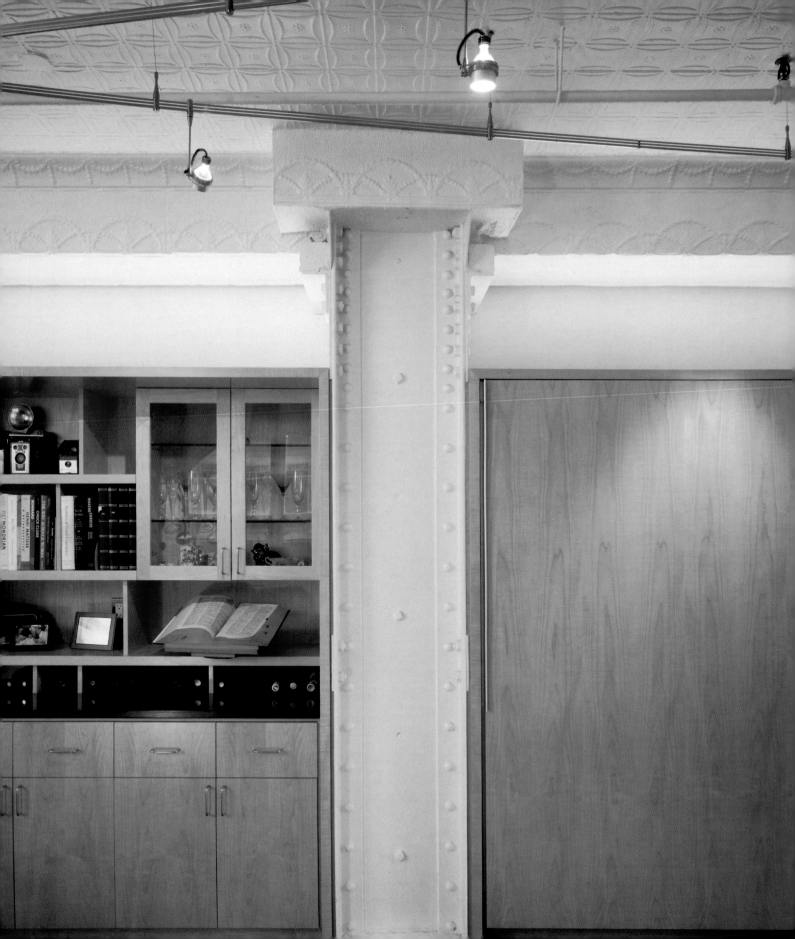

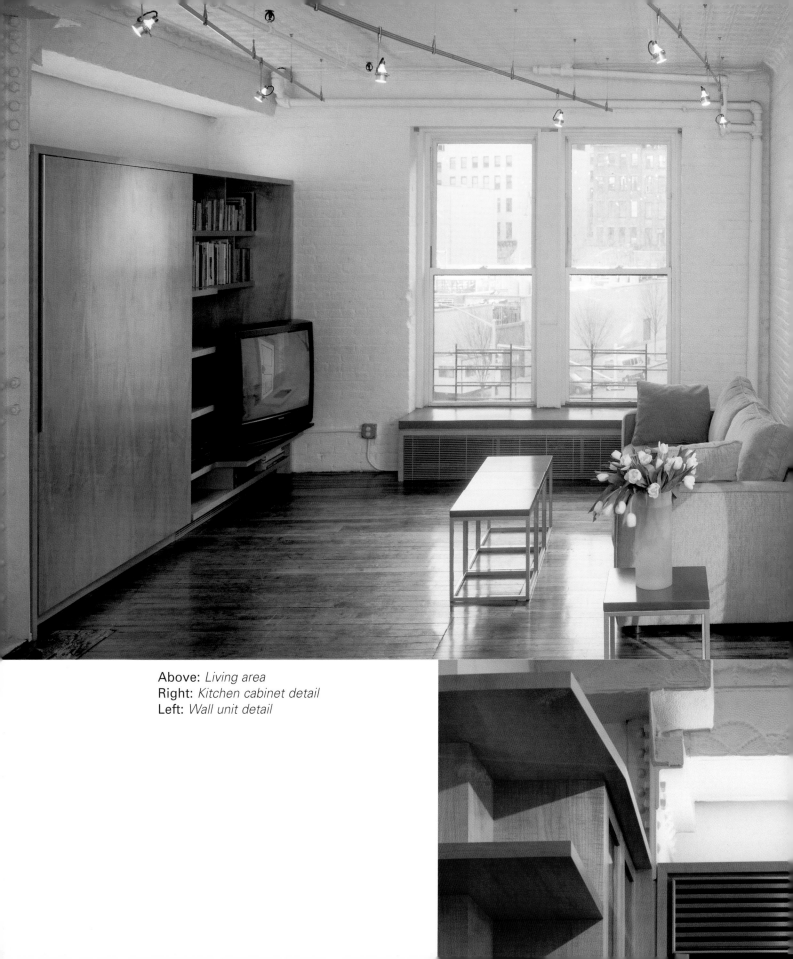

**Above:** *Living area*
**Right:** *Kitchen cabinet detail*
**Left:** *Wall unit detail*

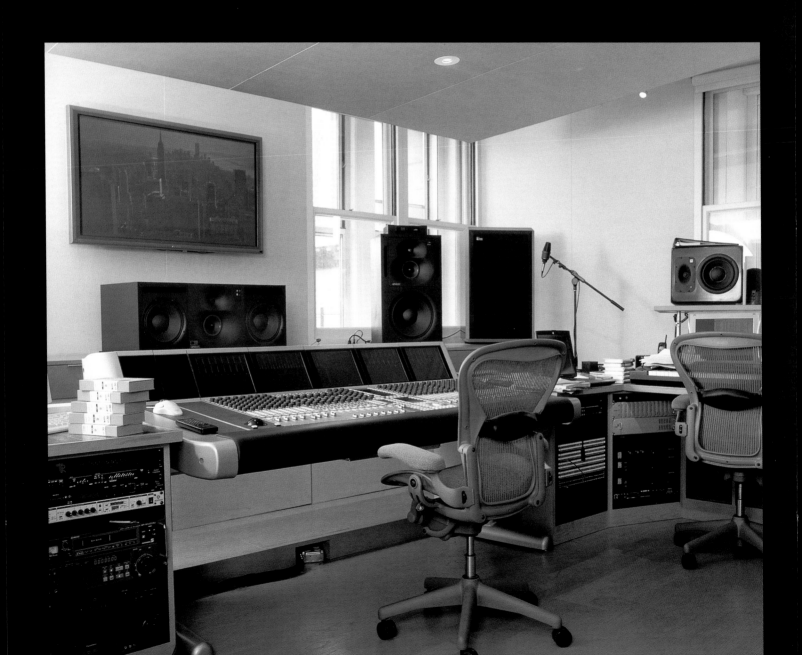

**This** 3000-square-foot loft was designed to accommodate a residence and a professional recording studio for a composer. The loft combines various functions to maximize the volumes of flexible living/working space. The bedroom and library are unified around a central fireplace, while the living room, dining area, kitchen, and home theater are located in an open courtyard configuration. Raw materials such as concrete, wood, metal, and glass are expressed to bring out their natural characteristics and textures.

Thousands of linear feet of audio, video, telephone, cable TV, and computer data wires run throughout the loft. Removable floorboards

Axonometric

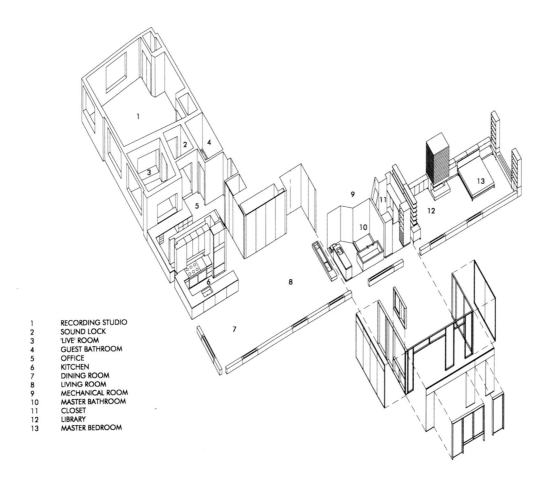

1   RECORDING STUDIO
2   SOUND LOCK
3   'LIVE' ROOM
4   GUEST BATHROOM
5   OFFICE
6   KITCHEN
7   DINING ROOM
8   LIVING ROOM
9   MECHANICAL ROOM
10  MASTER BATHROOM
11  CLOSET
12  LIBRARY
13  MASTER BEDROOM

Floor plan

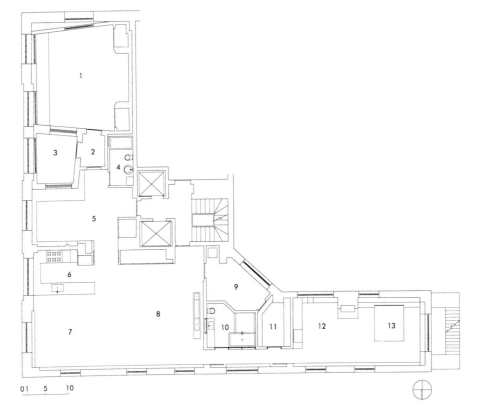

01   5      10

Previous page: *View of recording studio*
Right: *Wiring diagram and data patch-bay locations*

on the perimeter of the loft hide recessed wire troughs that are easily accessible to allow for wiring upgrades. All of these wires are integrated at 17 data patch bays where the client can send and receive information to and from the recording studio and multiple computers throughout the apartment. The patch bays can also serve as an intercom system.

Lighting is controlled by a Lutron Homeworks lighting system. The owner can reprogram the lighting levels from any computer in the home. Shades are also controlled mechanically. There are two different and independently controlled shades at each window in the recording studio. One shade is a "black-out" material, the other is semitranslucent, for maximum control over light levels.

*Desai/Chia Studio*
*New York, New York*

*Photography: Andrew Bordwin*

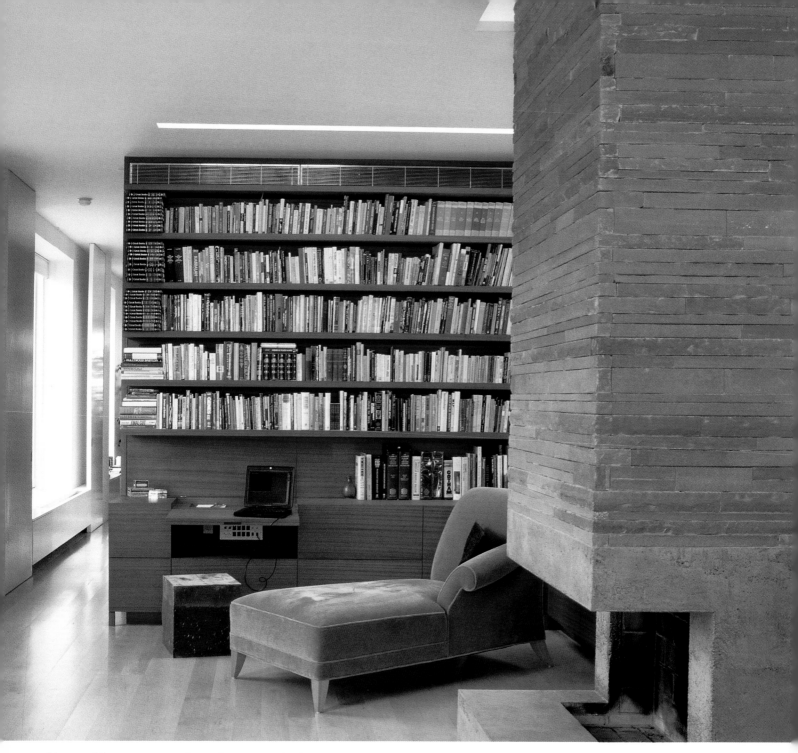

**Above:** *Library as seen from the master bedroom*

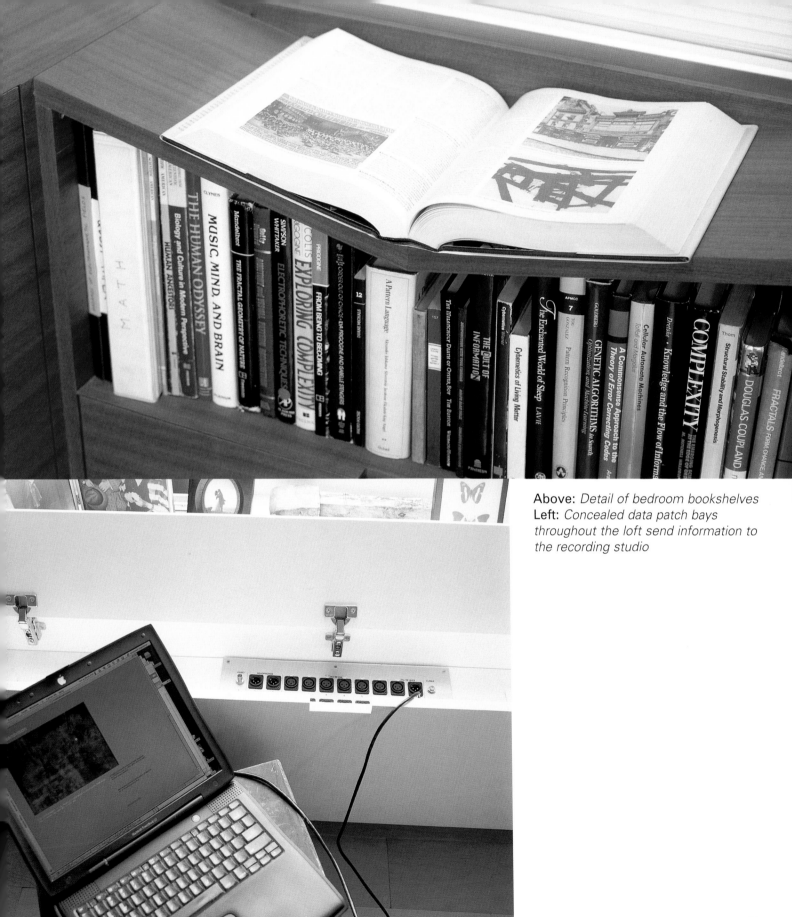

**Above:** *Detail of bedroom bookshelves*
**Left:** *Concealed data patch bays throughout the loft send information to the recording studio*

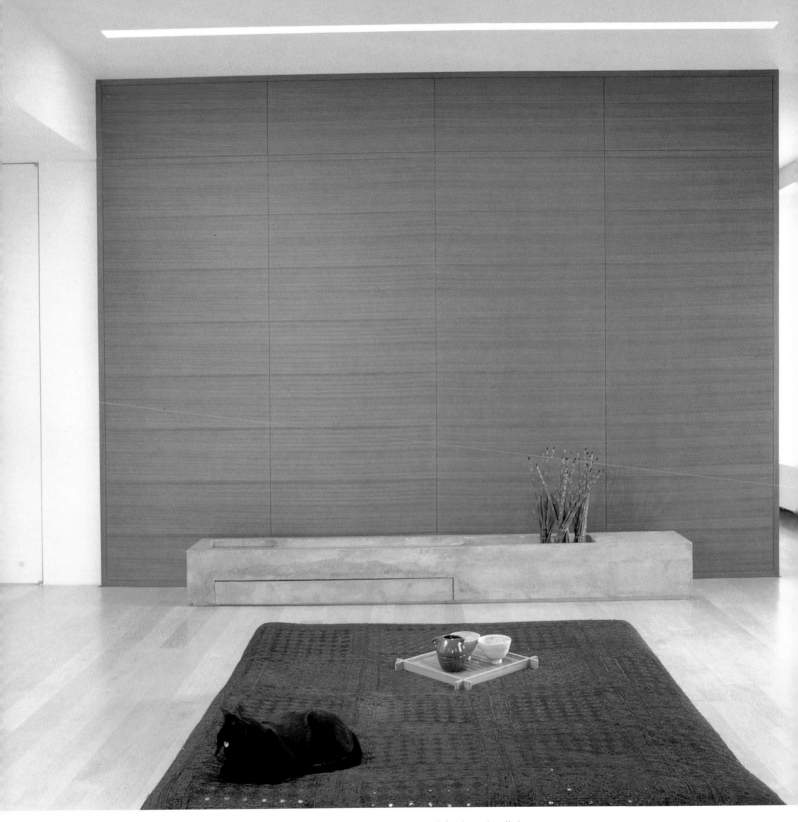

**Above:** *View of the cast concrete water feature with mahogany wall facing the living room*
**Right:** *Detail of water feature*

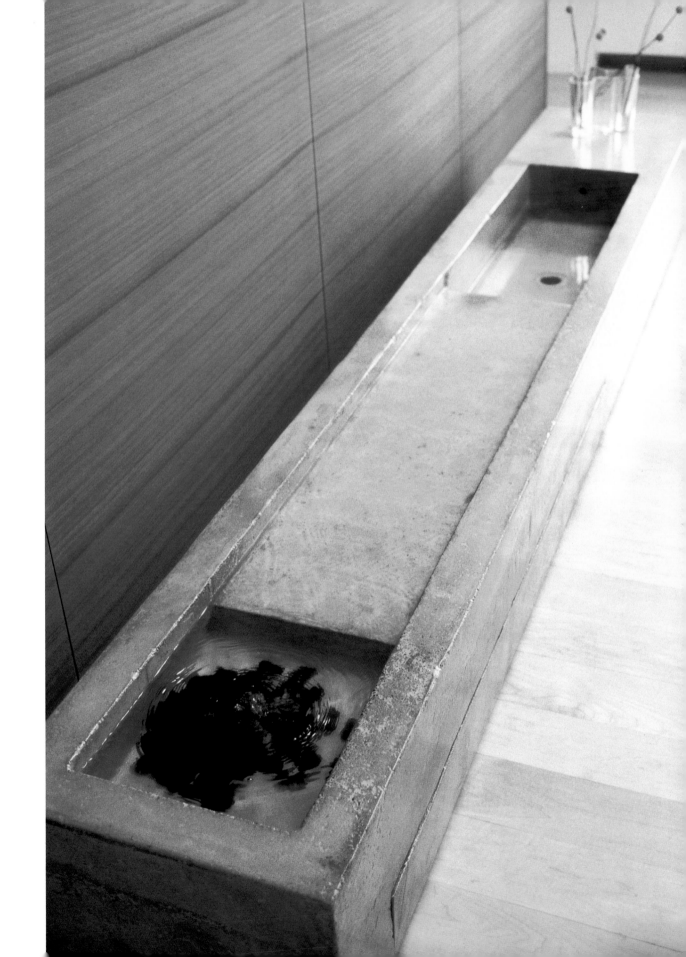

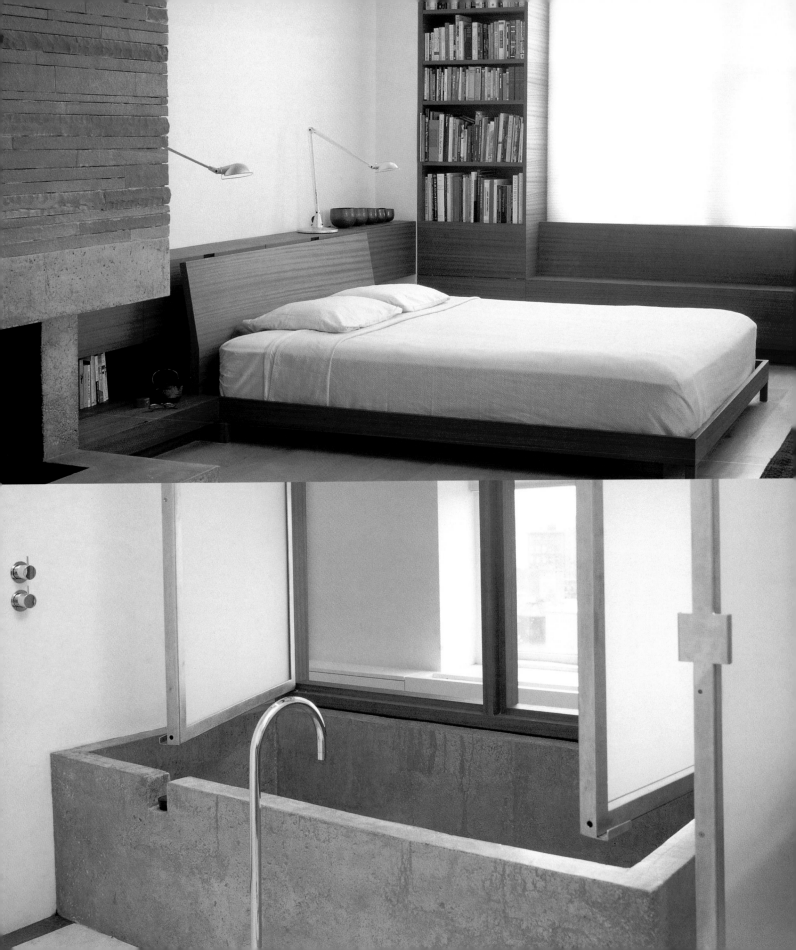

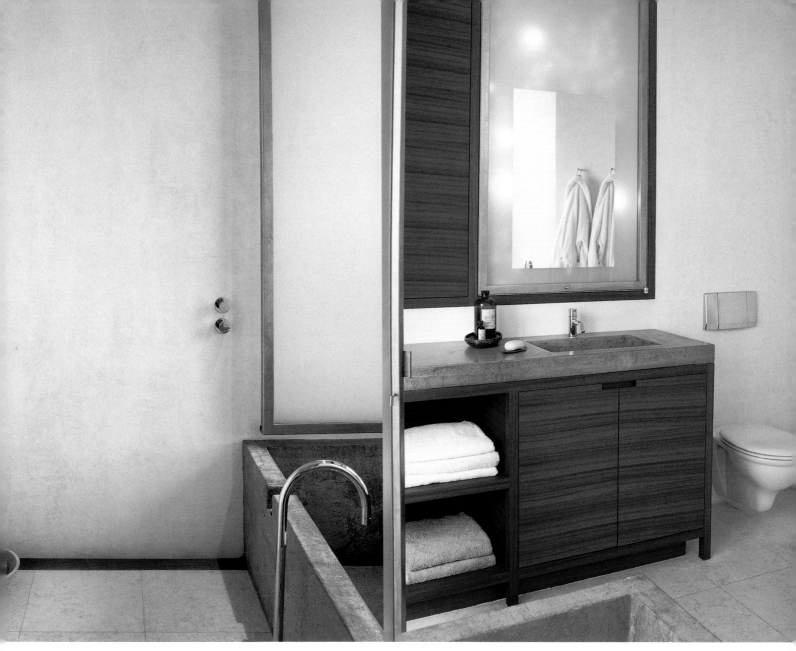

**Above:** *Concrete soaking tub detail*
**Right top:** *Master bathroom vanity*
**Left top:** *Master bathroom and fireplace*
**Left:** *Concrete soaking tub and operable translucent glass doors*

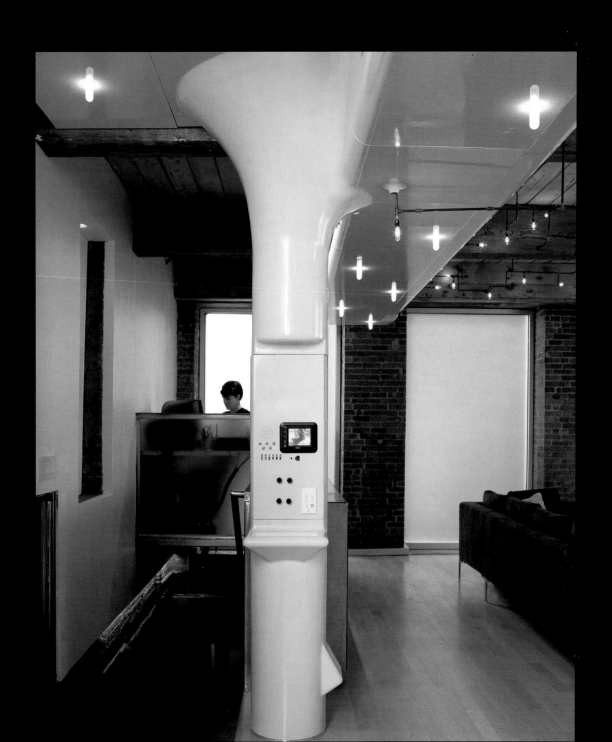

**This** duplex evolved from the concept of a loft as a microcosmic

urban space—an oversized setting for various activities and events.

Since the loft is surrounded by buildings and has no views, the

architects created loosely connected zones with varied environ-

ments making this loft a dynamic setting for exploration and con-

centration.

Fifteen panels of custom-designed and -molded fiberglass run

throughout the apartment concealing utility areas. A garden atrium

separates the living area from the kitchen/dining areas and, on the

second floor, the master suite from the children's bedrooms.  A

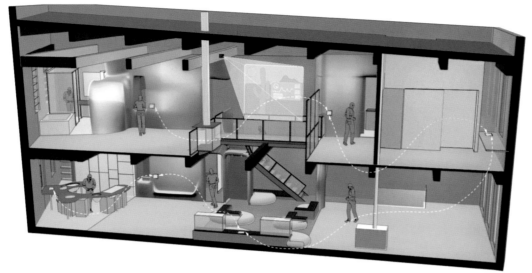

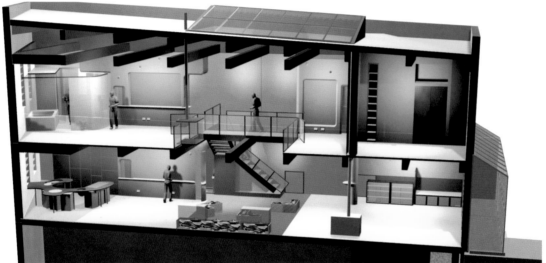

**Previous page:**
*Lighting controls and a video screen are contained in a fiberglass column that also serves as an HVAC soffit*
**Left:** *Diagram of the loft's internal network*
**Below:** *Sectional rendering*
**Right:** *Lower- and upper-level models of fiberglass wall*

First-floor plan

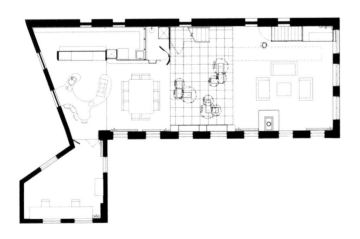

Second-floor plan/Mezzanine

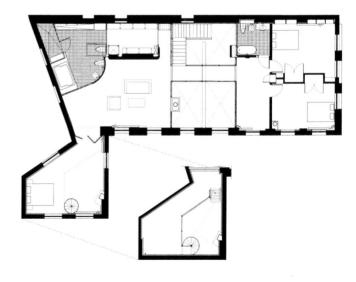

section of the floor is removed and a blue, steel-clad wall runs along the length of the two-

story space. This wall contains the loft's infrastructure. Lighting along the wall is provided by

small, movable LED lights fastened by magnets. Throughout the apartment, these lights are computer-programmed to change colors. Like the colors on a computer screen, the palette is virtually infinite. Small LCD screens embedded in walls, furniture, and cabinetry provide access to the home operating systems, a web-based home control and communication system. This system is not only internal, it also connects to the web.

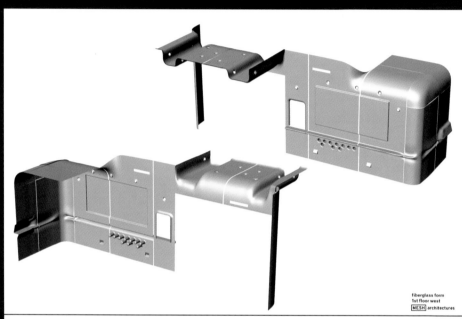

fiberglass form
1st floor west
MESH architectures

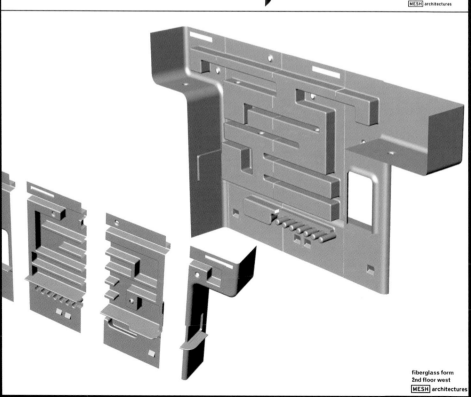

fiberglass form
2nd floor west
MESH architectures

*Mesh Architectures*
*New York, New York*

*Photography: Andrew Bordwin*

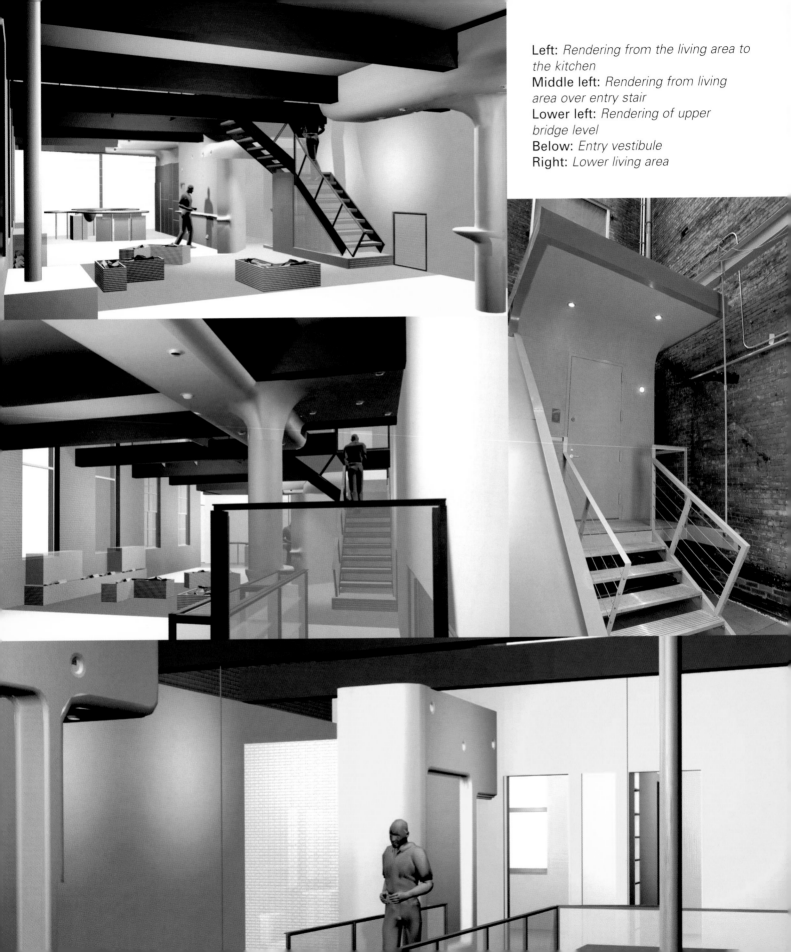

**Left:** *Rendering from the living area to the kitchen*
**Middle left:** *Rendering from living area over entry stair*
**Lower left:** *Rendering of upper bridge level*
**Below:** *Entry vestibule*
**Right:** *Lower living area*

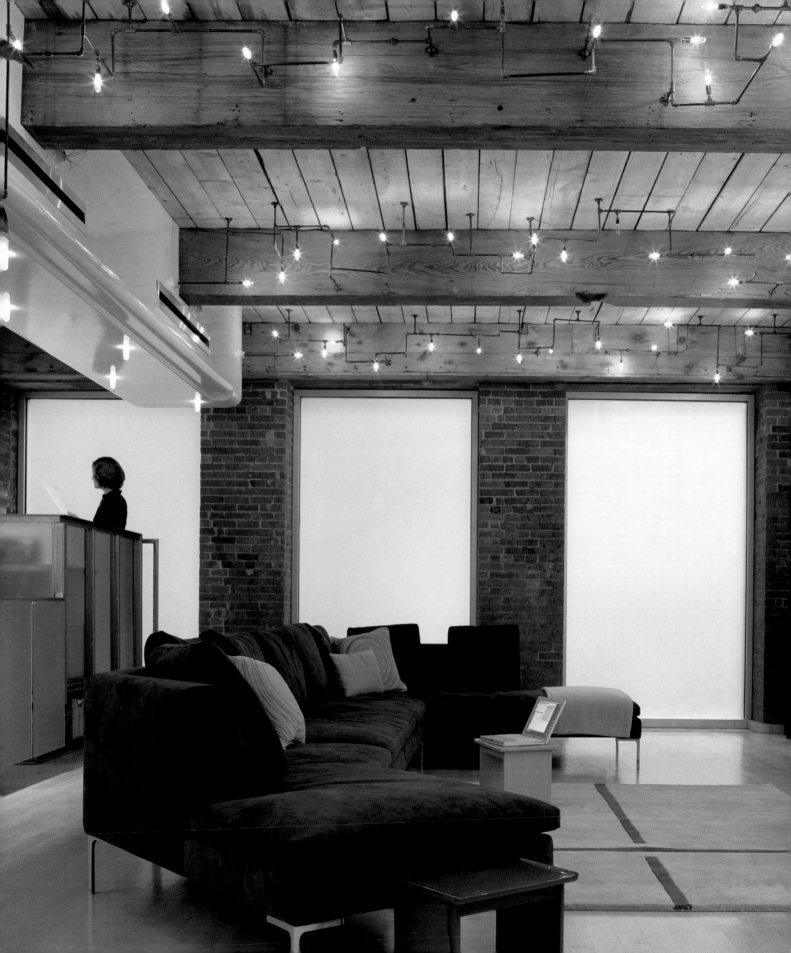

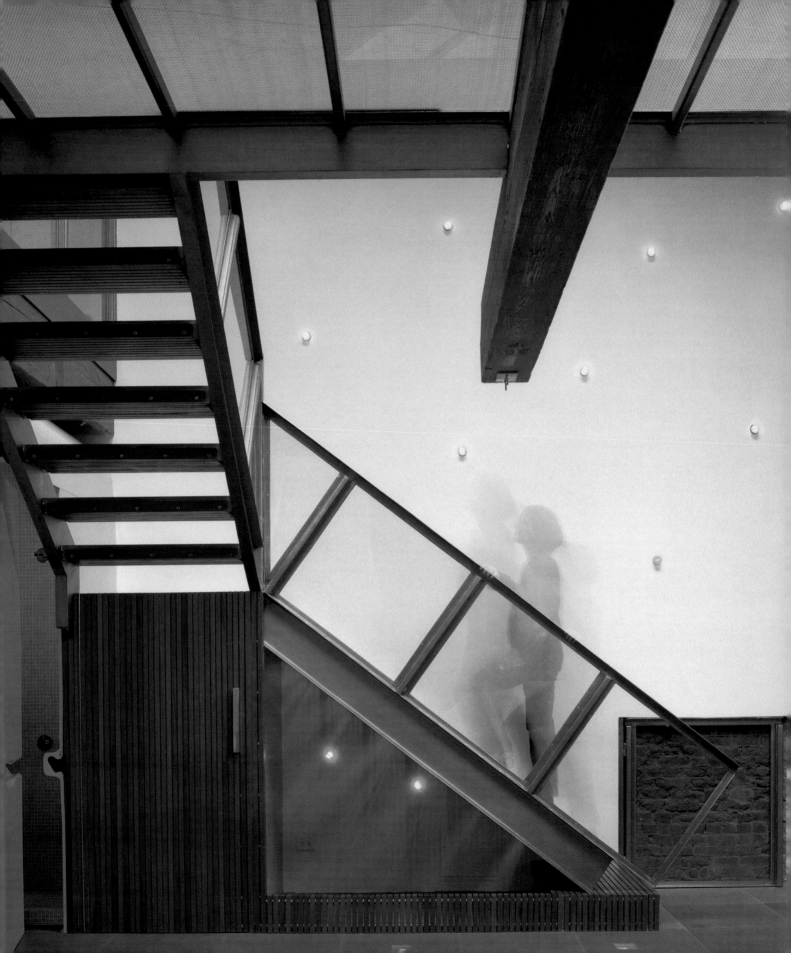

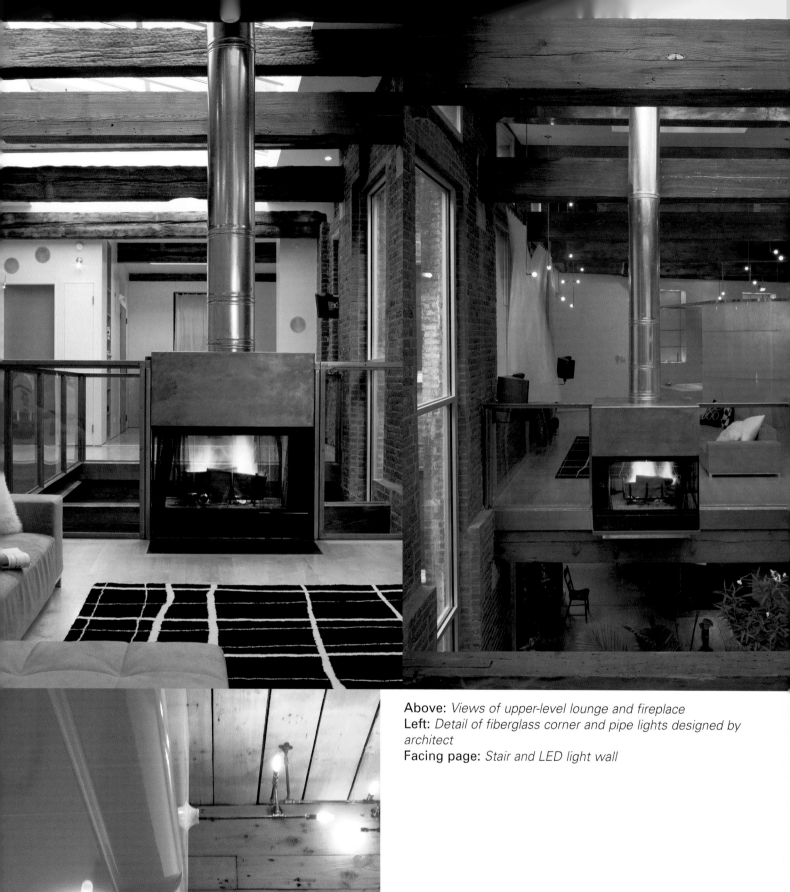

**Above:** *Views of upper-level lounge and fireplace*
**Left:** *Detail of fiberglass corner and pipe lights designed by architect*
**Facing page:** *Stair and LED light wall*

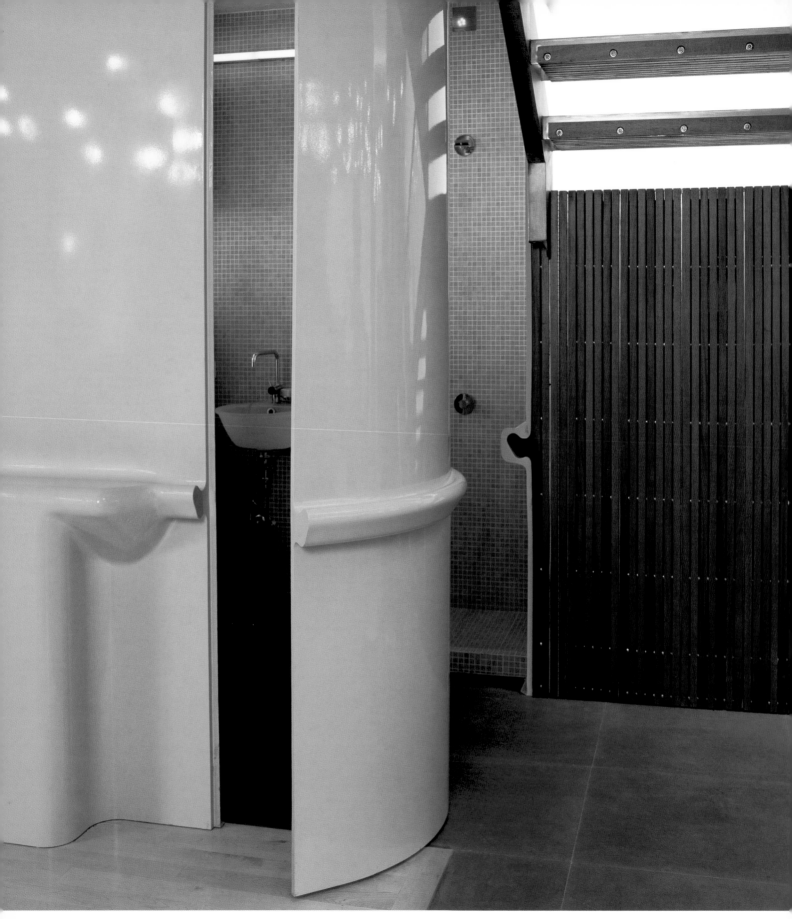

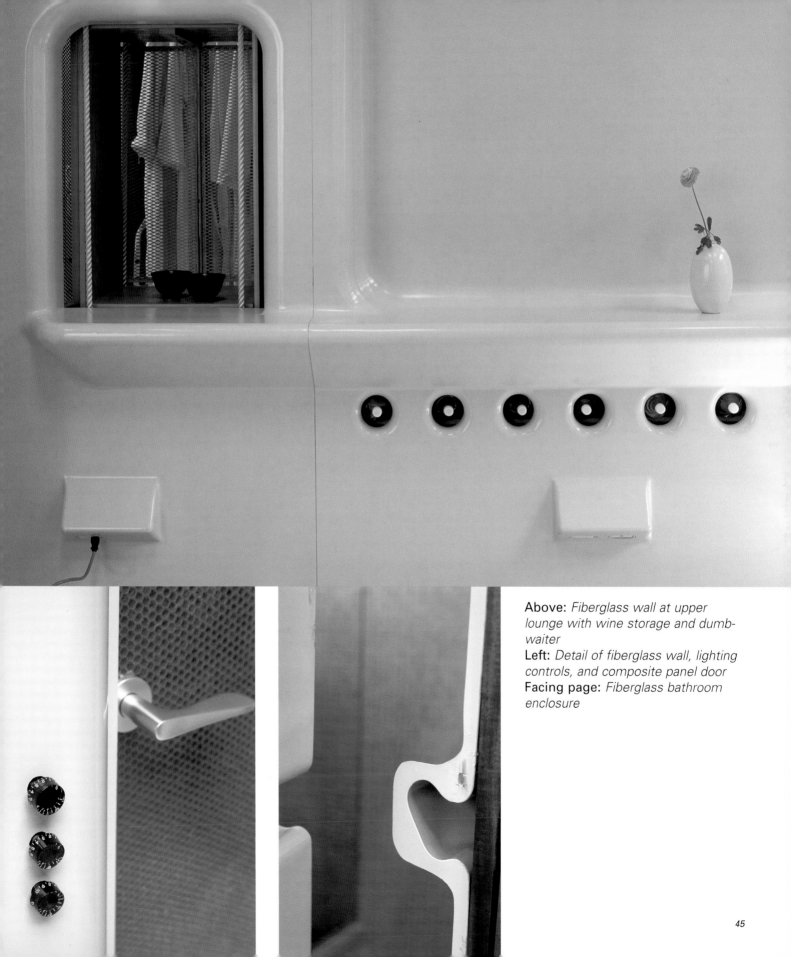

**Above:** *Fiberglass wall at upper lounge with wine storage and dumb-waiter*
**Left:** *Detail of fiberglass wall, lighting controls, and composite panel door*
**Facing page:** *Fiberglass bathroom enclosure*

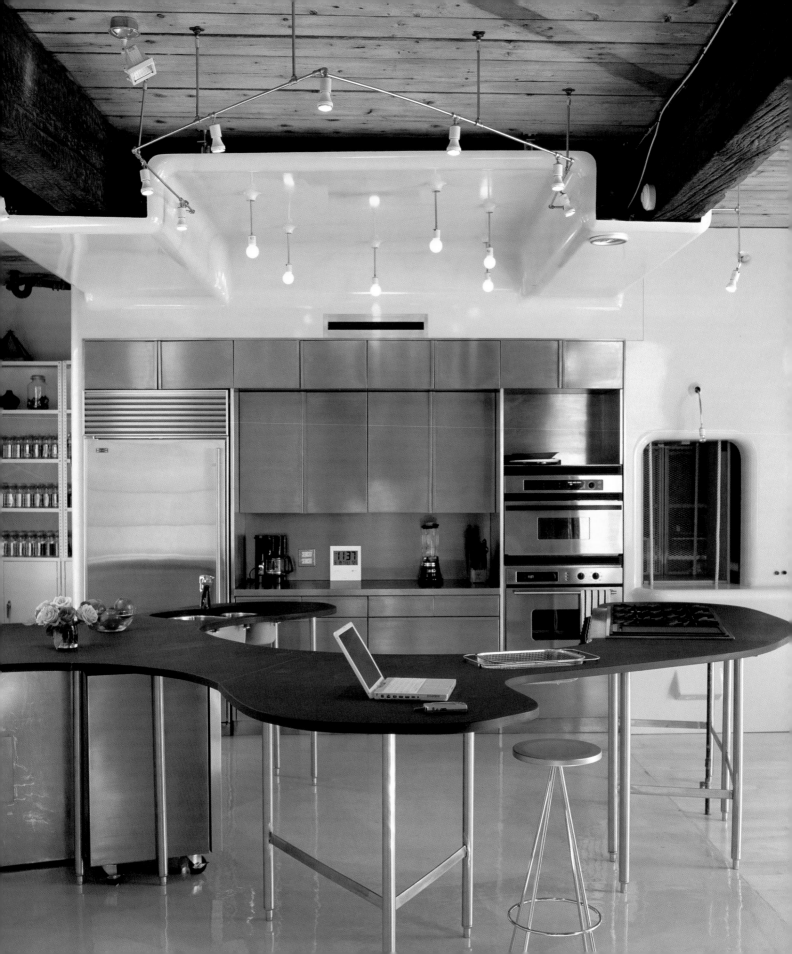

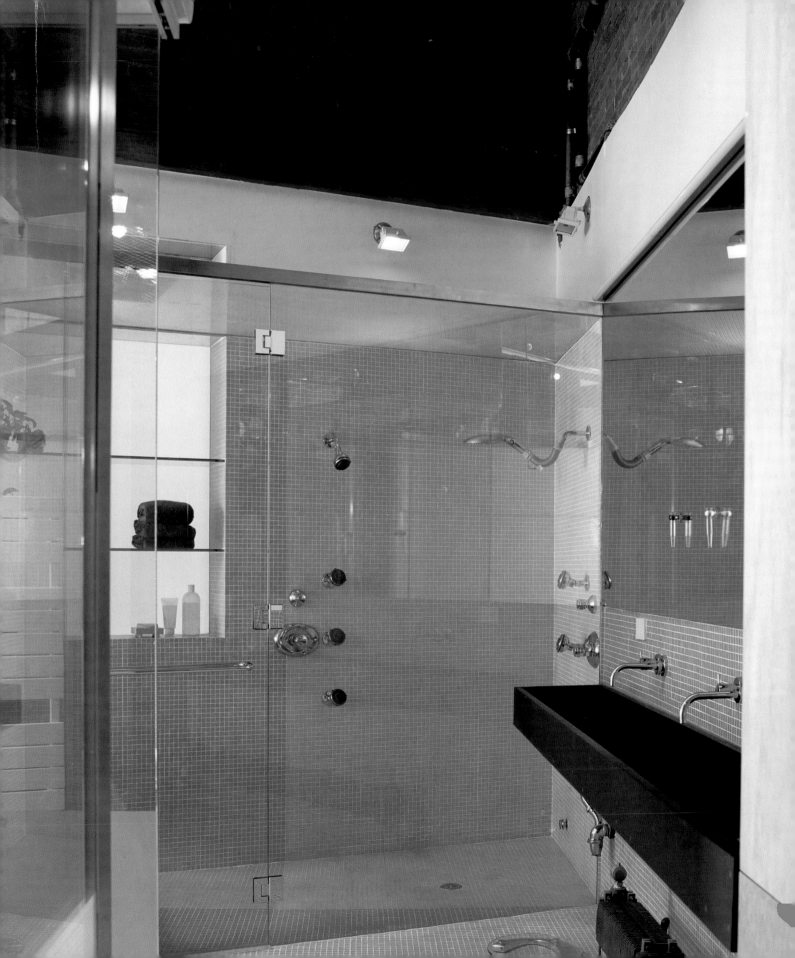

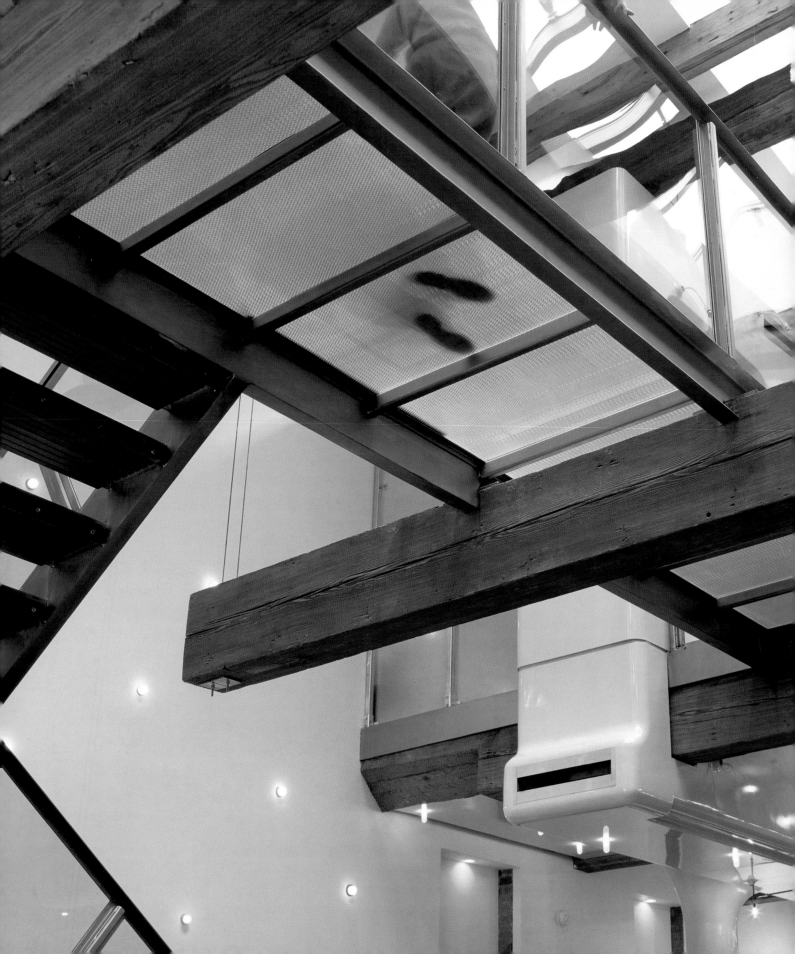

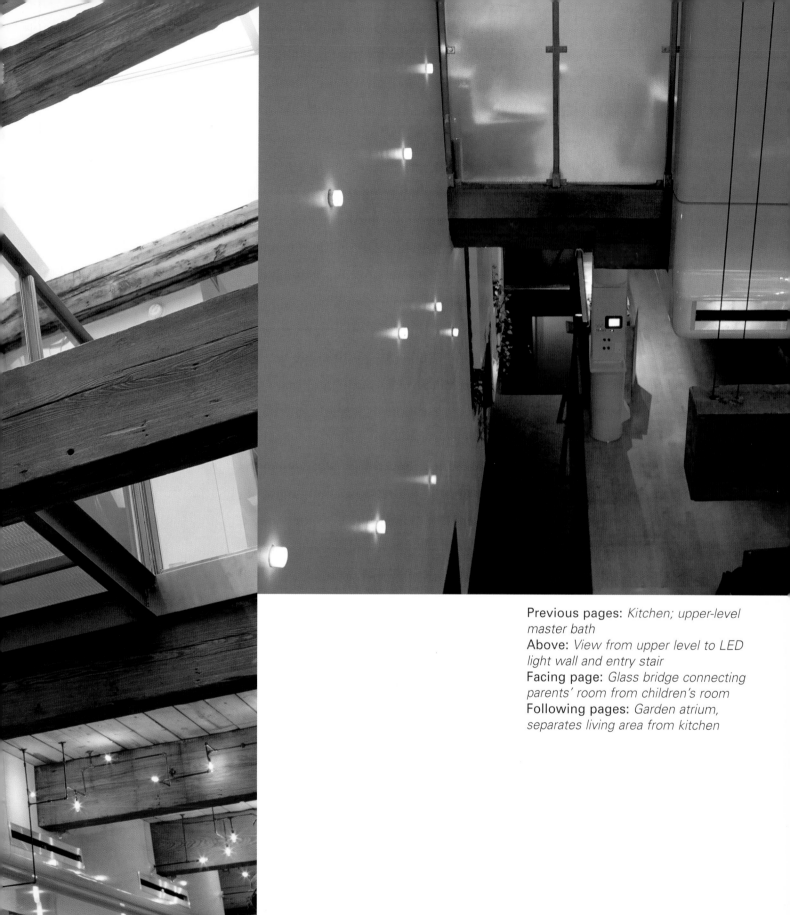

Previous pages: *Kitchen; upper-level master bath*
Above: *View from upper level to LED light wall and entry stair*
Facing page: *Glass bridge connecting parents' room from children's room*
Following pages: *Garden atrium, separates living area from kitchen*

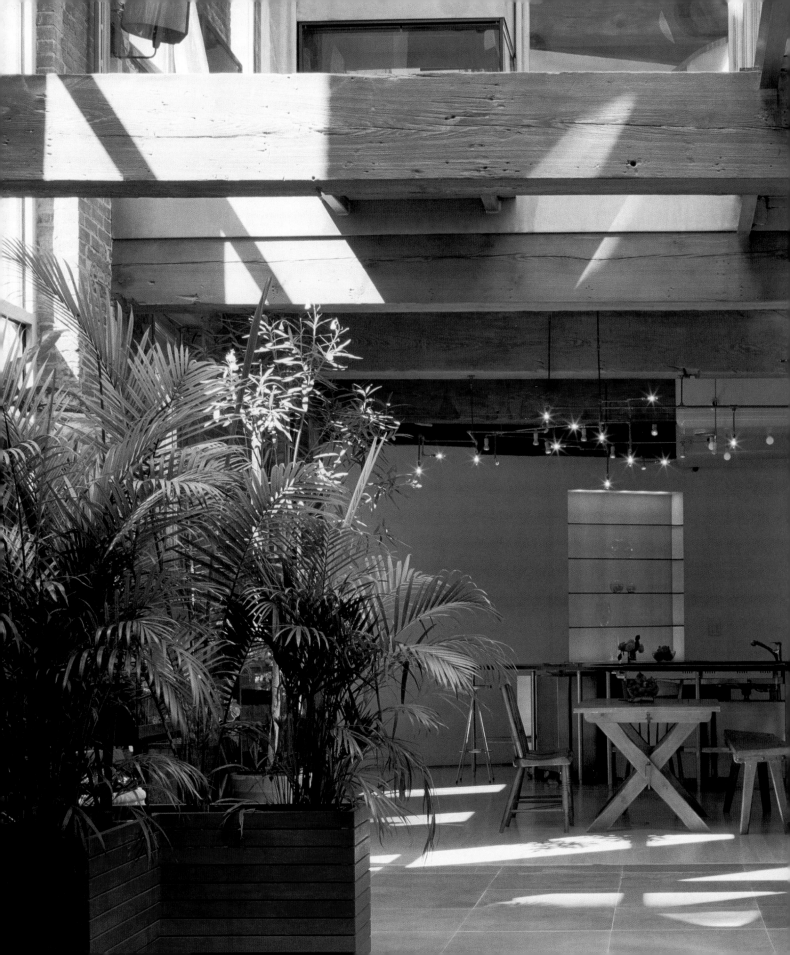

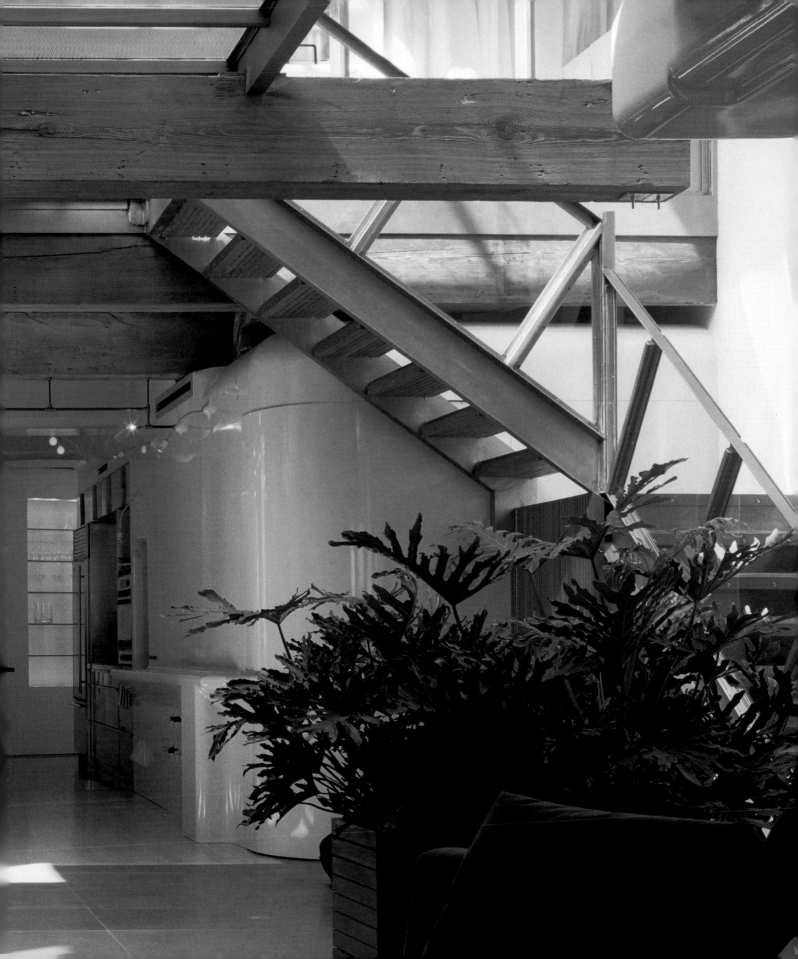

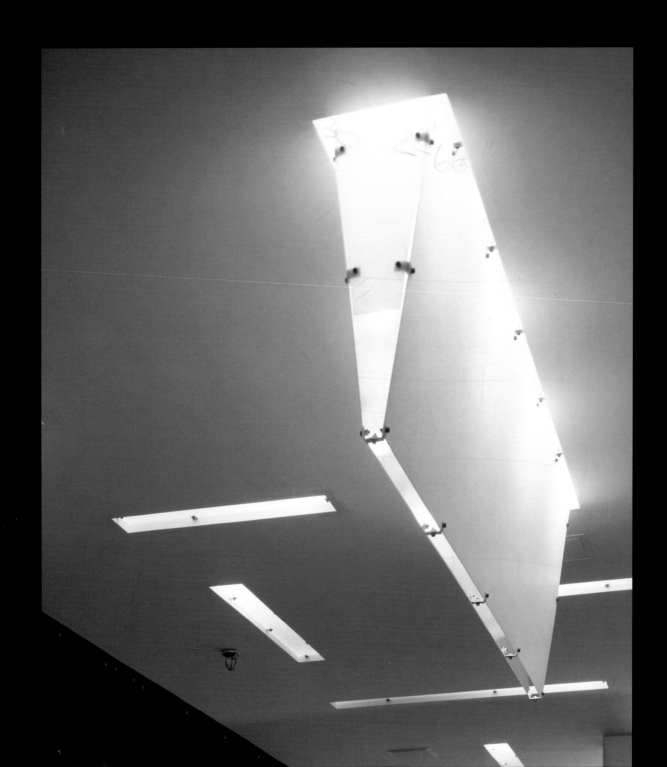

**The** plan for this loft renovation is dominated by an open volume

for entertaining that spills past a central kitchen to a bathroom core ter-

minating in two bedrooms at the rear of the space.

The main living area is sheathed by a series of planes intended to artic-

ulate the edges and thresholds of the space. Within this volume, zones

of use are suggested by the placement of specific planes of material.

A raised plane of concrete ceiling panels identifies the living zone.

Flanked by an anchored wall of steel and a floating wall of plaster, the

dining area is defined by a penetrating wedge of light from above,

while a slipped plane of stone defines the fireplace to one side.

Previous page: *Lighting detail*
Below: *Panoramic computer model*
Following pages: *Views of the sliding
steel panel entry door notched for
hardware and light switches*

Floor plan

1. entry
2. living
3. dining
4. kitchen
5. bedroom
6. guest
   bedroom

0  4  8        16

Kitchen cabinets and appliances form another edge of the living area.

Kitchen and dining zones are unified by a series of rectangular bars of light that are carved into the ceiling. The twenty bars of light are regulated by four dimming controls that can be adjusted to highlight different areas of the kitchen/dining area.

Thresholds of the spaces are layered with planes that slide, pivot, and roll. The sliding "front door" provides security at the elevator. The pivoting bedroom door provides privacy while allowing light on a continuous brick wall to slip past, connecting the full length of the loft. Rolling, perforated window scrims diffuse sunlight and provide privacy from the outside. The master bed is composed of several cantilevered planes, and storage cabinets are accented with aluminum dividers.

*Resolution: 4 Architecture*
*New York, New York*

*Photography: Eduard Hueber*

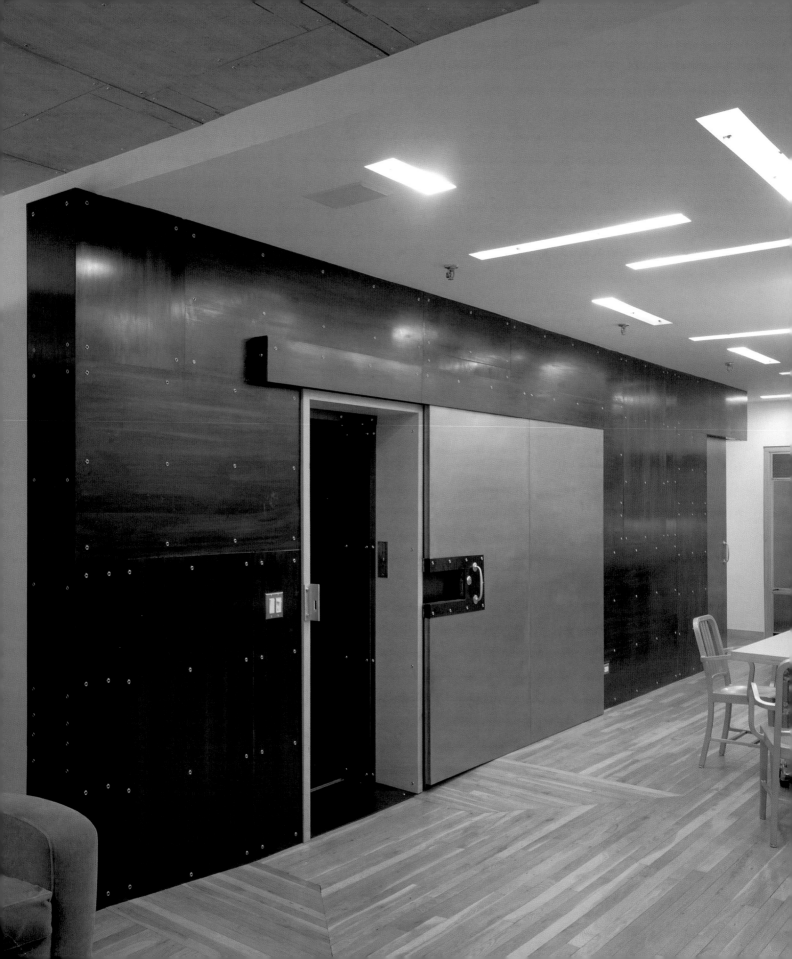

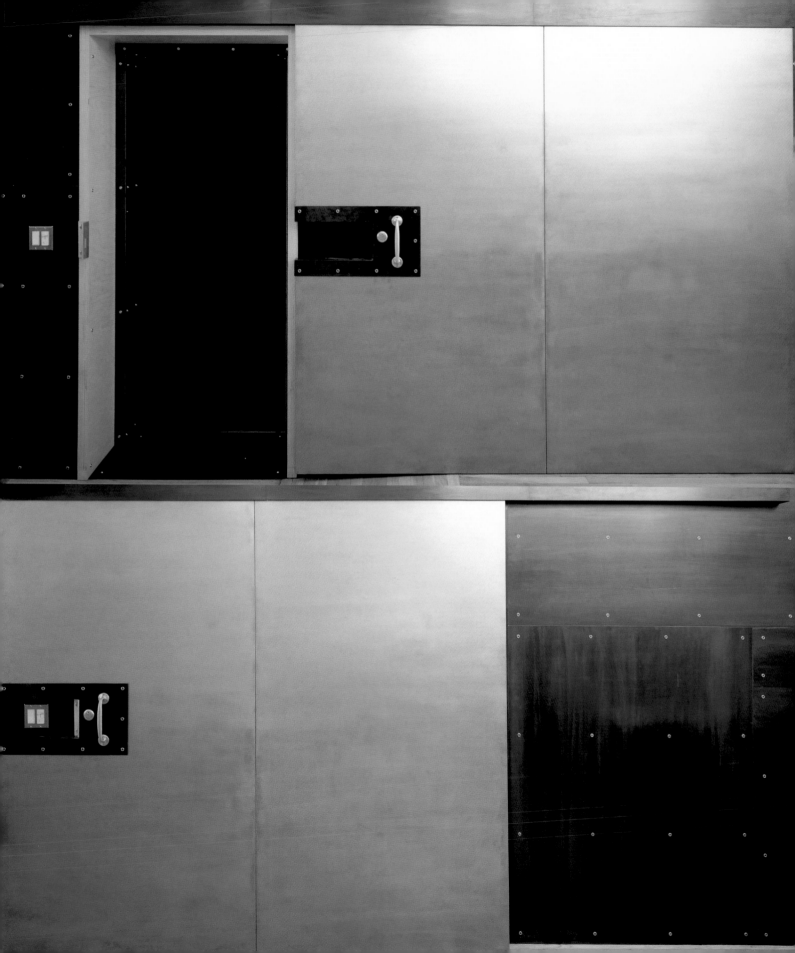

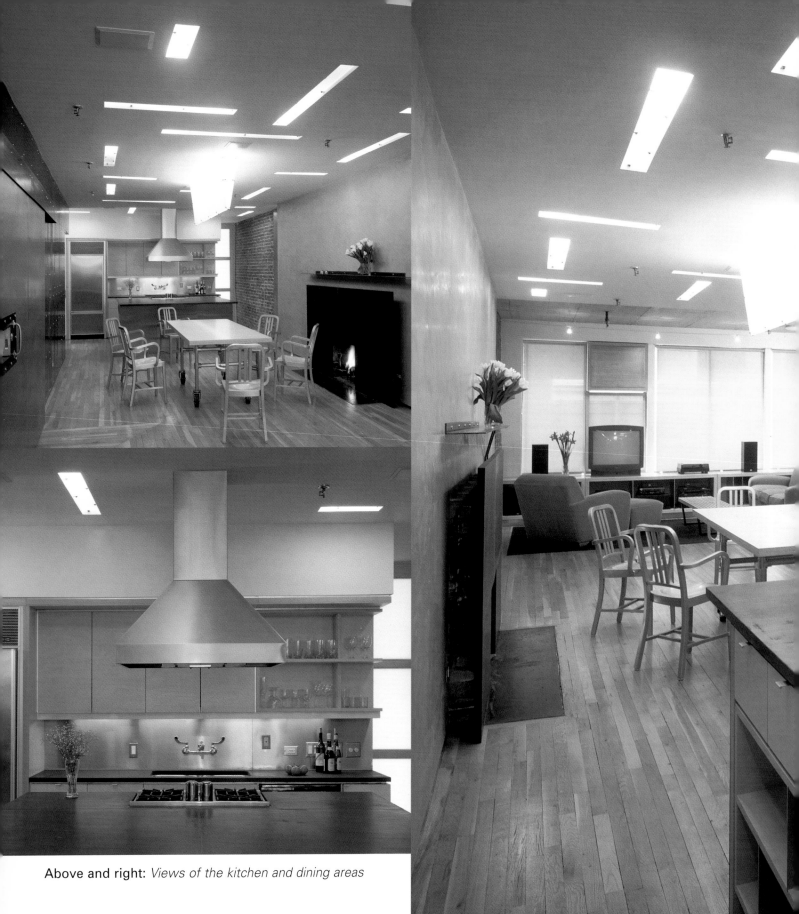

**Above and right:** *Views of the kitchen and dining areas*

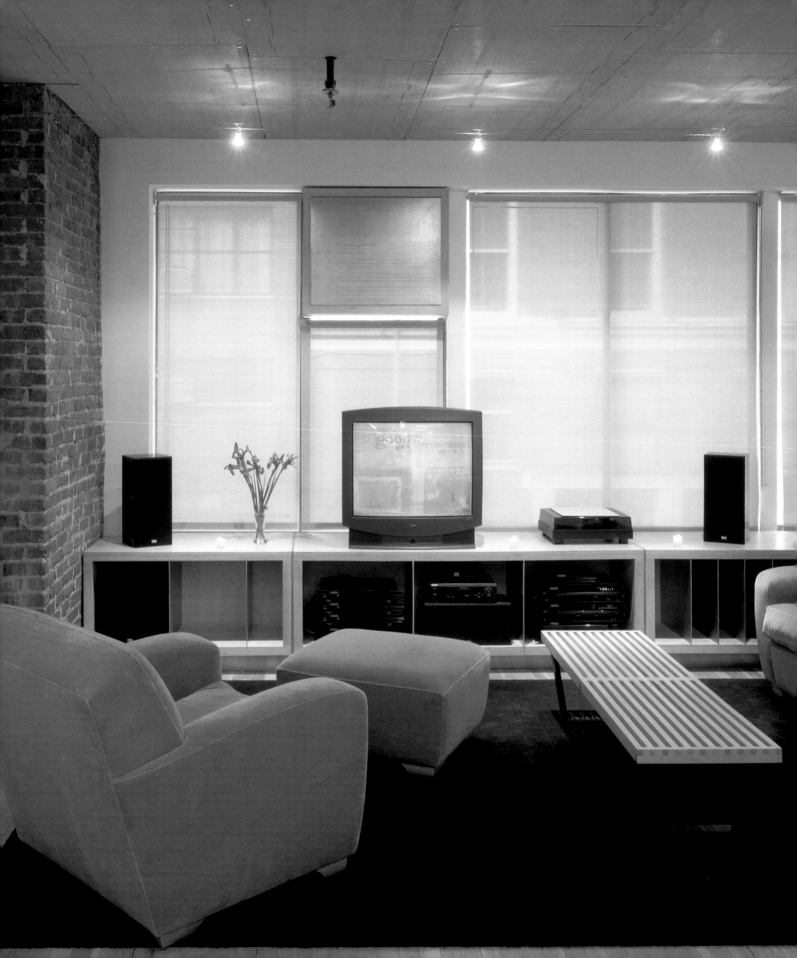

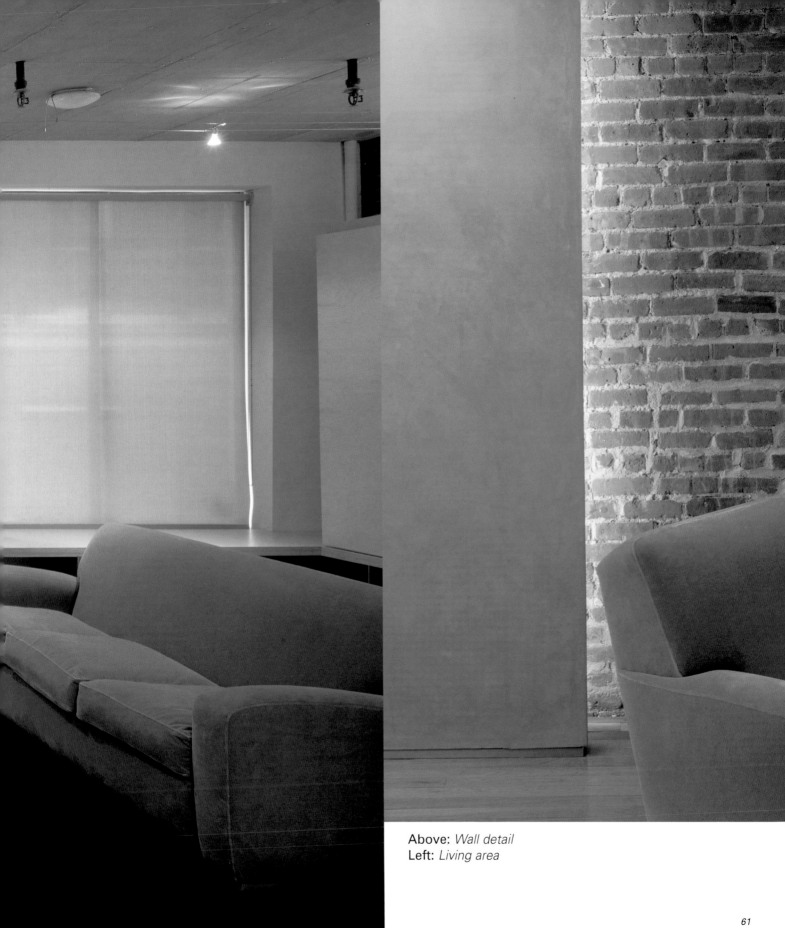

**Above:** *Wall detail*
**Left:** *Living area*

**Above:** *The doors are aluminum and faced with Lumasite to allow light transmission*
**Right:** *Master bedroom*

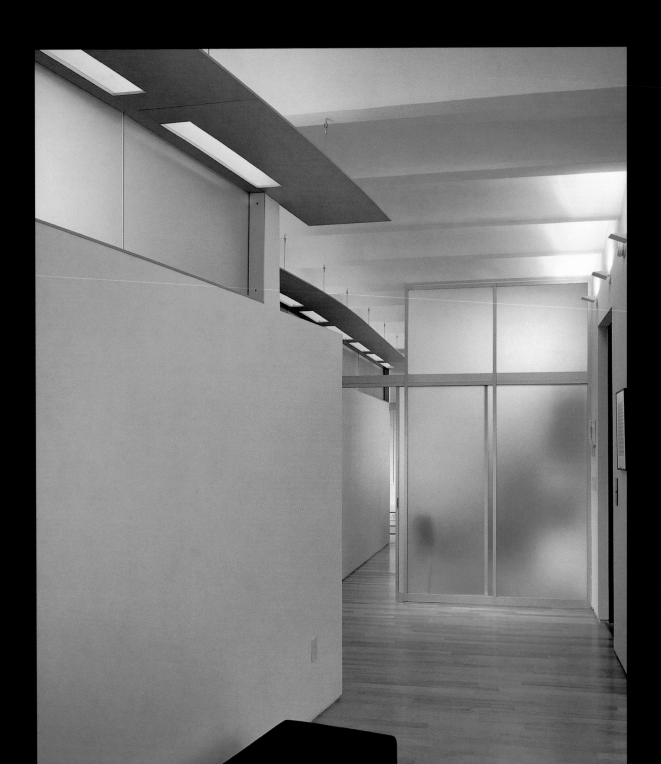

**This** loft in the Tribeca neighborhood in Manhattan was designed

to take advantage of a narrow space by creating a sense of warmth

and style for the clients. The design capitalizes on the contrast

between the vaulted ceiling and a linear, floating light shelf. The

shelf was designed to create a datum throughout the loft that sets

up transoms, doors, and lines for lighting. The shelf delineates a

curved spine dividing public from private spaces and defining differ-

ently lit areas. The aluminum plate detailing of the shelf creates a

low-maintenance but distinctive language for the multiple thresholds

Section

0 1        5        10

Floor plan

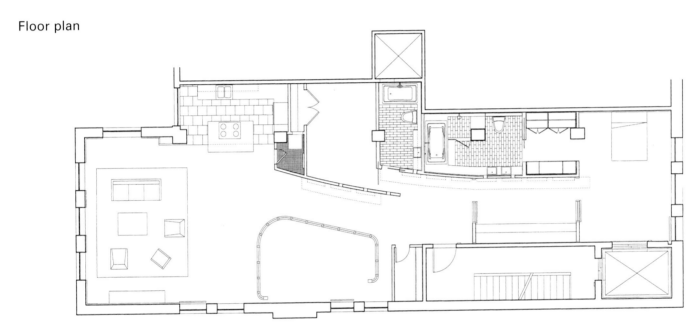

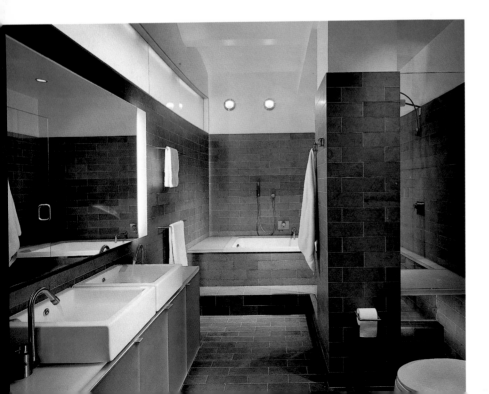

**Previous page:** *View of the entry with detail of vaulted ceiling and aluminum light shelf*
**Left:** *Master bathroom*
**Right:** *Lighting detail drawing*

in the space. The lighting strategy was developed in concert with Jim Conti Lighting Design and uses the vaults themselves as a lantern for the space.

Glass, stone, and beech wood are used throughout to create warmth, contrast, and color.

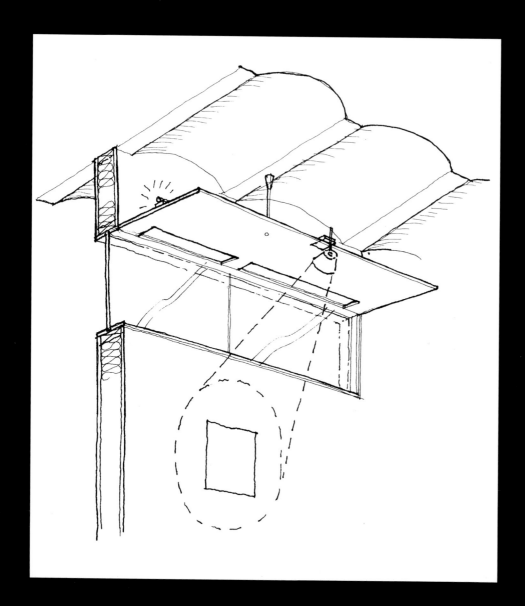

**Weisz + Yoes Architecture**
New York, New York

**Photography: Paul Warchol**

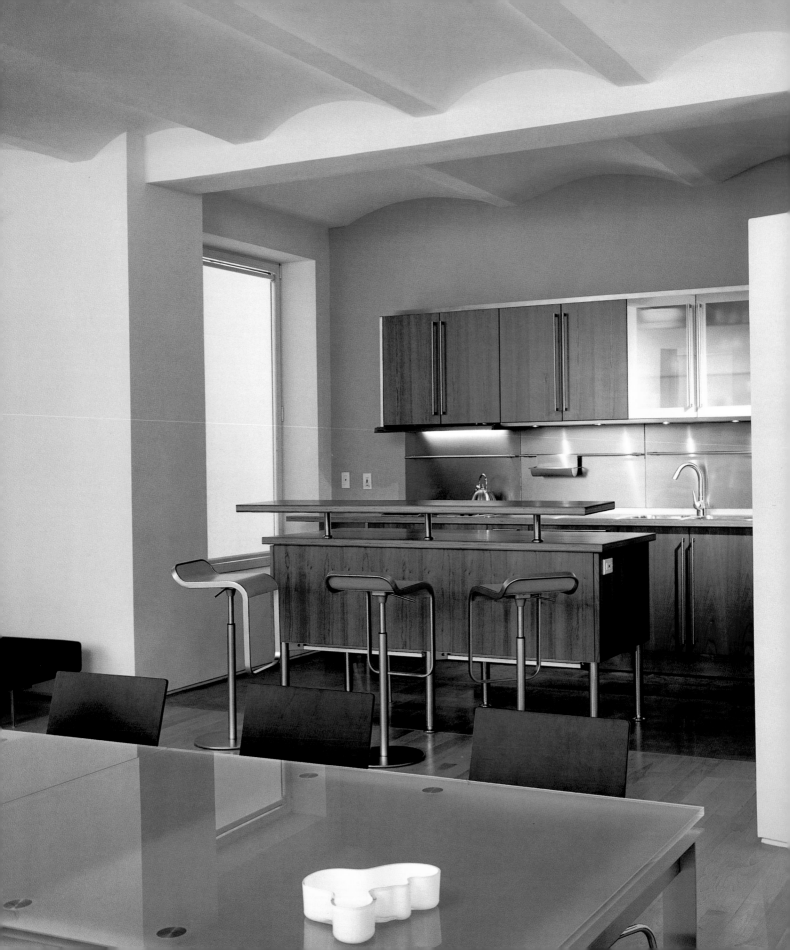

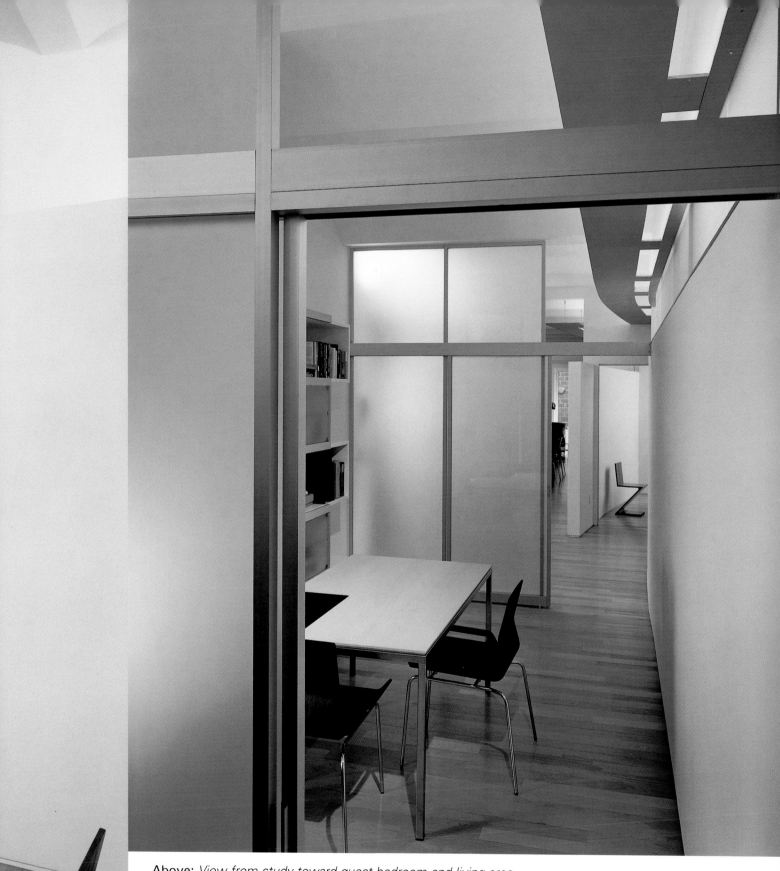

**Above:** *View from study toward guest bedroom and living area*
**Left:** *View of kitchen from dining area*

**Capturing** and maximizing light is a recurring theme in loft

design, and architect Alastair Standing has elevated this task to a

scientific art. The Rosser loft is housed in a four-story building sand-

wiched between an eleven- and a six-story building. All aspects of

the design, from window treatments to furniture and privacy parti-

tions, were created by the architect to soak up and disperse as

much of the available natural light as possible. Old-fashioned elec-

tric lights do the rest of the job. Floodlights are concealed in the

window reveals and focused to mimic daylight shadows. Task

Site plan

Previous pages: *Acid-etched glass and three types of natu-rally dried wood from diseased trees are used for the tables*
Right: *Mounting detail of frosted Plexiglas window louvers*

Floor plan

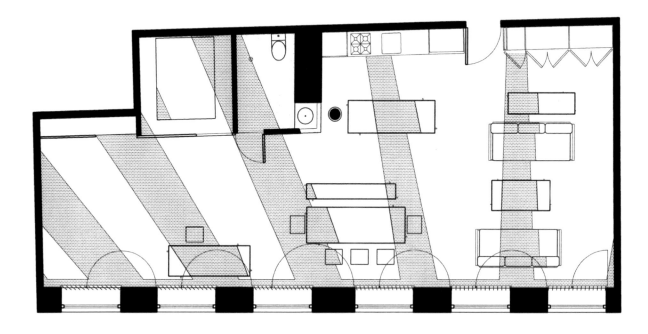

ing is focused onto the table surfaces from spots in the ceiling.

The apartment's six large north-facing windows have operable frosted Plexiglas louvers set in stainless steel frames. The angle of the louvers is adjusted to correspond to the direction of natural light for each window. They obscure direct view of the adjacent buildings without reducing the light level. The Plexiglas is held in tension to the frame by springs.

The interior bathroom has a glass ceiling. The white and gray wall tile traces shadows, an idea continued on the terrazzo floor, and indeed throughout the apartment. Shadow lines have been carefully mapped, and through the use of translucent and opaque materials, they have been permanently etched in tables and wall surfaces.

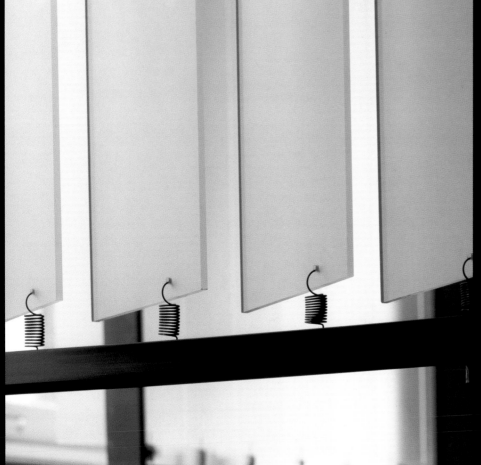

**Standing Architecture**
*New York, New York*

*Photography: Scott Frances*

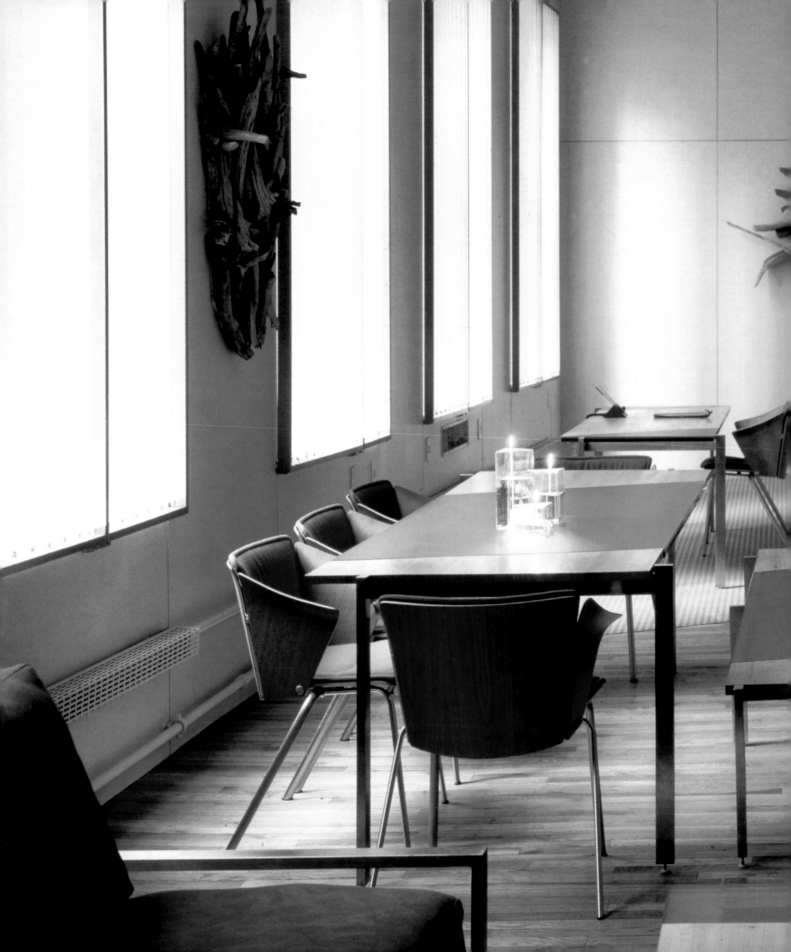

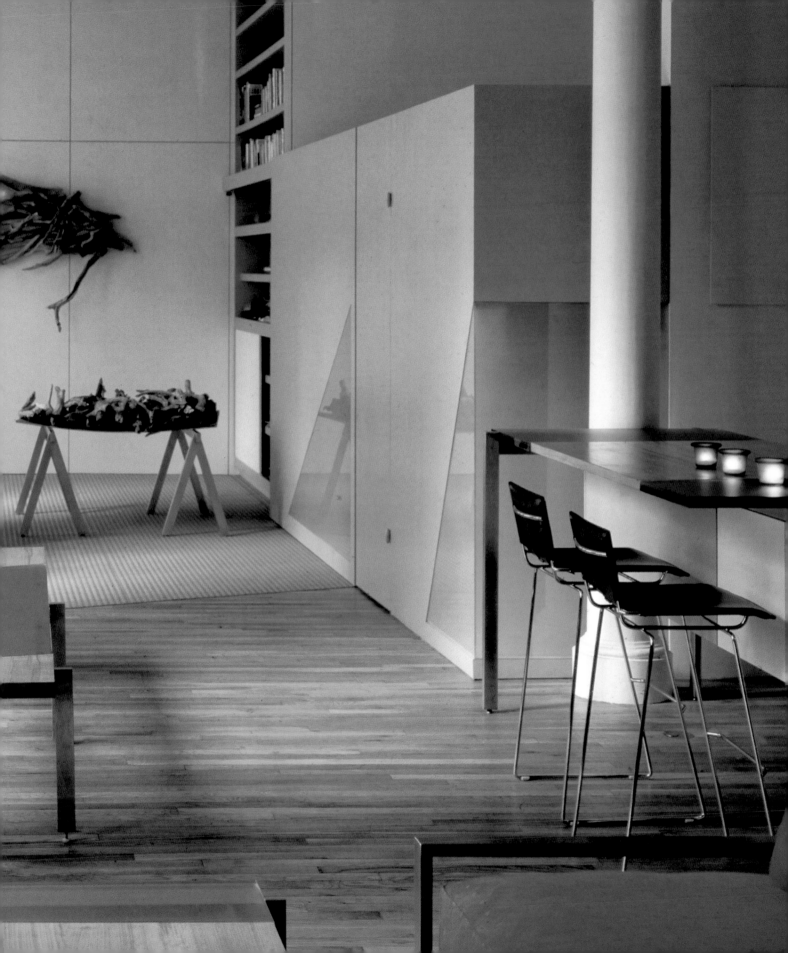

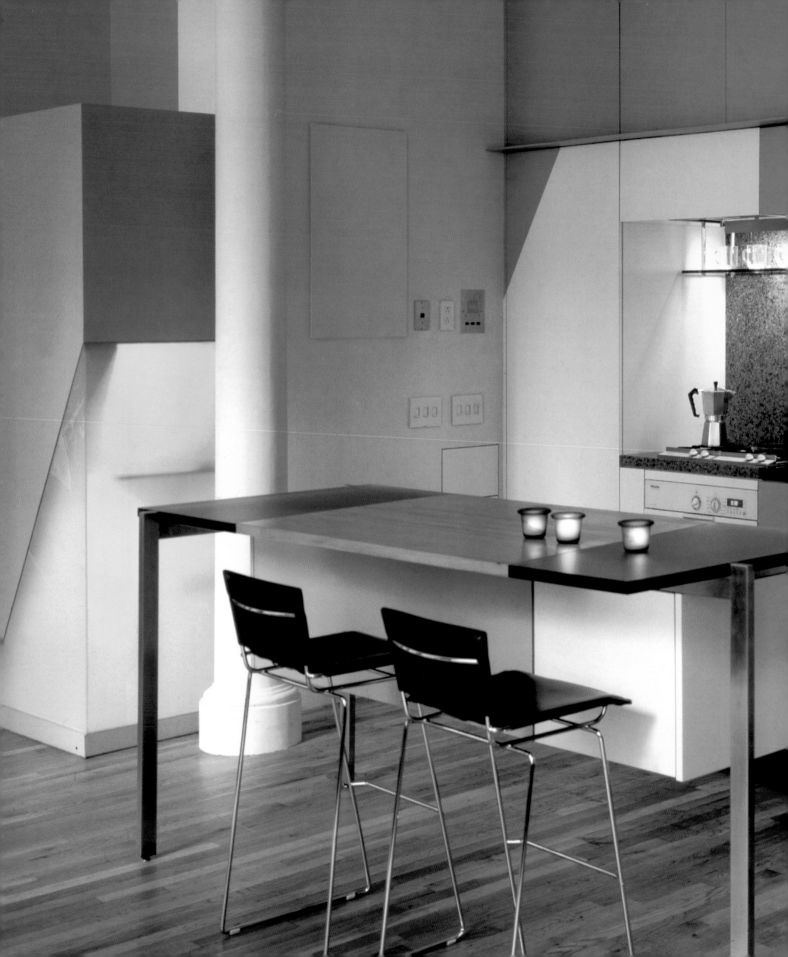

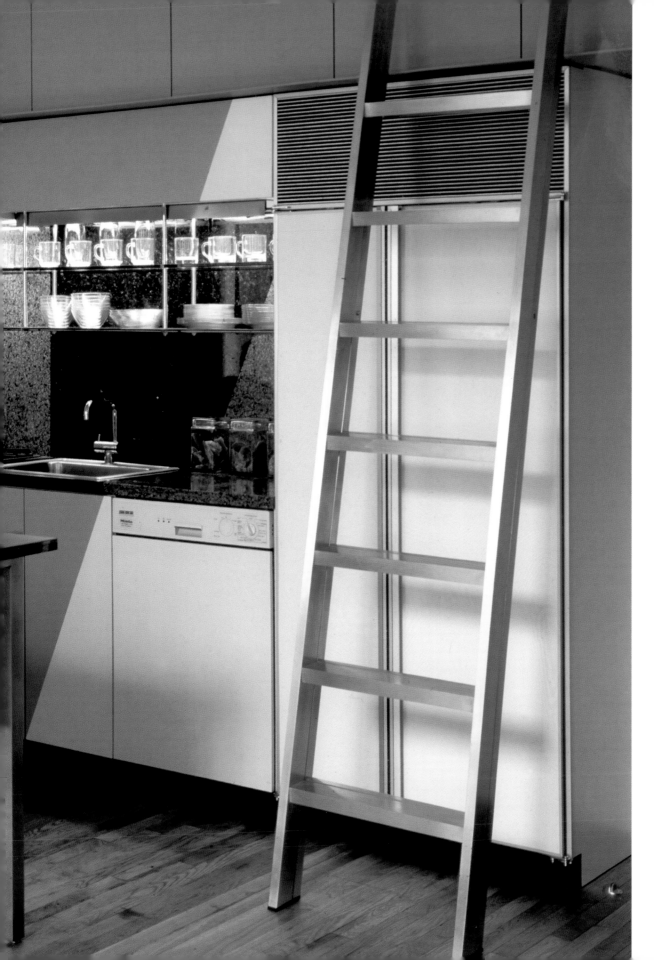

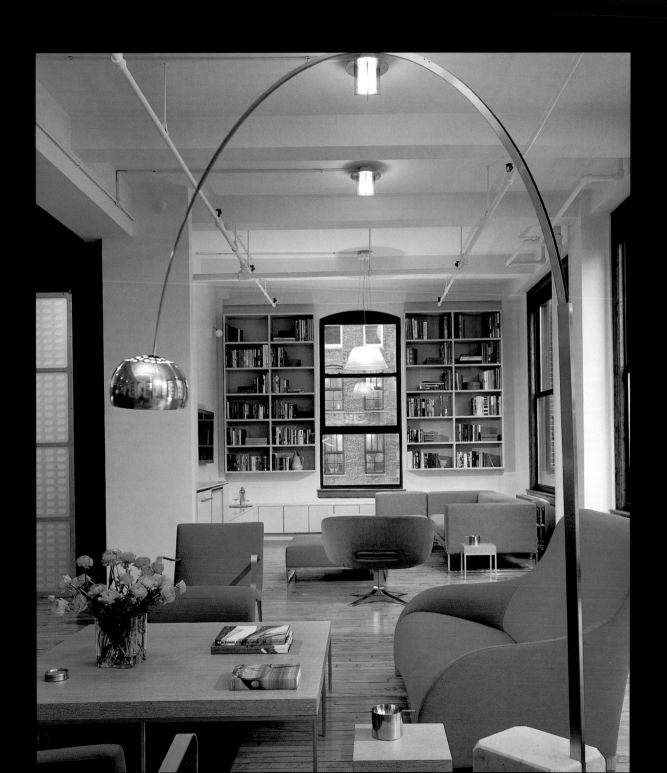

**The** client, a young entrepreneur, asked the architects to design

a flexible live/work space that would also work as a family home in

the future. Maintaining a sense of openness throughout the 3000-

square-foot industrial space was important as was maximizing natu-

ral light from all four exposures. The open public areas are visually

choreographed so that spaces can merge, compress, and expand,

depending on the client's needs. As a result, the space can accom-

modate a 100-person party or contract into separate zones for

more intimate gatherings and events.

A tight core of private spaces consisting of the guest bedroom,

## Axonometric

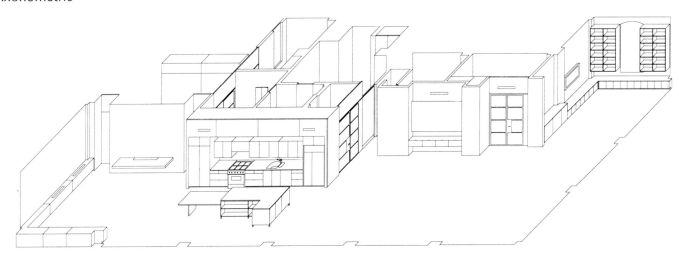

## Floor plan

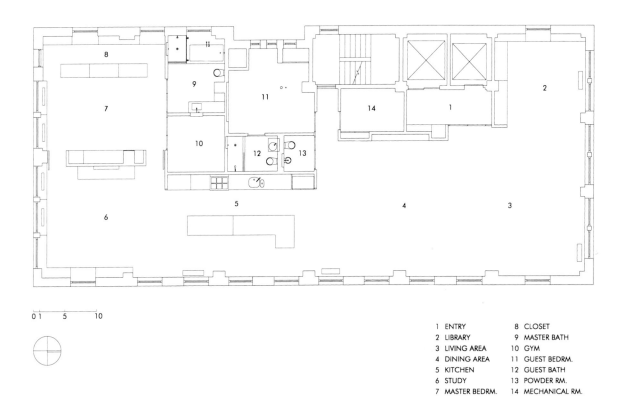

0 1   5   10

| 1 ENTRY | 8 CLOSET |
| 2 LIBRARY | 9 MASTER BATH |
| 3 LIVING AREA | 10 GYM |
| 4 DINING AREA | 11 GUEST BEDRM. |
| 5 KITCHEN | 12 GUEST BATH |
| 6 STUDY | 13 POWDER RM. |
| 7 MASTER BEDRM. | 14 MECHANICAL RM. |

gym, powder room, and two bathrooms are grouped behind the kitchen, which is a focal point of the loft. By creating this compact core of service spaces, the architects were able to maximize the volume of the public areas.

Translucent doors allow light to flow from this private core into the public areas. They are a composite of etched glass and laser-cut Acrylite panels housed in aluminum frames. Their patterning was inspired by a traditional Indian motif. As one walks by the doors, the changing refraction of light between the sandwiched materials creates a shifting pattern of translucency. Different laser-cut Acrylite panels can be interchanged, altering the color and pattern of the doors' surfaces.

1/4" THK LASER-CUT ACRYLITE PANEL
4 MM ETCHED GLASS
3/8" X 1/2" ALUMINUM FLAT
3/16" THK ALUMINUM SKIN
1 1/4" X 1 1/4" ALUMINUM TUBE
3/4" X 1/4" ALUMINUM FLAT

**Desai/Chia Studio**
**New York, New York**

**Photography: Paul Warchol**

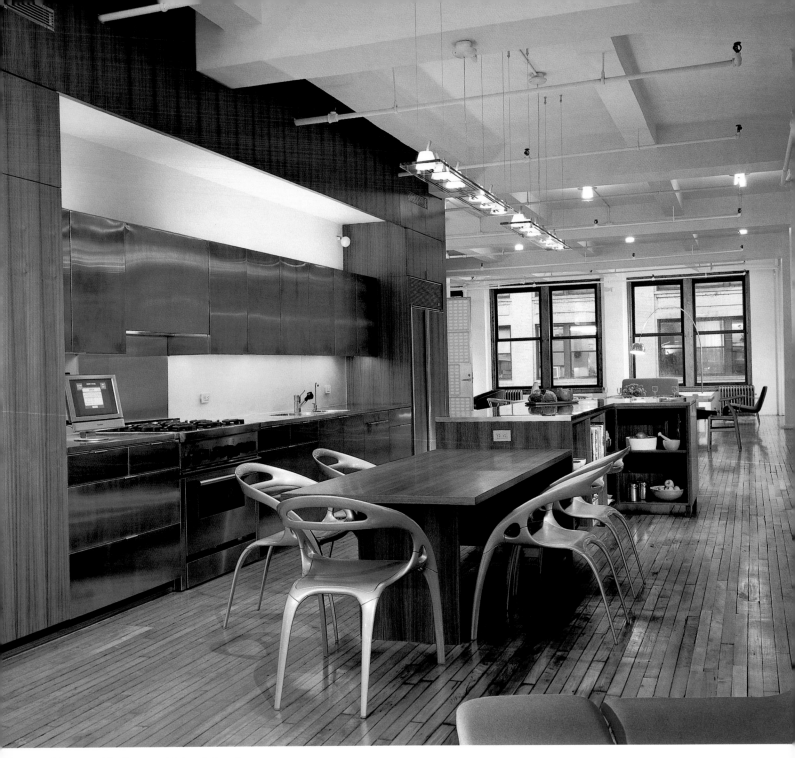

**Above:** *Kitchen and island details*
**Right:** *View of kitchen from living area*

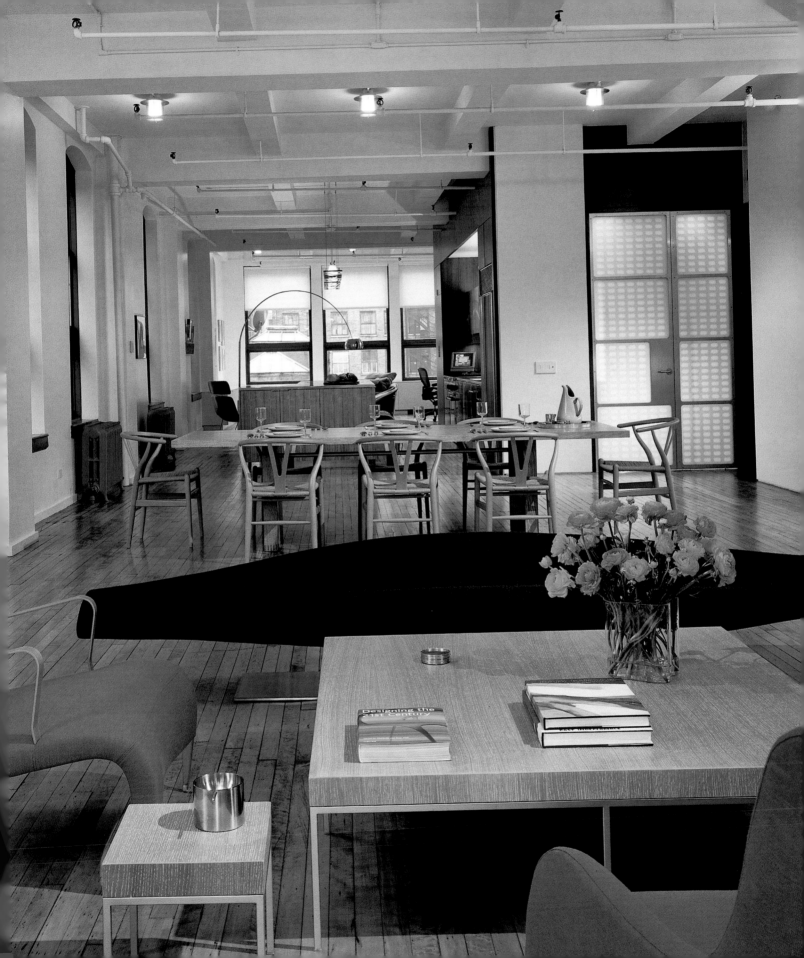

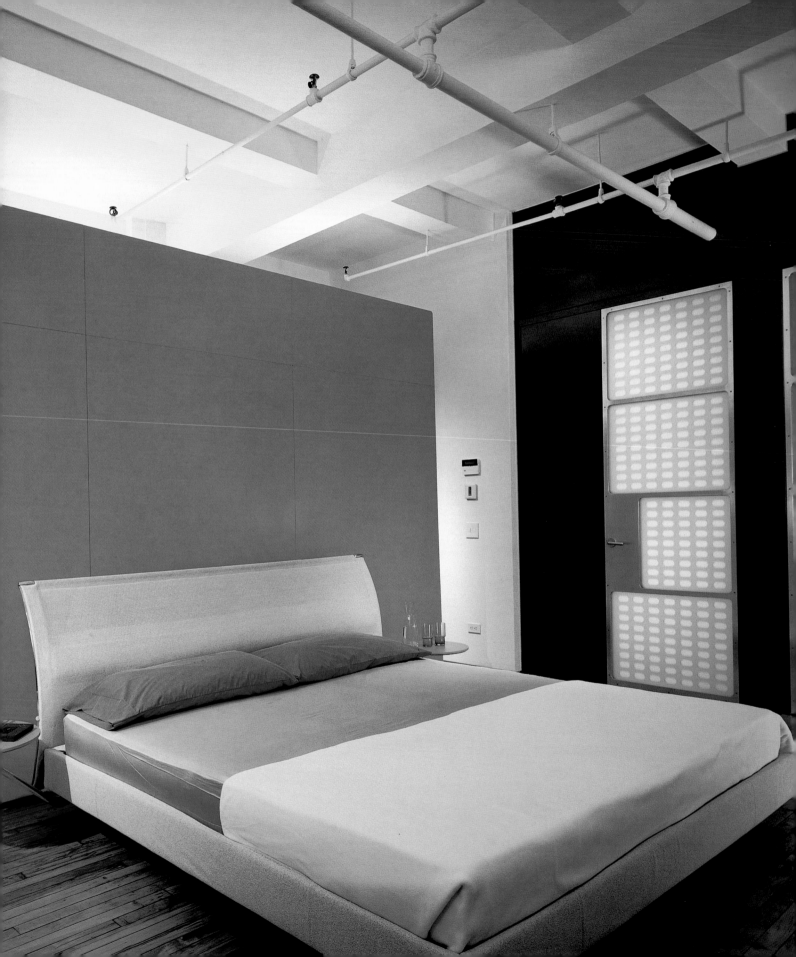

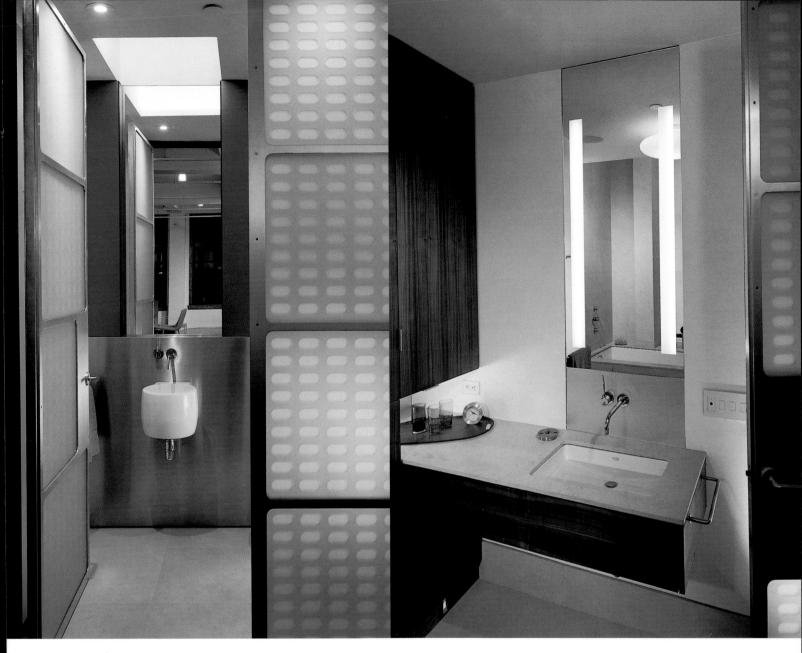

**Above:** *Powder room with translucent screen doors and stainless steel and anodized glass wall*
**Above right:** *Master bathroom vanity*
**Left:** *Master bedroom with storage monolith and doors to gym and bathroom*

**Most** lofts in this book are the result of adaptive reuse. Former factories or office buildings or—in one instance—a Civil War munitions factory are converted into residential or live/work spaces. However, the design for this loft gives a whole new dimension to the concept of adaptive reuse. To create private spaces in this loft on the fourth floor of a former parking garage, the architects recycled a petroleum trailer tank. The tank was cut into two sections and hoisted into the loft with a crane.

One of the sections was placed horizontally over the living room and converted into two sleeping pods. Four large hatchback doors

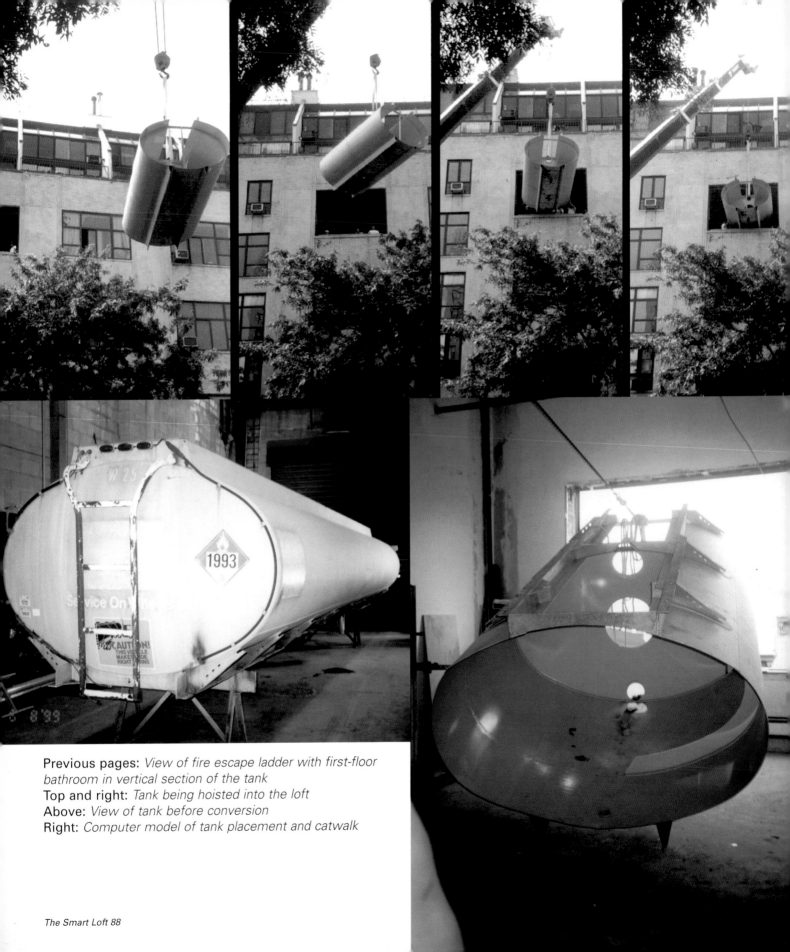

**Previous pages:** *View of fire escape ladder with first-floor bathroom in vertical section of the tank*
**Top and right:** *Tank being hoisted into the loft*
**Above:** *View of tank before conversion*
**Right:** *Computer model of tank placement and catwalk*

cut from either side of the tank are operated by hydraulic pistons. They open at the push of a button, bringing sunlight and ventilation to the sleeping compartments. The second section of the tank was placed vertically from floor to ceiling. It contains two bathrooms stacked on top of each other with the plumbing exposed on the outside. The interiors of the tanks are coated with automotive enamel. A fire escape ladder leads to a ring of metal grating catwalks at the mezzanine level. The metal grating is filled with a clear resin to generate a smooth walking surface. The catwalk provides access to the upper bathroom, sleeping pods, and closets on either side.

*LOT-EK*
*New York, New York*

*Photography: Paul Warchol*

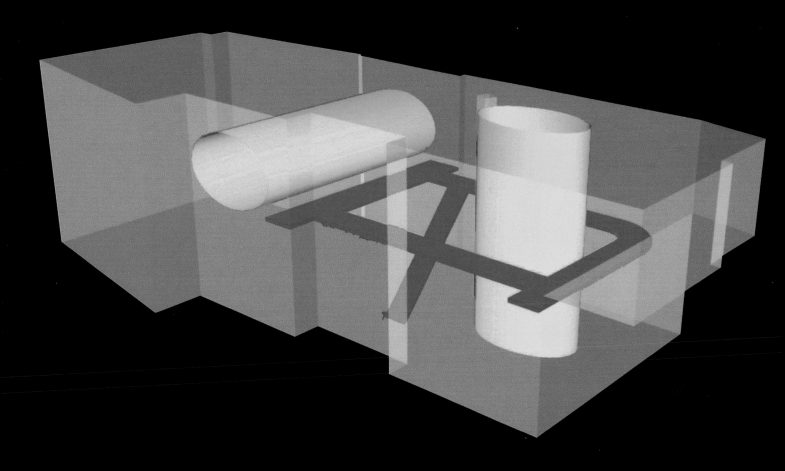

Bathroom tower details

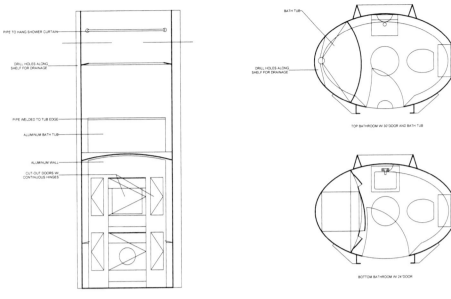

PIPE TO HANG SHOWER CURTAIN

DRILL HOLES ALONG
SHELF FOR DRAINAGE

PIPE WELDED TO TUB EDGE

ALUMINUM BATH TUB

ALUMINUM WALL

CUT-OUT DOORS W/
CONTINUOUS HINGES

BATH TUB

DRILL HOLES ALONG
SHELF FOR DRAINAGE

TOP BATHROOM W/ 30"DOOR AND BATH TUB

BOTTOM BATHROOM W/ 24"DOOR

Section

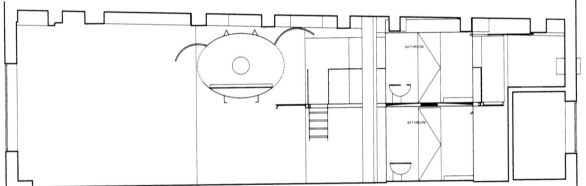

BATHROOM

BATHROOM

Mezzanine-floor plan

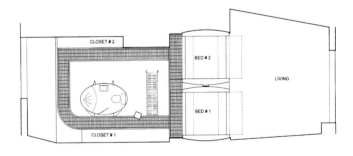

CLOSET # 2

BED # 2

LIVING

BED # 1

CLOSET # 1

Main-floor plan

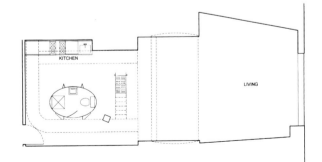

KITCHEN

LIVING

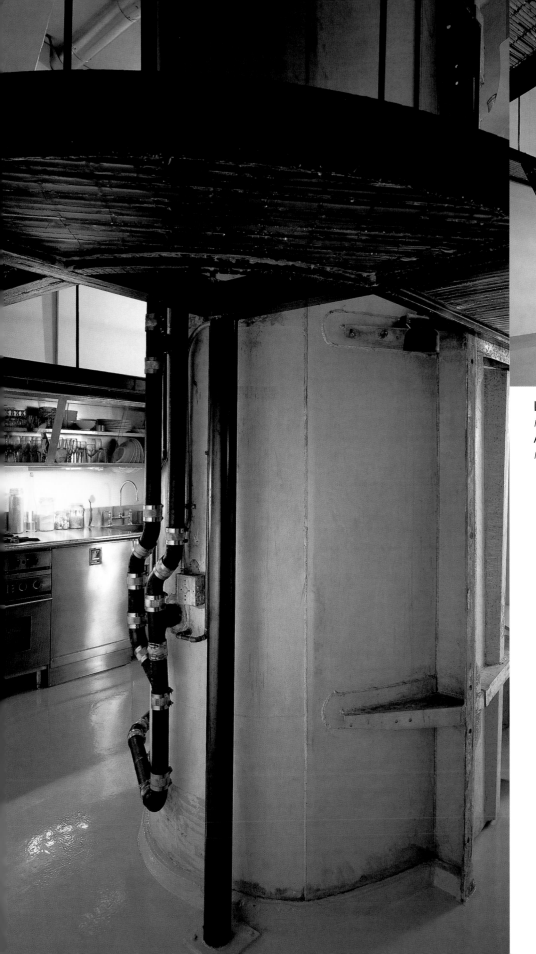

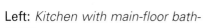

**Left:** *Kitchen with main-floor bath-room*
**Above:** *Fire escape ladder to mezza-nine*

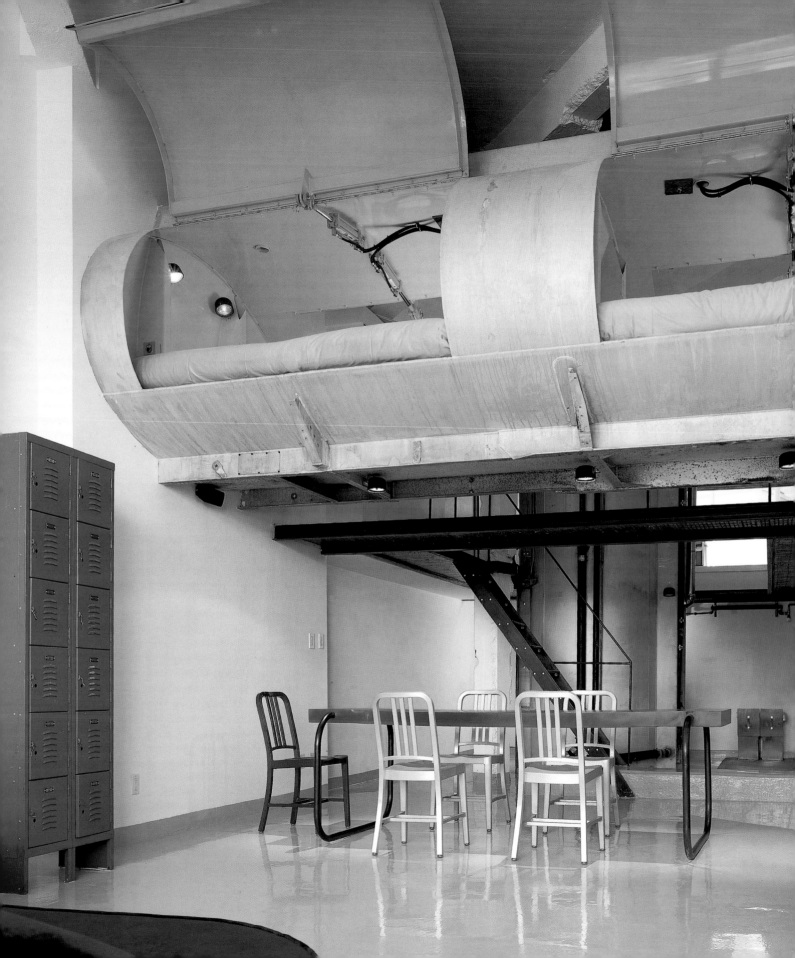

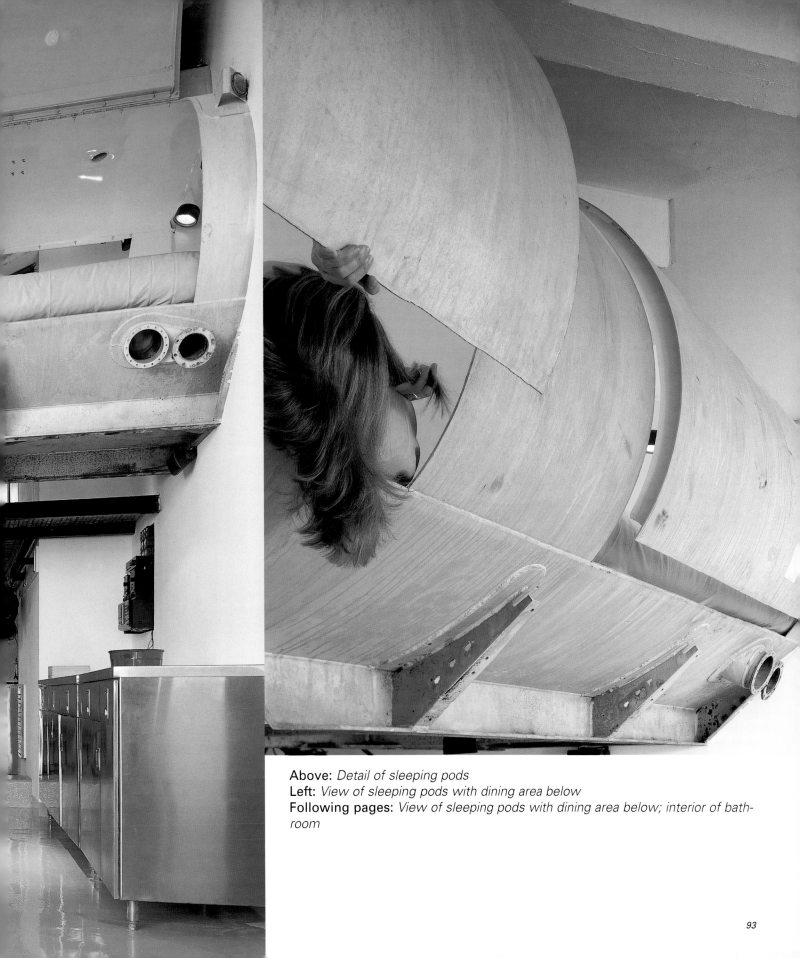

**Above:** *Detail of sleeping pods*
**Left:** *View of sleeping pods with dining area below*
**Following pages:** *View of sleeping pods with dining area below; interior of bathroom*

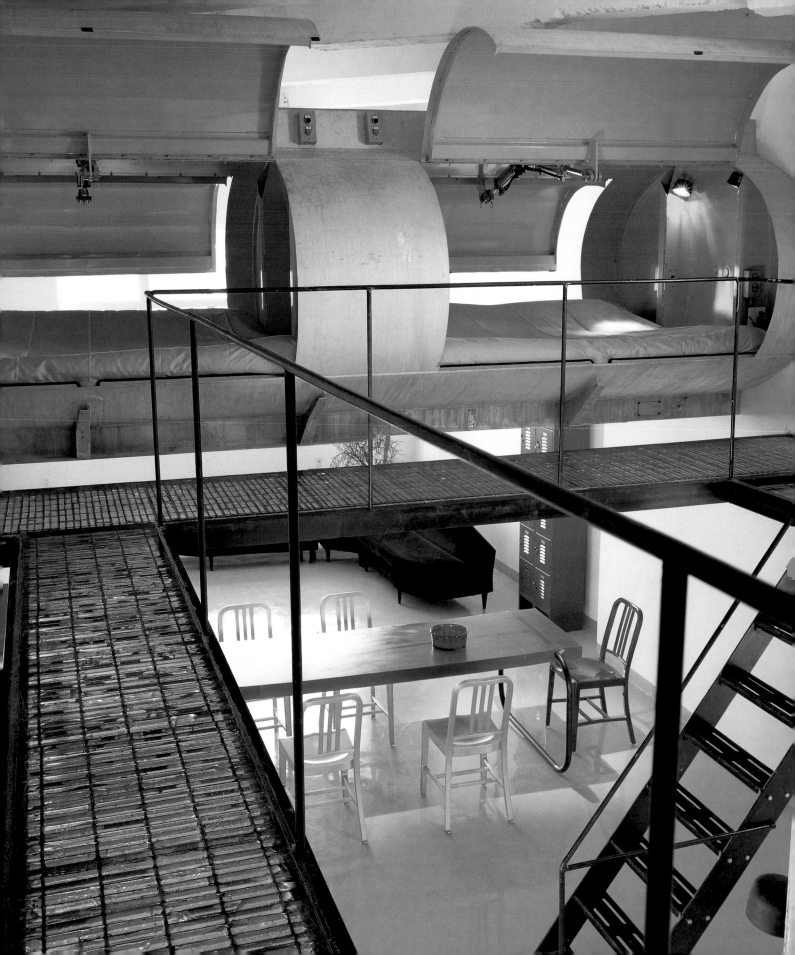

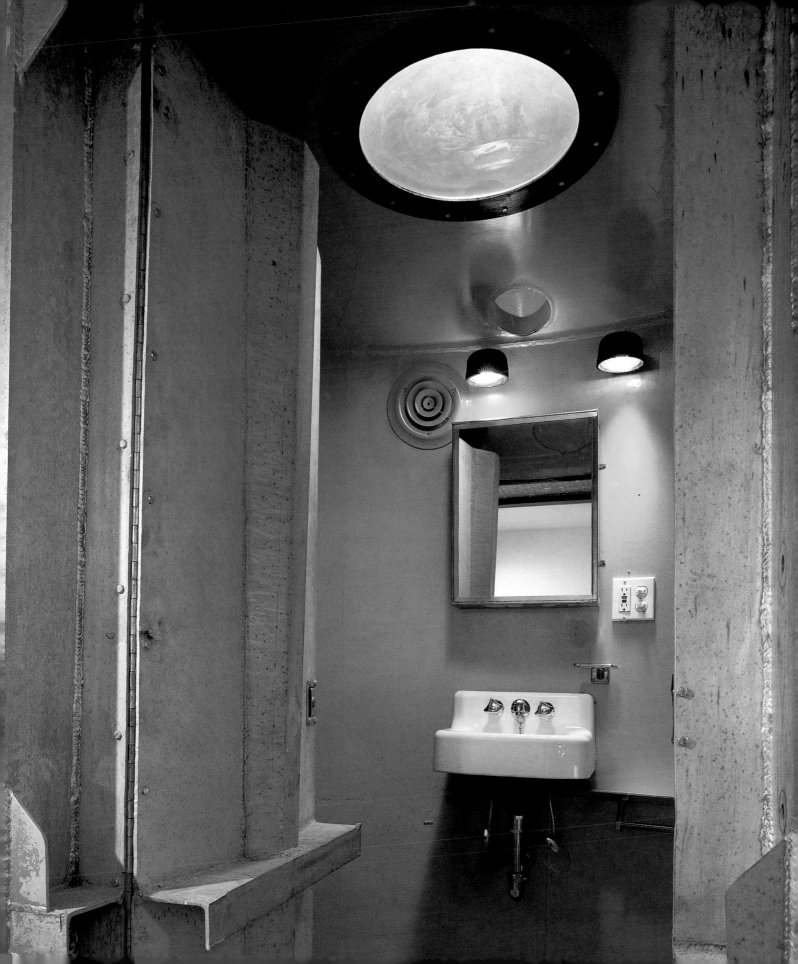

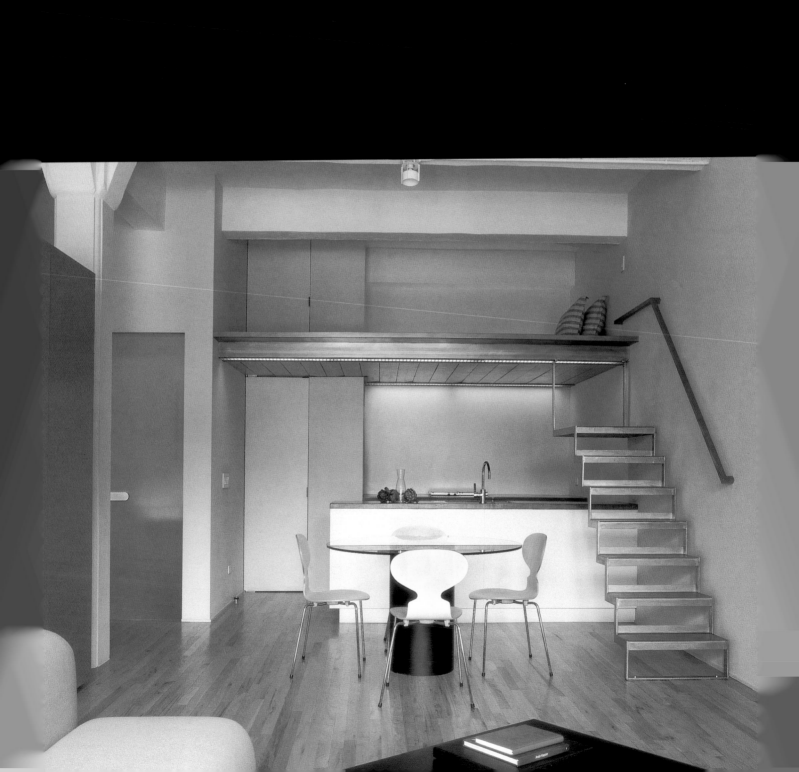

**Flexibility** of use was the guiding principal behind the

design of this 650-square-foot loft. The primary use was to be a

pied-à-terre when the owners were in the city, and they wanted to

be able to entertain and accommodate weekend visitors without

compromising their passion for clean, modern design aesthetics.

The multilevel topography of the space makes the loft visually

dynamic and engaging.

The rear of the apartment, away from the windows, is carefully

organized so that the kitchen, bathroom, and laundry become a

visual composition linked by a stainless steel structure supporting

**Previous pages:** *View of the kitchen with sleeping loft*
**Left:** *Stair and lighting detail*
**Right:** *Sleeping platform and stair section*

## Axonometric

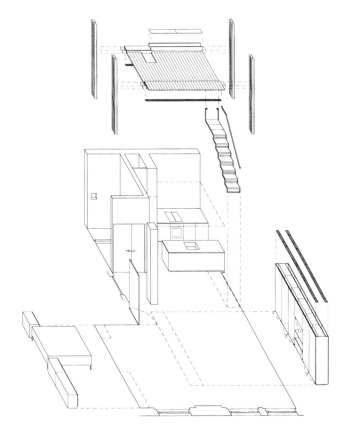

*The Smart Loft 98*

## Floor plan

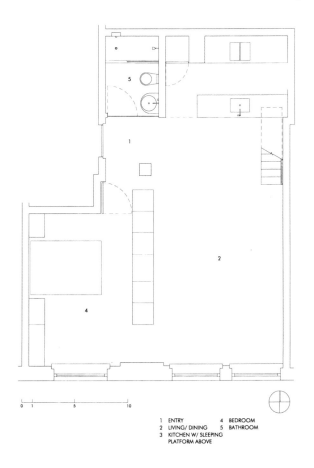

0  1      5      10

1  ENTRY                    4  BEDROOM
2  LIVING/ DINING           5  BATHROOM
3  KITCHEN W/ SLEEPING
   PLATFORM ABOVE

the guest sleeping loft above. Lighting fixtures are embedded between pairs of structural steel tubes and illuminate both the upper and lower levels. Structural wood decking spans between the tubes, providing a concealed, recessed space for a mattress. The natural wood

provides a warm contrast to the cool steel elements. A minimalist steel stair hangs from the steel beams and creates a sculptural backdrop for the dining area.

The external bathroom wall, made of translucent etched glass, glows like a lantern

near the entry foyer. Inside, the bathroom is sheathed in smooth, hand-waxed stucco and cast-concrete tiles to create a monolithic water-proof shell. A tall fiberboard cabinet divides the bedroom and living areas. Inside, the cabinet contains audiovisual equipment, clothing storage, and recessed cove lighting.

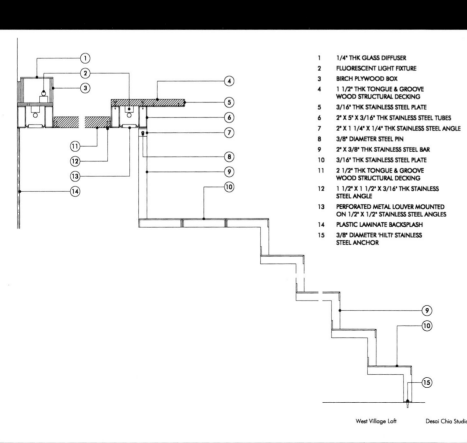

1   1/4" THK GLASS DIFFUSER
2   FLUORESCENT LIGHT FIXTURE
3   BIRCH PLYWOOD BOX
4   1 1/2" THK TONGUE & GROOVE WOOD STRUCTURAL DECKING
5   3/16" THK STAINLESS STEEL PLATE
6   2" X 5" X 3/16" THK STAINLESS STEEL TUBES
7   2" X 1 1/4" X 1/4" THK STAINLESS STEEL ANGLE
8   3/8" DIAMETER STEEL PIN
9   2" X 3/8" THK STAINLESS STEEL BAR
10  3/16" THK STAINLESS STEEL PLATE
11  2 1/2" THK TONGUE & GROOVE WOOD STRUCTURAL DECKING
12  1 1/2" X 1 1/2" X 3/16" THK STAINLESS STEEL ANGLE
13  PERFORATED METAL LOUVER MOUNTED ON 1/2" X 1/2" STAINLESS STEEL ANGLES
14  PLASTIC LAMINATE BACKSPLASH
15  3/8" DIAMETER 'HILTI' STAINLESS STEEL ANCHOR

West Village Loft          Desai Chia Studio

**Desai/Chia Studio**
*New York, New York*

*Photography: Joshua McHugh*

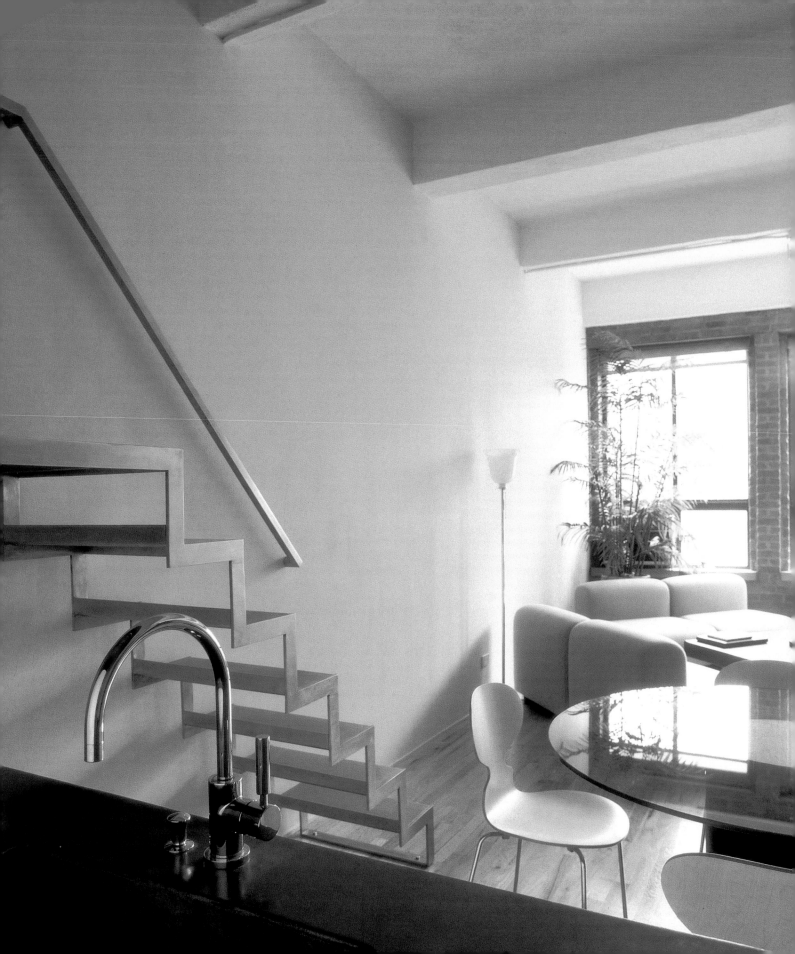

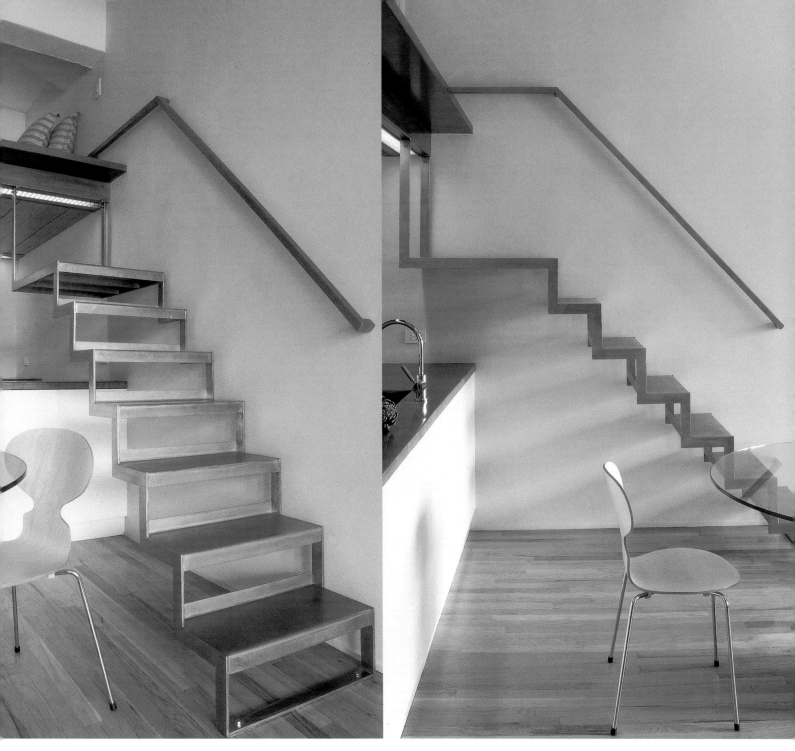

**Above and right:** *Views of the stainless steel stair to the sleeping loft*
**Left:** *Living/dining area*

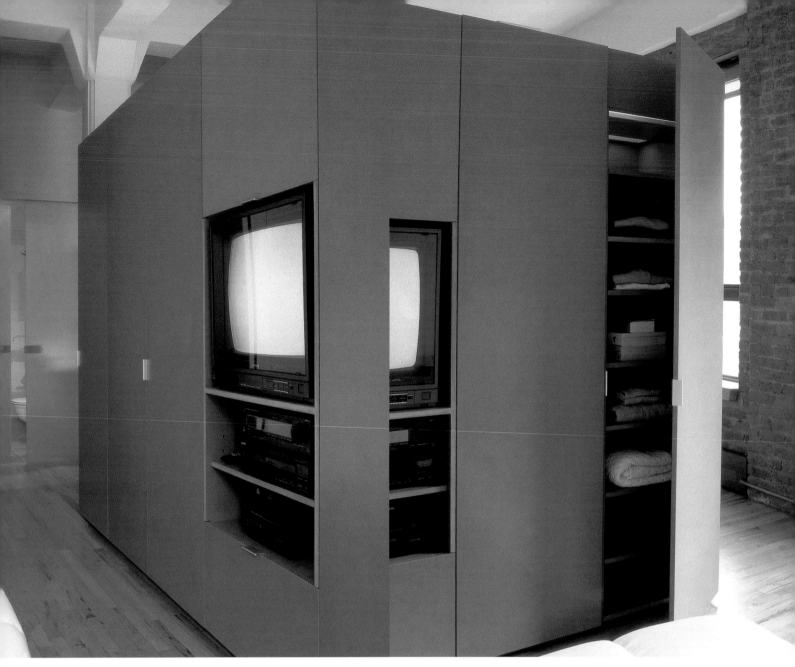

**Above:** *Views of the cabinet dividing the sleeping area from the living area*

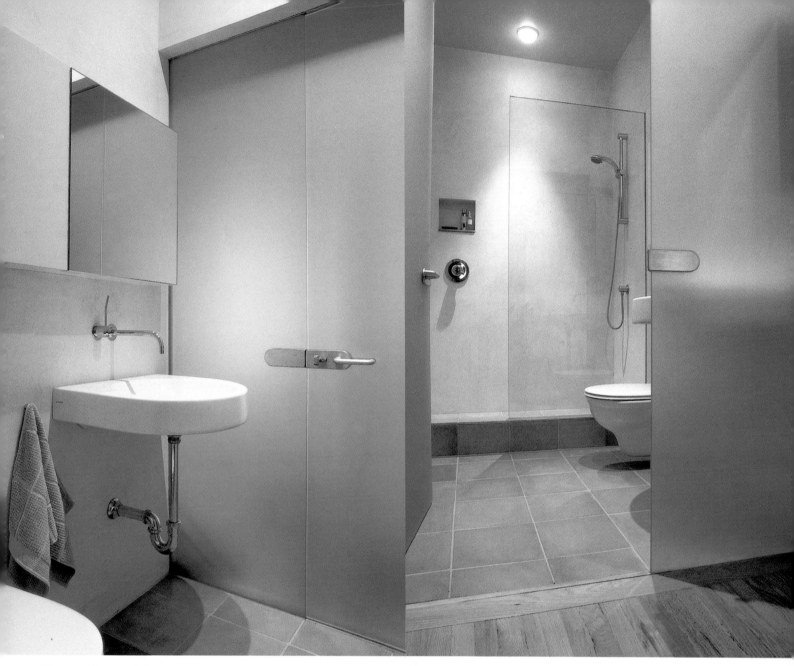

**Above:** *Views of the bathroom and the translucent external wall*

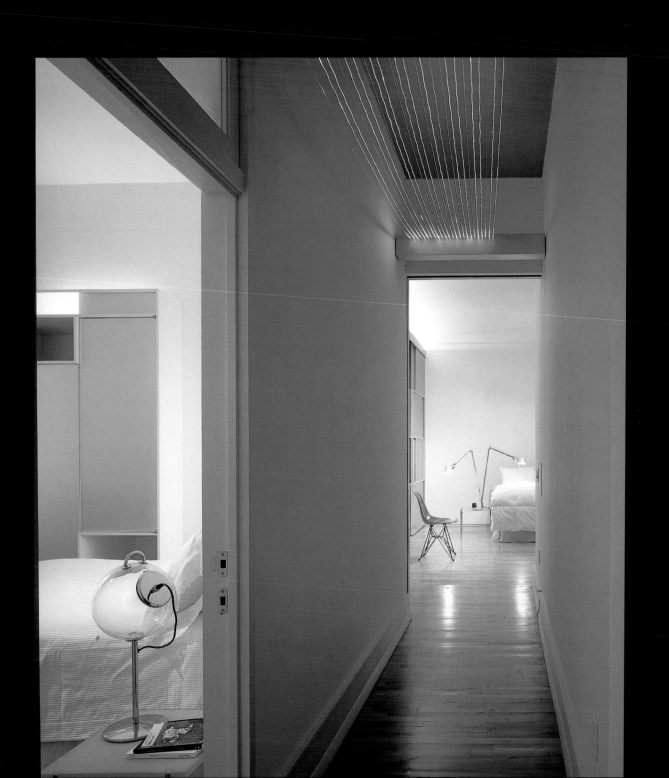

**This** loft in Greenwich Village was transformed from a series of

dark rooms into bright, light-filled spaces through the creative use of

doors, windows, sliding screens, lighting, and panels to bring new

order and clarity. A minimalist gallery links the bedrooms in the rear

with the large living, dining, and kitchen area at the front of the resi-

dence. Multiple strands of 50-foot-long fiber-optic cable have been

stretched along the ceiling of the gallery and serve as a light and

color source for the gallery.

Architecturally, each wall is designed to provide both openness and

privacy. For example, a closet in the guest room shares space with

## Section

## Floor plan

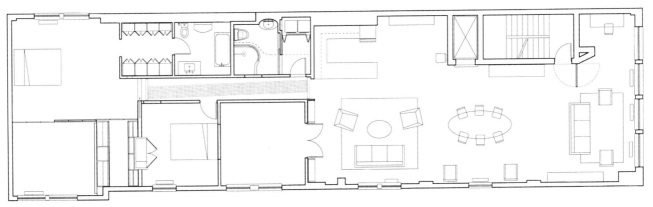

0 1 5 10

**Previous pages:** *View toward master bedroom of gallery with fiber-optics installation*
**Below:** *View of the bathroom with curved glass shower stall*
**Right:** *Guest bedroom closet detail*

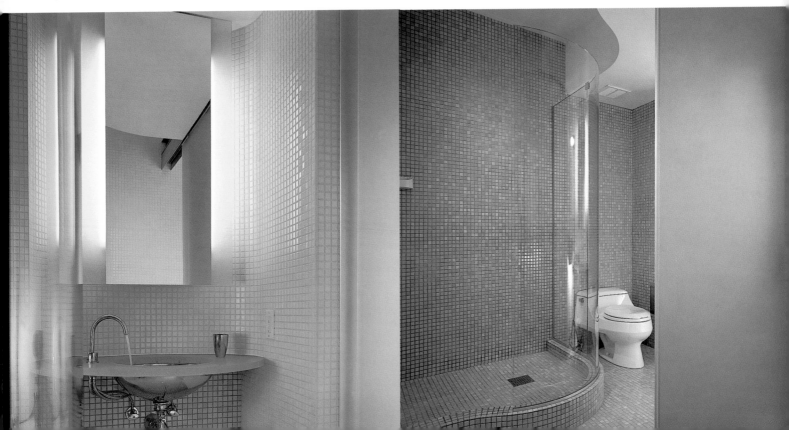

the master closet and its embedded design prevents it from protruding into the smaller space. It "floats" within the wall, serving as night-light, mirror, and furniture. A mesh screen separating the master bedroom from an adjacent study creates a sense of privacy or openness during the evening, depending on which side is lit. The moire pattern created by the screen mesh animates the wall when the screens are closed.

light slot

area of
removed
backing

ghost mirror

area of
removed
backing

area of
removed
backing

*Weisz + Yoes Architecture*
*New York, New York*

*Photography: Paul Warchol*

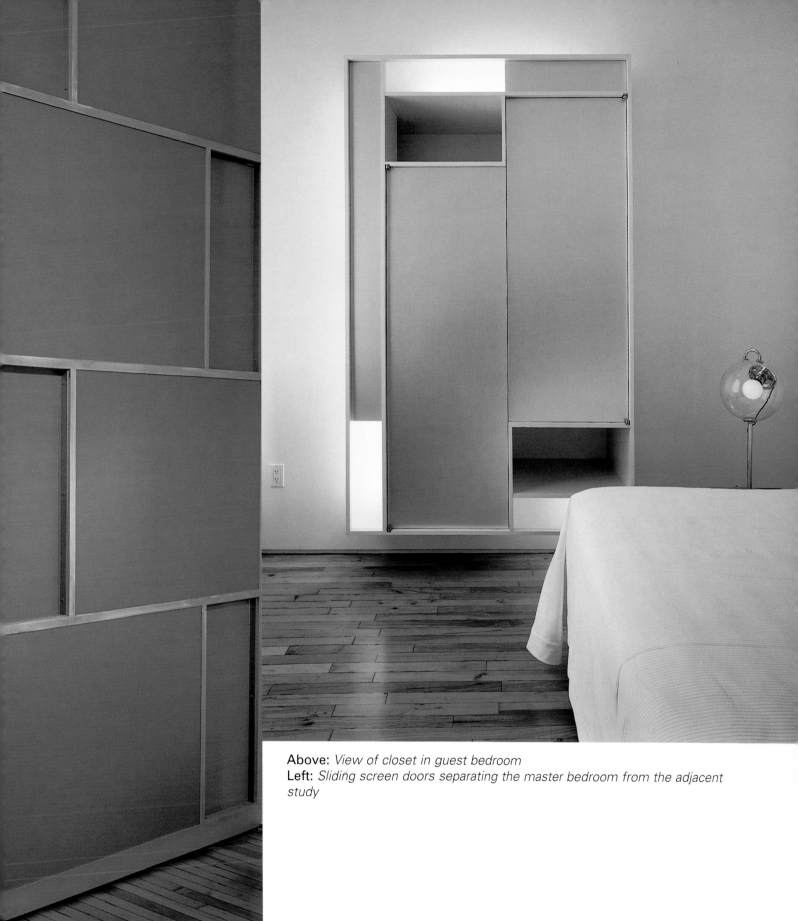

**Above:** *View of closet in guest bedroom*
**Left:** *Sliding screen doors separating the master bedroom from the adjacent study*

**This** smart loft was designed to serve both the professional and

personal needs of a creative strategist.  The loft's concentrated

workspaces and lounge-like areas are all packed with convenient

high-speed connectivity. The different work zones are designed to

inspire creativity, idea generation, and collaboration—to serve as a

motivational think-tank for client meetings.

The more intimate spaces, such as the master bedroom and the

private office, are veiled behind sweeping, textured glass walls.

The living space is centralized within the loft while the work space

is extruded. The two areas are separated by a 32-foot-long sliding

Perspective drawing

Floor plan

Previous page:
*Kitchen cabinet
detail with
metallic automo-
tive paint*
**Right:** *Glass
wall detail*

wall. The "working" half borrows from the "living" half when presentations are made on the high-definition plasma monitor in the living area. The built-in networking capabilities of the loft make it possible to mount a presentation on the plasma screen from a wireless laptop anywhere in the apartment.

The loft is more than just a technologically smart space. The architects used smart materials—including metallic automotive paint for the kitchen and audiovisual cabinetry, textured white glass and hot rolled steel for the glass partitions, and recycled and natural glass tile—in innovative ways throughout the loft.

*VIA Architecture*
*New York, New York*

*Photography: Michael Moran*

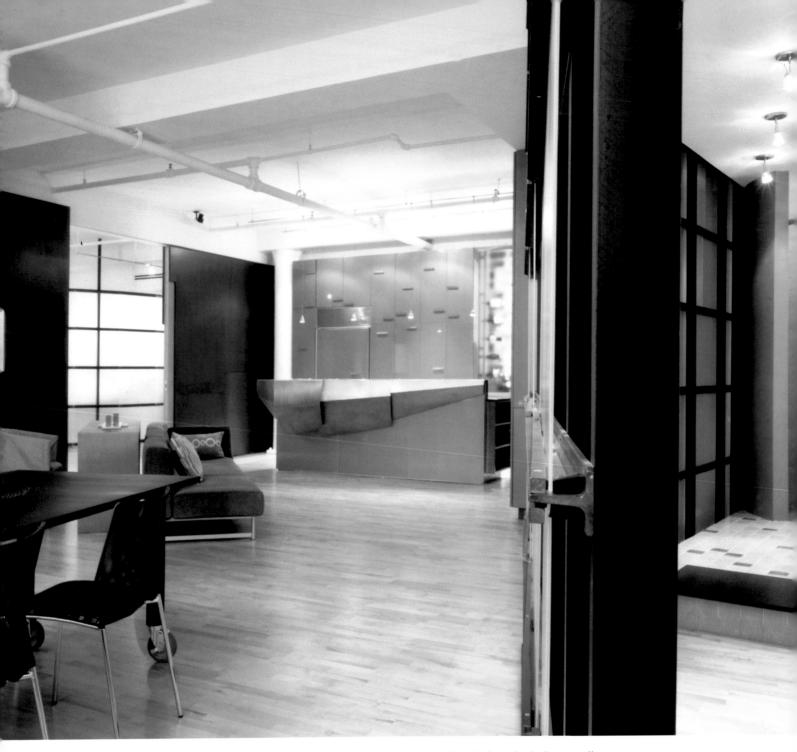

**Above:** *View of the kitchen from the dining area and master bedroom behind angled glass wall*
**Right:** *The angled glass wall as seen from the master bedroom*

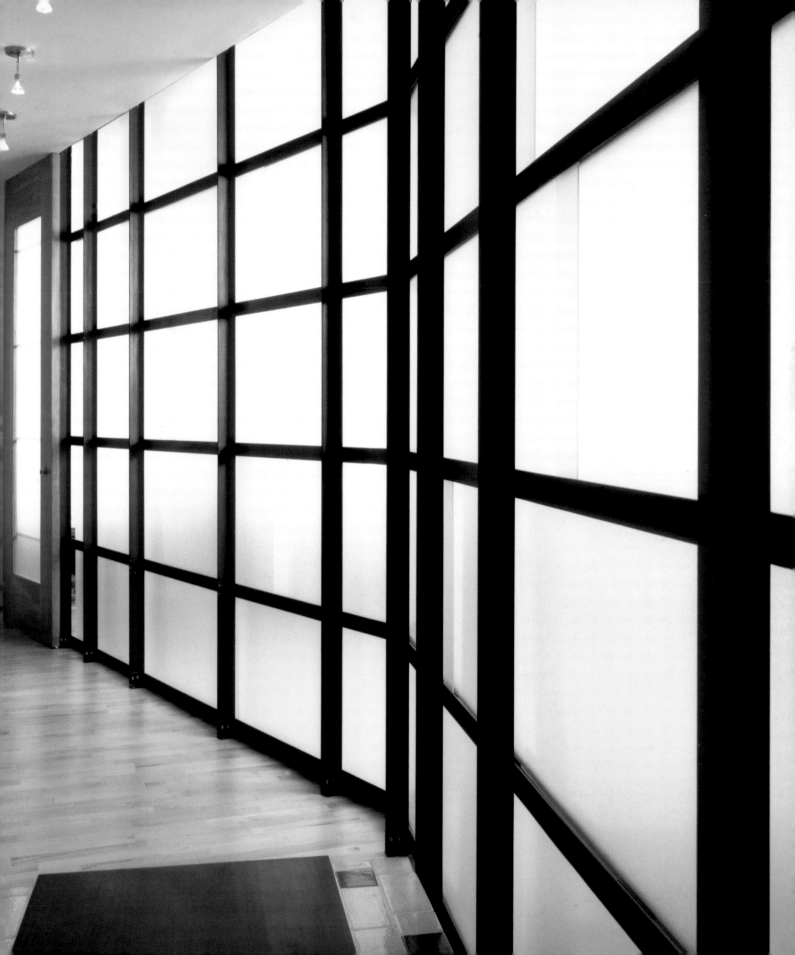

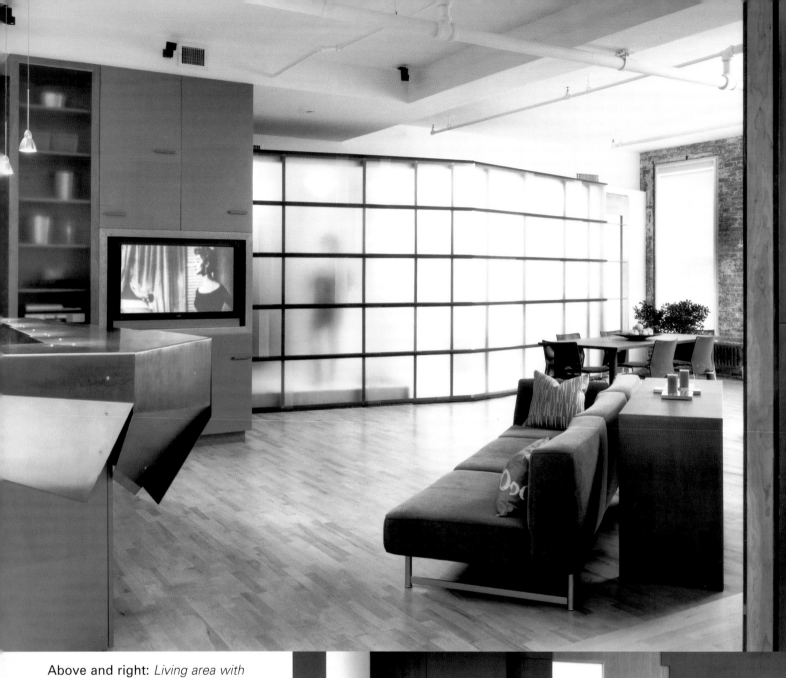

**Above and right:** *Living area with high-definition plasma monitor*
**Facing page:** *Views of the kitchen island made with folded and overlapping brushed stainless steel with automotive paint on face panels and cabinets*

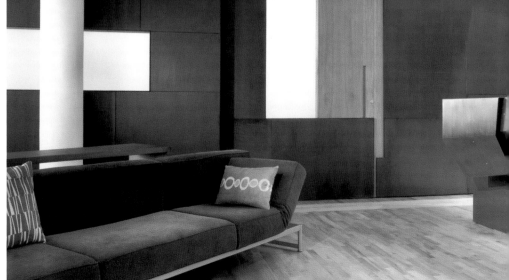

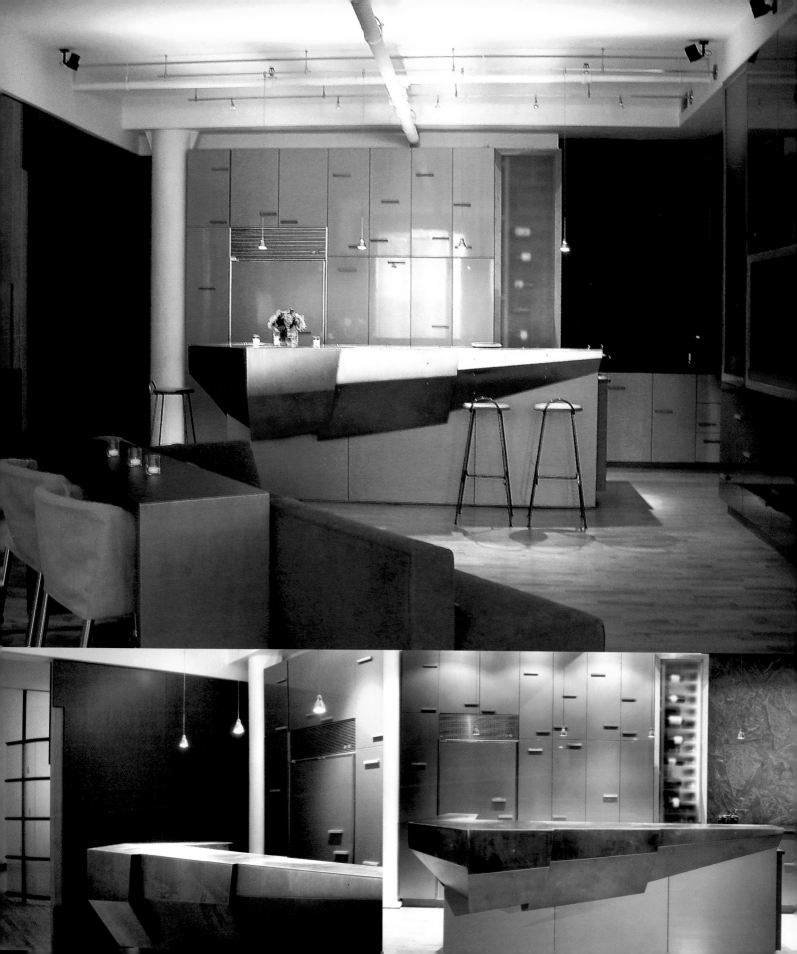

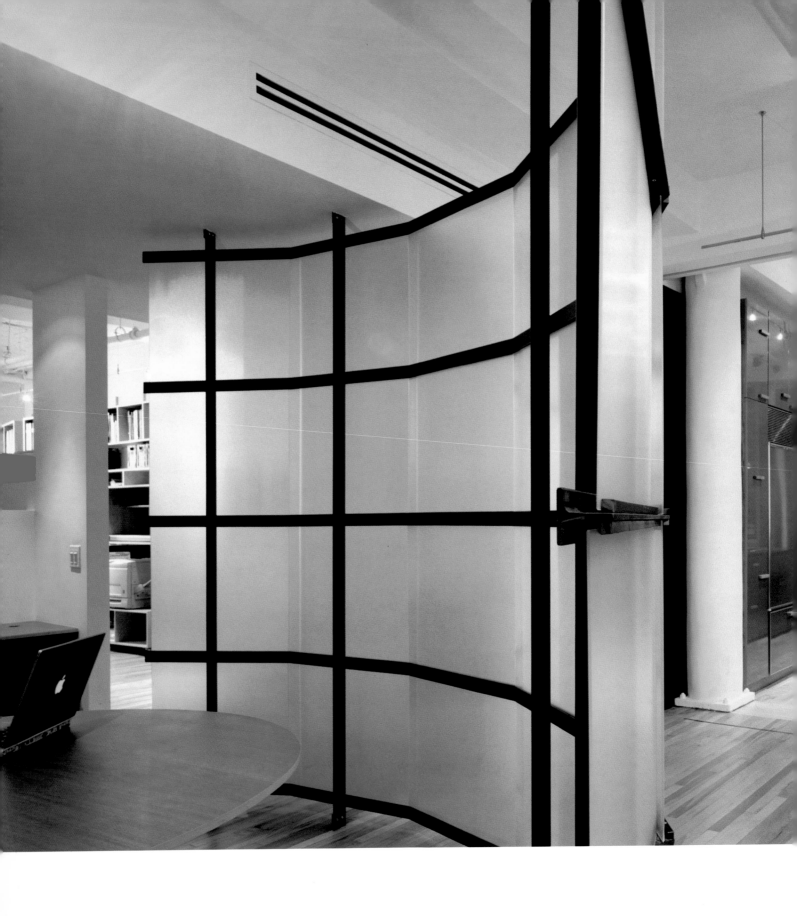

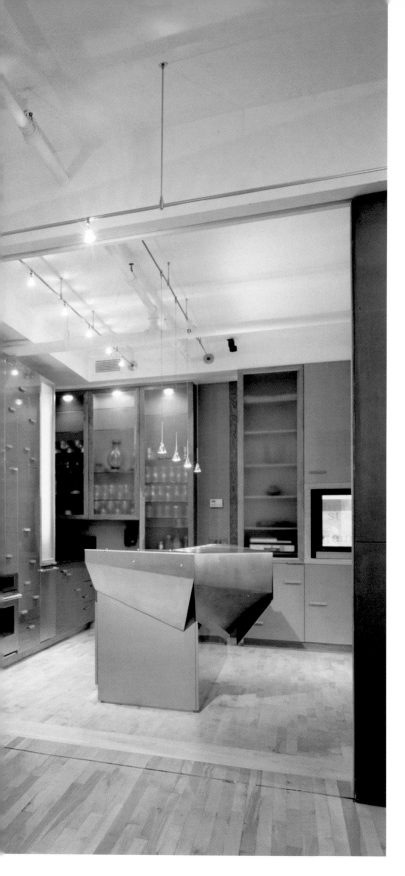

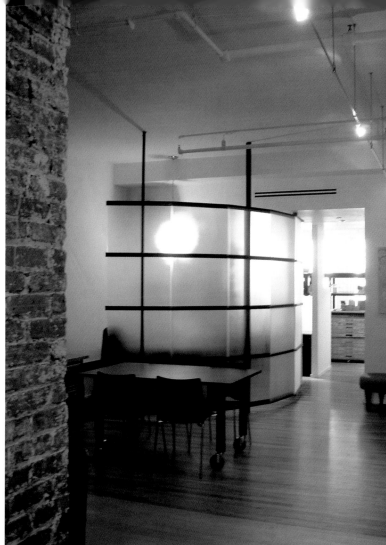

**Left:** *The kitchen as seen from the private office with curving glass wall*
**Above:** *The private office is concealed behind the curving glass wall*

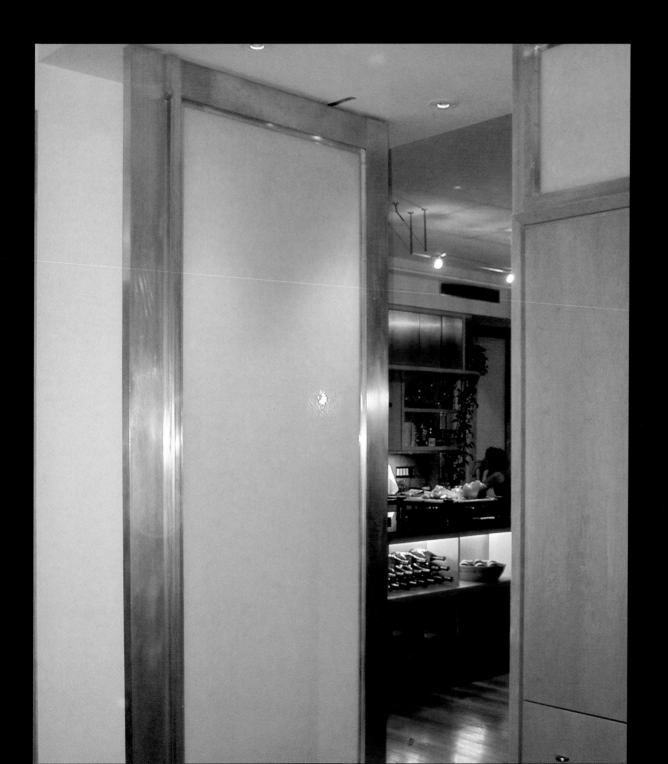

**To** take advantage of the unique light-filled corner location of this

loft, the architects followed a program of minimal intervention

creating a space that is at once open and formal. Two cabinet vol-

umes float within the large loft, permitting maximum view of the

windowed perimeter walls. Large custom aluminum and glass

doors, which either pivot or slide, are used throughout the loft.

One of the cabinet volumes contains kitchen appliances and stor-

age space for kitchen-related items on one side and storage space

for media and guest room requirements on the other. The massive

island separating the kitchen area from the dining and living areas

## Perspective drawing

## Floor plan

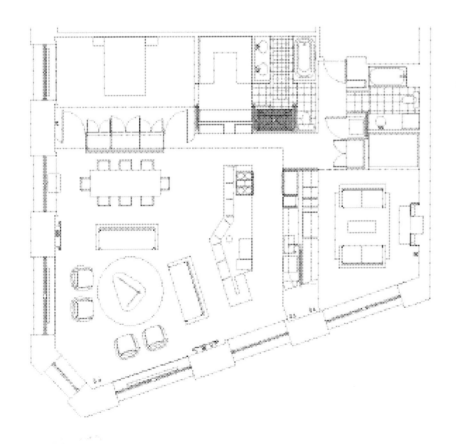

**Previous page:** *Door detail*
**Right:** *Aerial view*

creates a center for informal entertaining. It is distorted on one side, reflecting the non-orthogonal geometry of the street below.

The other cabinet volume is surrounded by frosted glass on three sides and serves as a buffer between the dining area and the master bedroom. This volume provides storage space for the bedroom side of the loft and, at the same time, serves as a translucent backdrop for the dining area.

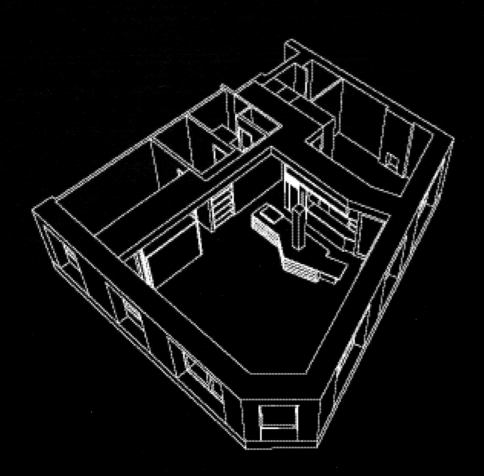

**Resolution: 4 Architecture**
*New York, New York*

*Photography: Paul Warchol*

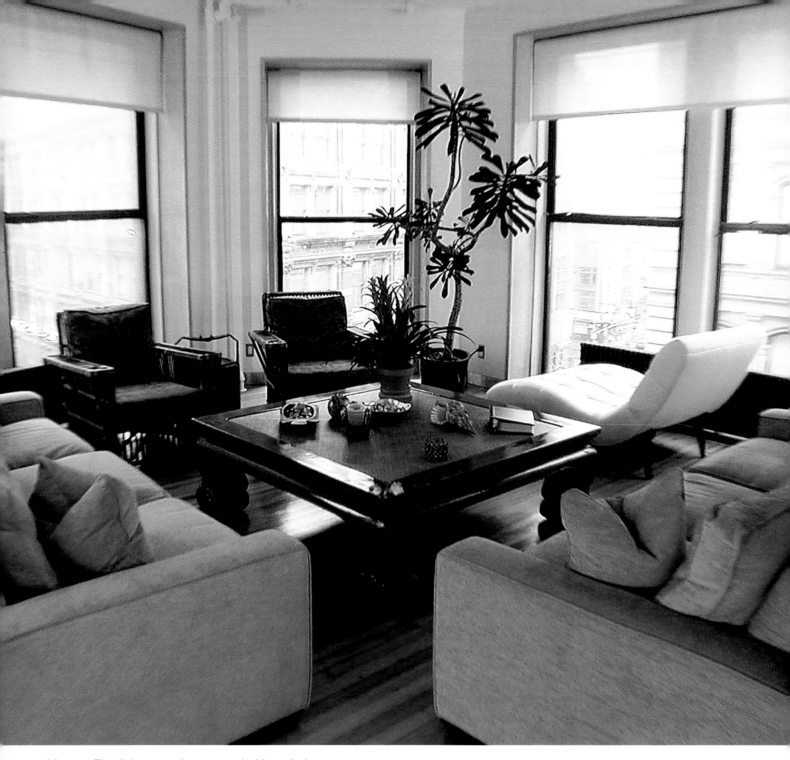

**Above:** *The living area is surrounded by windows*
**Right:** *Large aluminum pivoting door and cabinetry separating the master bedroom from the dining/living area*

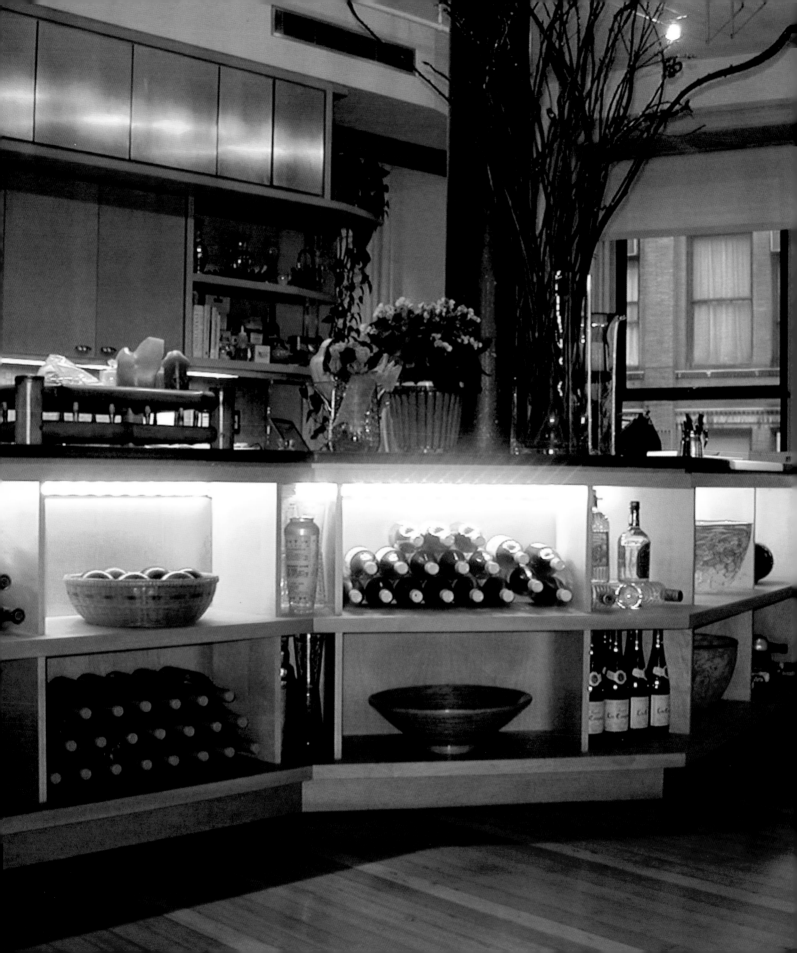

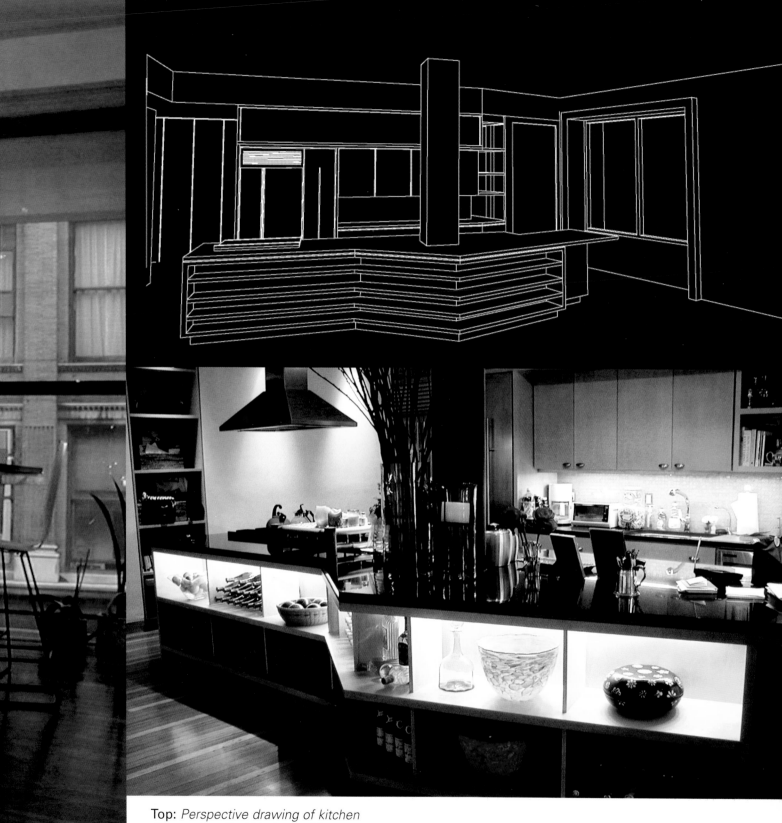

**Top:** *Perspective drawing of kitchen*
**Above:** *Detail of kitchen cabinetry*
**Left:** *Kitchen with island*

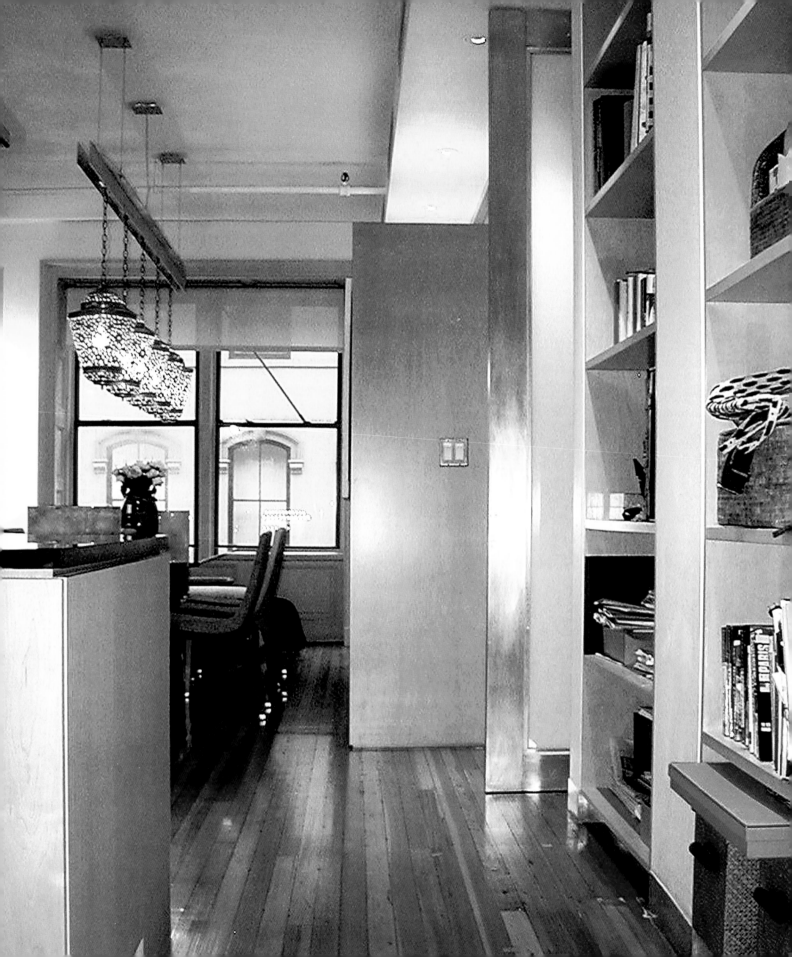

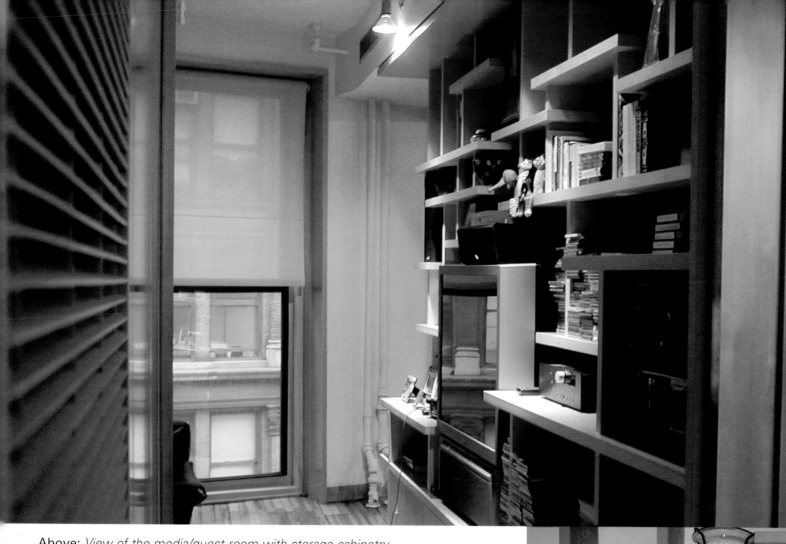

**Above:** *View of the media/guest room with storage cabinetry*
**Right:** *Shelving detail*
**Left:** *View of dining area*

**This** loft is located in an eight-story brick building with cast-iron columns and timber floors that dates from the 1860s when it was a munitions factory supplying arms for the Civil War. The loft has northern, eastern, and western exposures, and an unusual northwestern view onto a diagonal avenue that interupts the street grid. The floor plan devised by the architect reflects the juxtaposition of the orthogonal building and street grid with the diagonal avenue. It has two axes. One is created by the north/south line of cast iron columns bisecting the space. The other, anchored at the northwest corner by a sitting room, continues the diagonal of the avenue into

**Site plan**

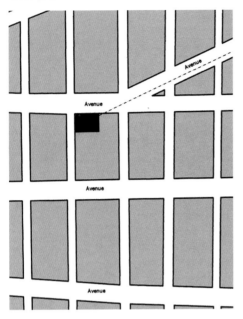

**Previous page:** *Dining area*
**Right:** *Detail drawings*
**Below:** *Perspective drawing*

**Floor plan**

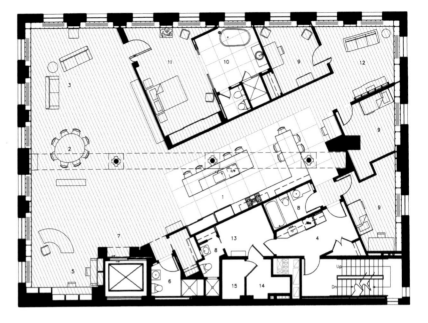

1. Kitchen
2. Dining Room
3. Living Room
4. Utility
5. Library
6. Powder Room
7. Entry
8. Bath
9. Bedroom
10. M. Bath
11. M. Bedroom
12. Sitting Room
13. Exercise
14. Boiler
15. Mechanical

the loft, bringing daylight from the northwest into the loft's interior. The wide-plank mahogany flooring, the limestone floor of the master bathroom, the mother-of-pearl terrazzo kitchen floor, and all of the interior walls are aligned on this diagonal-axis view corridor. The oversized pivoting door between the master bedroom and the living room screens the sleeping area and master bath from public view while enhancing the feeling of spaciousness in both areas.

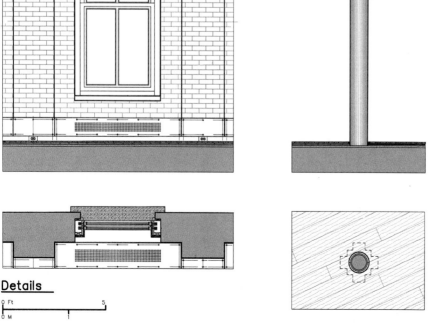

Details

0 Ft       5
0 M       1

*Roger Ferris + Partners*
*Westport, Connecticut*

*Photography: Paul Warchol*

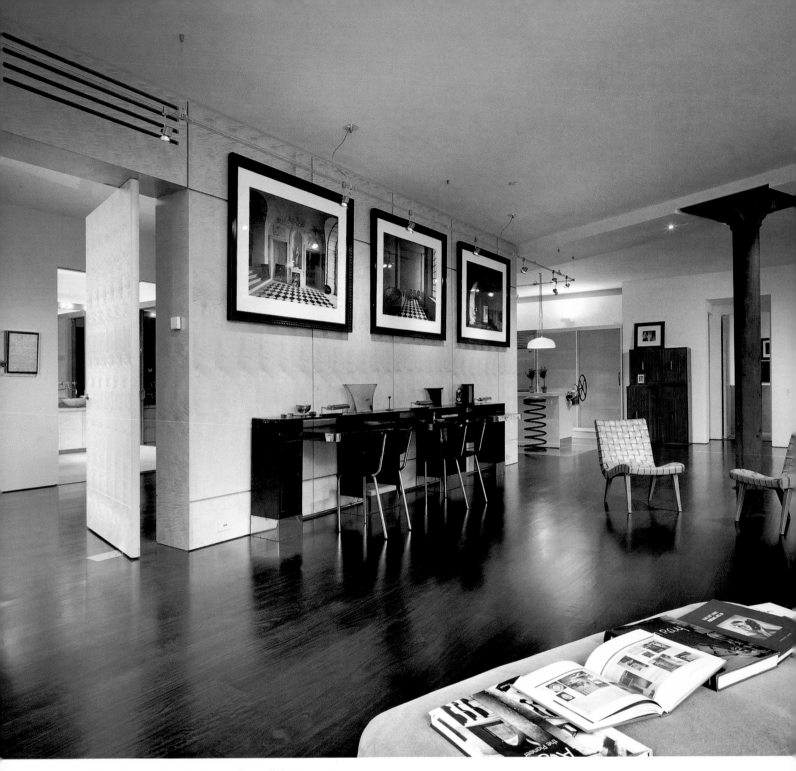

**Above:** *View to master bedroom from living room*
**Right:** *Living room*

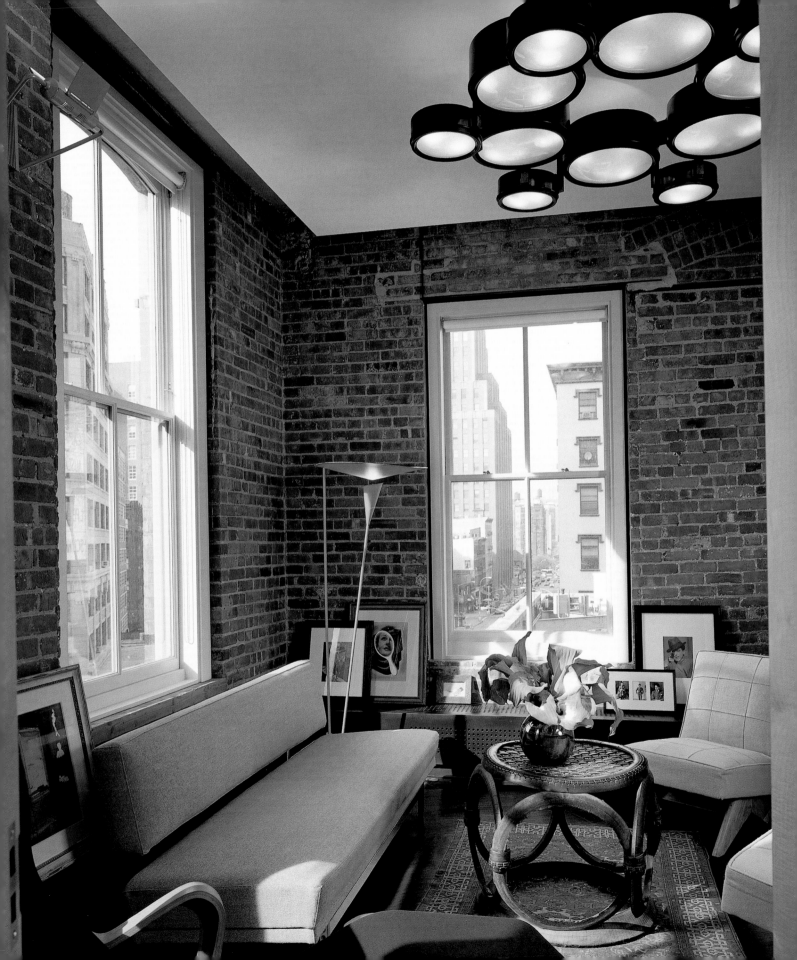

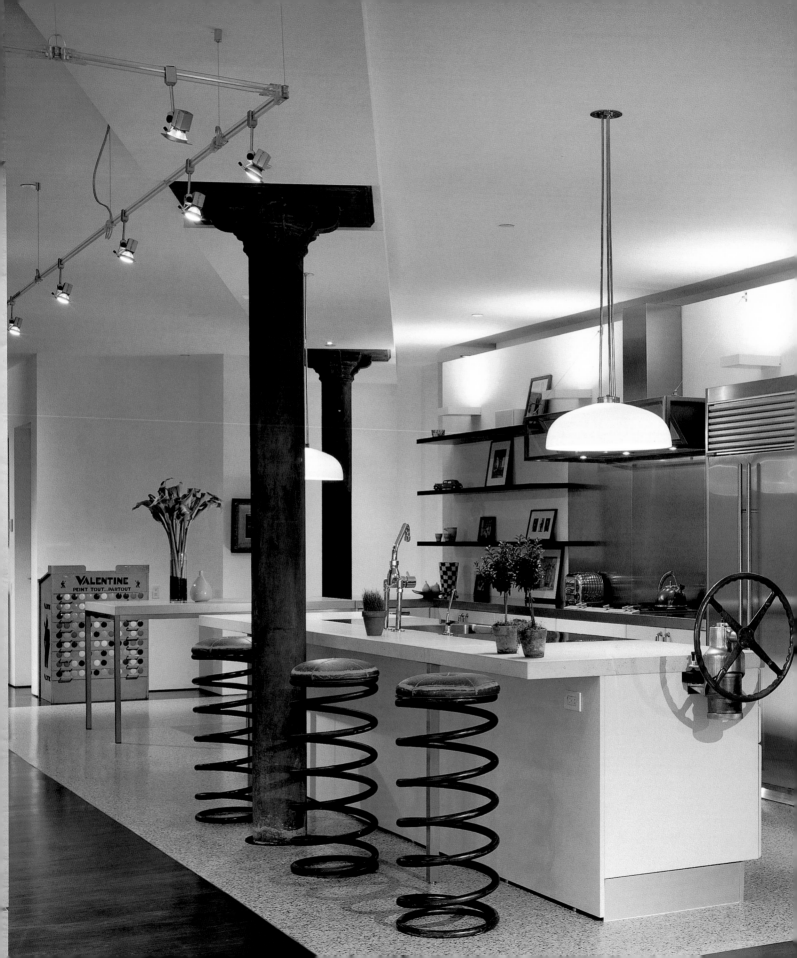

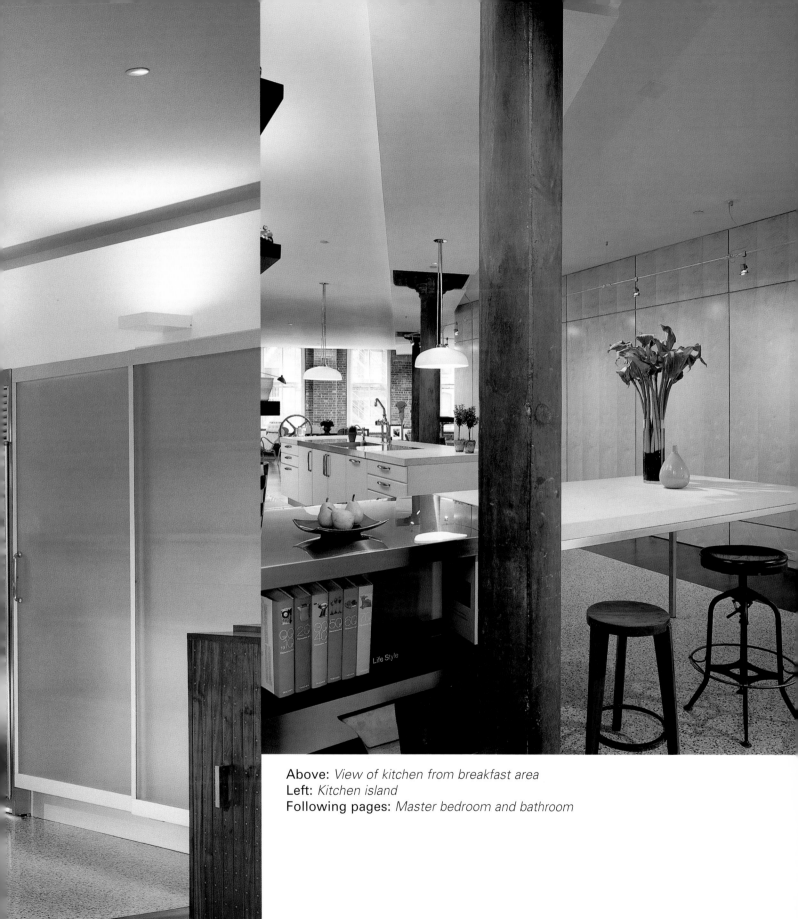

**Above:** *View of kitchen from breakfast area*
**Left:** *Kitchen island*
**Following pages:** *Master bedroom and bathroom*

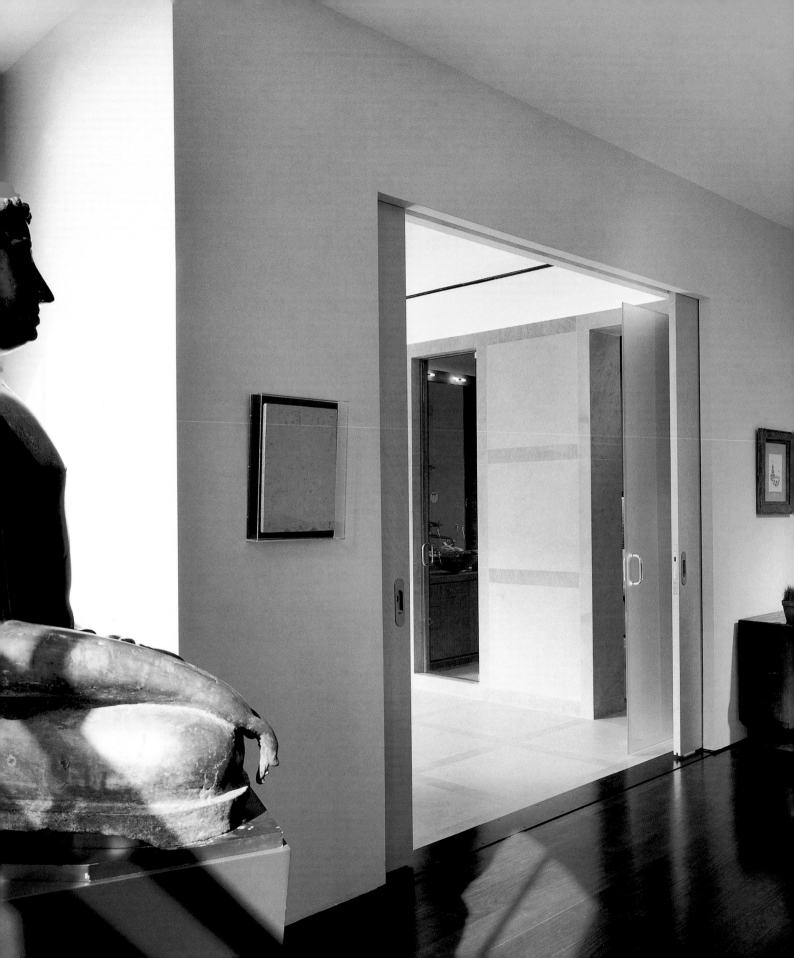

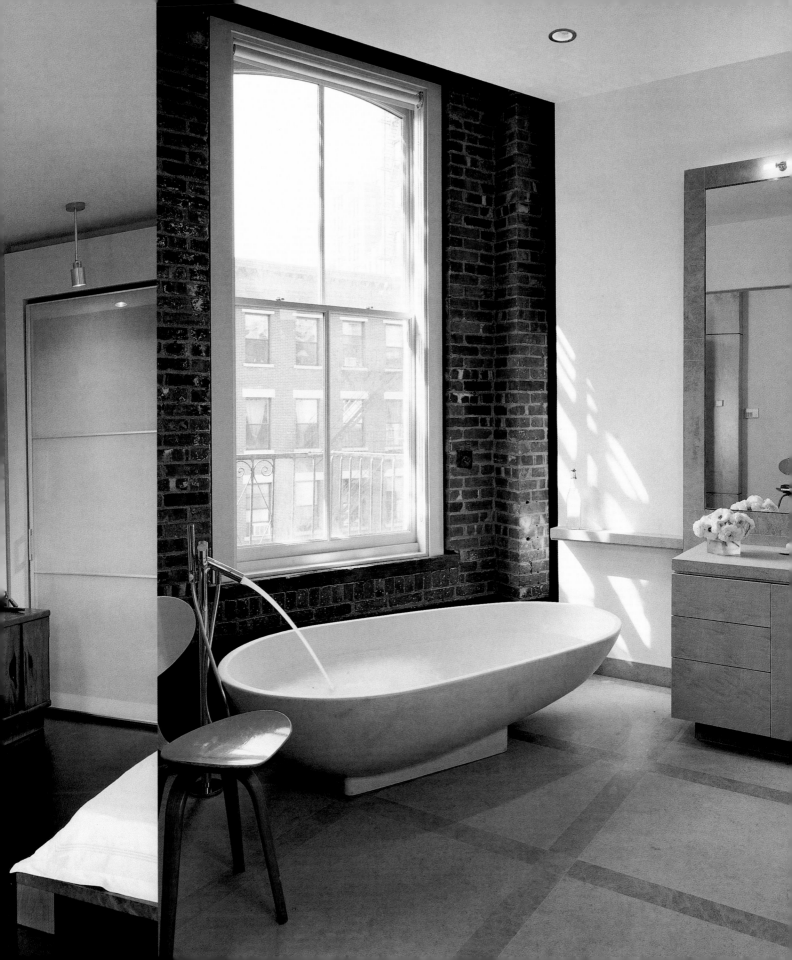

**This** small loft—740 square feet—is all about making an efficient, aesthetically clean space work for the architects/owners and their young child and the books and the toys and all of the other necessities of life. The loft is only 14 feet wide, but the ceiling soars to 20 feet and there is a bedroom overlooking the living room.

In the living room, a raised platform with a cutout was constructed. The cutout serves as a playpen and contains drawers for toy storage. When the playpen is not in use, a custom tea table hinges down from the two-story-high mountain of teak-veneer cabinetry,

Axonometric

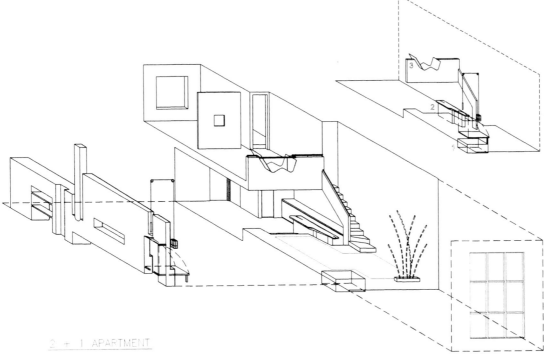

2 + 1 APARTMENT

Floor plan

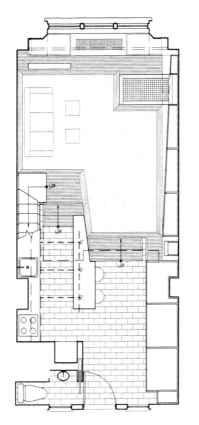

2 + 1 APARTMENT

① LOFT FLOOR PLAN
1/4" = 1'-0"

Bedroom loft

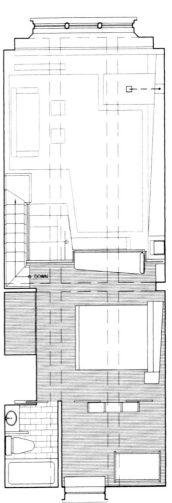

2 + 1 APARTMENT

② LOFT FLOOR PLAN
1/4" = 1'-0"

**Previous page:** *View of the living room from bedroom balcony with custom chaise lounge in foreground* **Right:** *Detail of cabinetry and playpen*

Covering the playpen and becoming an intimate dining area with ample leg room provided by the cutout.

Upstairs, a chaise lounge made of rusted steel is notched into the balcony wall. Perfectly fitted to the contours of the owner, it provides a relaxing place for reading and observing the child playing below.

The highlight of the compact kitchen is an island constructed of a smoothly worn piece of found driftwood.

**Robert D. Henry,**
**Architects**
**New York, New York**

**Photography: Paul Warchol**

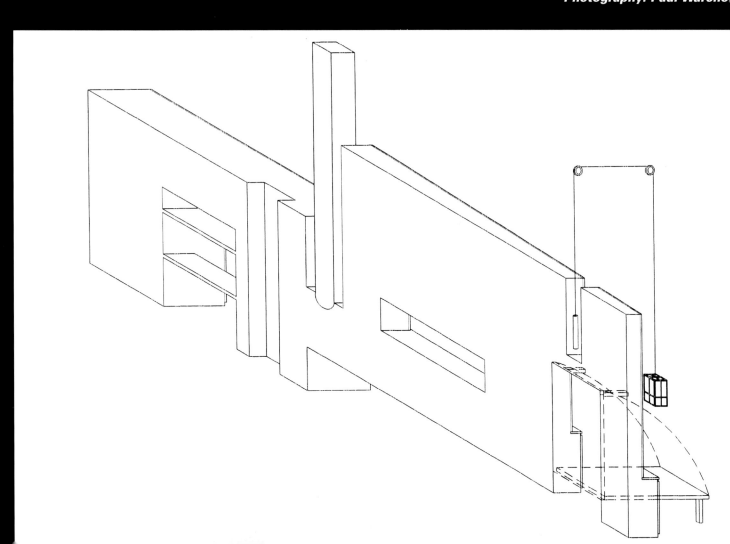

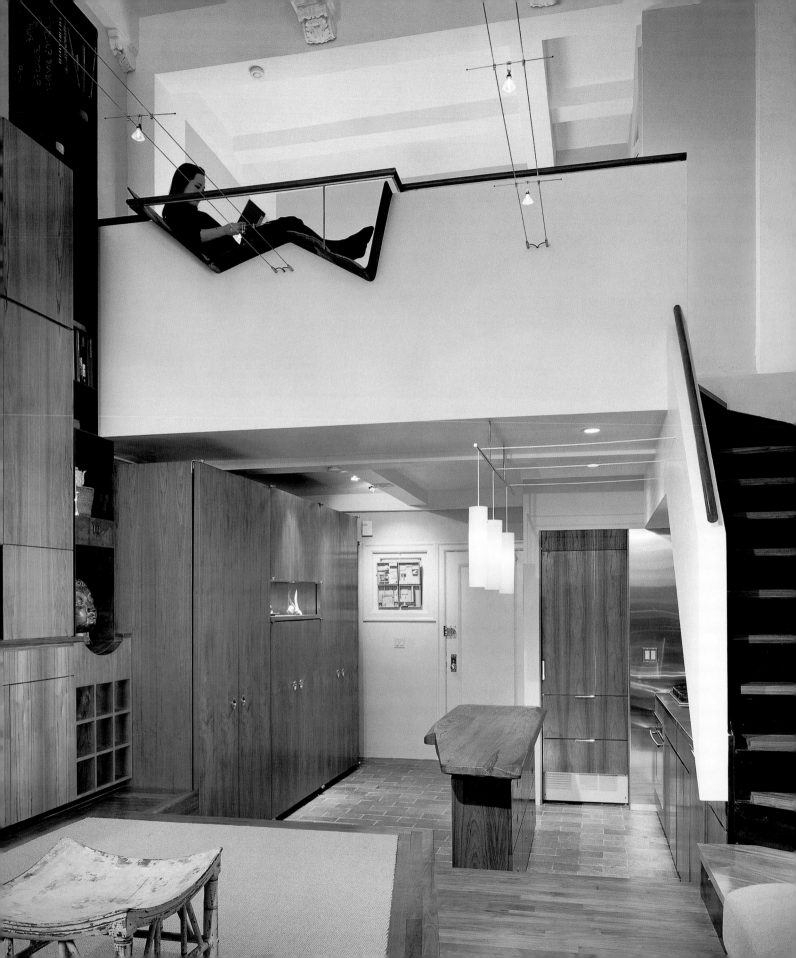

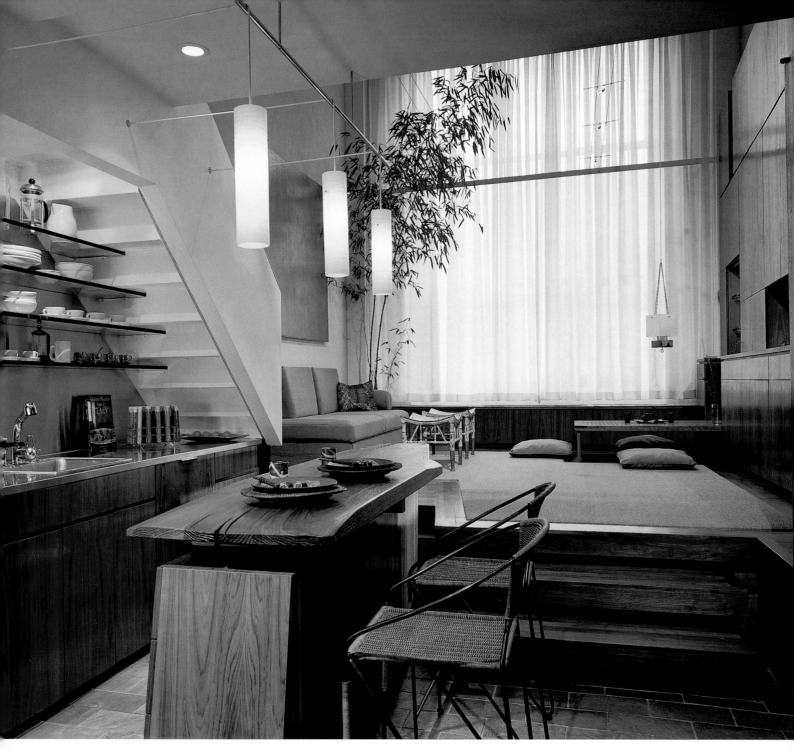

**Above:** *View of living area with raised platform with tea table and candlelit lantern that can be lowered into place*
**Left:** *View of entry and bedroom loft from living area*

**Above:** *Bedroom loft*
**Left:** *Fold-down tea table over playpen*

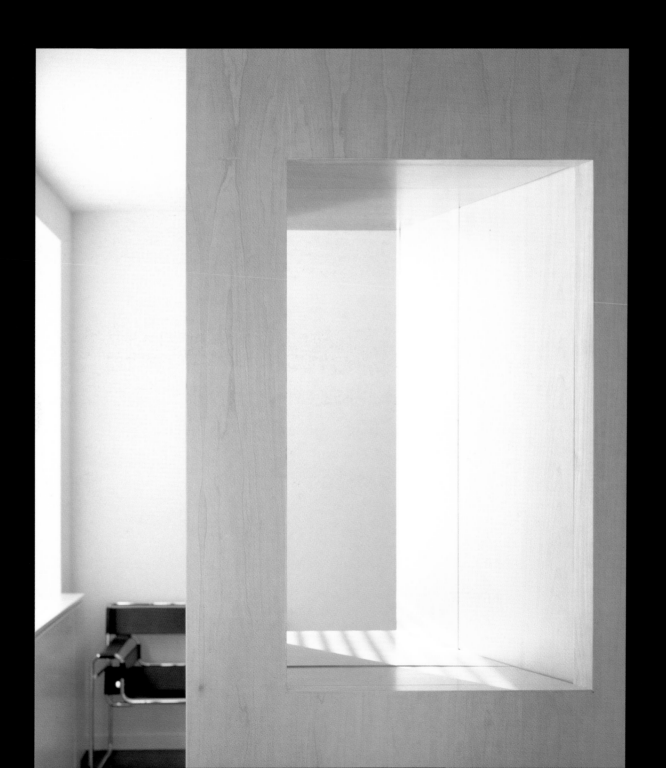

**The** goal for this project was to create an interior that functioned

both as a home and as an office for a graphic designer within a

modest 600-square-foot loft. The challenge was to achieve this

without sacrificing either the bedroom or the living/dining area.

The solution was to divide the space with a structure that allows

the client to literally transform the living area into an office, and

back again, on a daily basis. This 13-foot-long by 8-foot-high free

standing structure divides the living area from the sleeping area

while allowing passage on both sides.

In the "home" position, the structure takes the form of a box, solid

## Floor plan: Office unit open

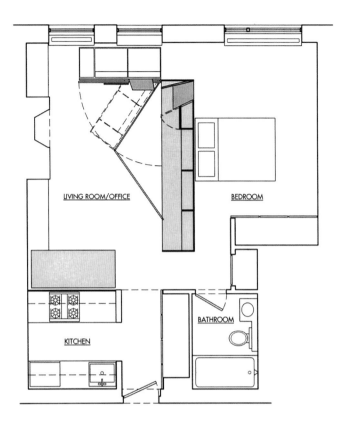

## Floor plan: Office unit closed

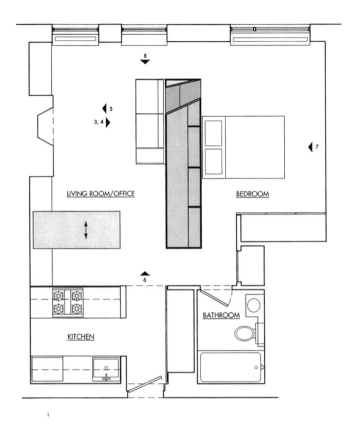

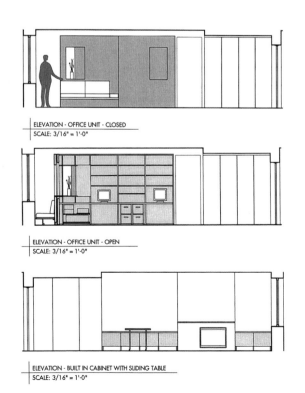

ELEVATION - OFFICE UNIT - CLOSED
SCALE: 3/16" = 1'-0"

ELEVATION - OFFICE UNIT - OPEN
SCALE: 3/16" = 1'-0"

ELEVATION - BUILT IN CABINET WITH SLIDING TABLE
SCALE: 3/16" = 1'-0"

**Previous page:** *An angled opening in the work station structure*

on all sides except for a deep, angled opening which offers selected views. A low cushioned bench that serves as both a sofa and guest bed cantilevers from the structure. In the "work" position, a wall of the structure opens to transform the living room into an office. As the large bi-folding panels open, the cantilevered sofa automatically glides away and is concealed from view and two complete workstations are exposed.

The dining table also moves in a controlled path within a channel in the top of the wall cabinet. When the office is closed, the table glides out into the room for dining. When the office is open, the table glides back against the wall, providing another workstation.

On the bedroom side, the structure acts as a wooden headboard, which houses recessed night tables that fold down on either side.

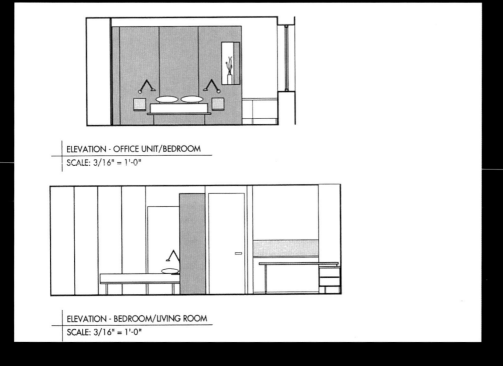

ELEVATION - OFFICE UNIT/BEDROOM
SCALE: 3/16" = 1'-0"

ELEVATION - BEDROOM/LIVING ROOM
SCALE: 3/16" = 1'-0"

*Roger Hirsch Architect*
*with Myriam Corti*
*New York, New York*

*Photography: Minh+Wass*

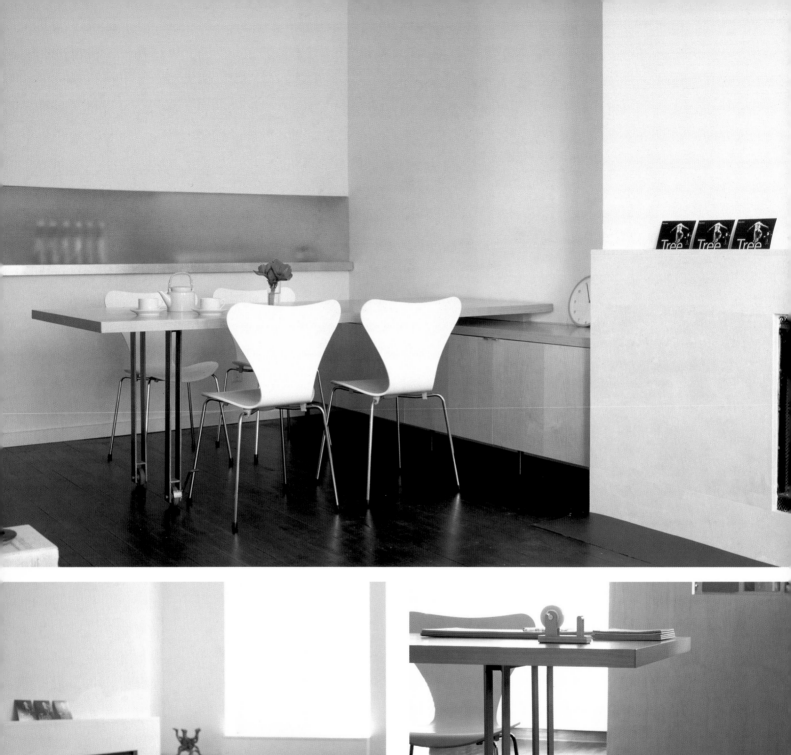

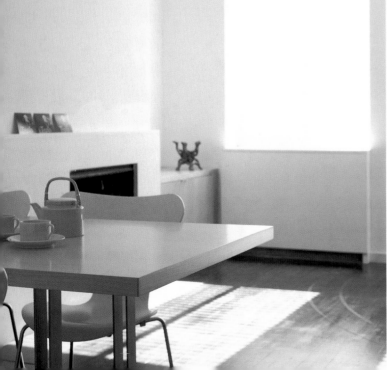

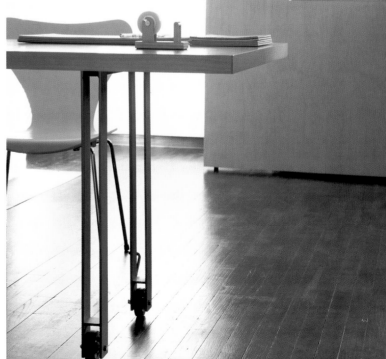

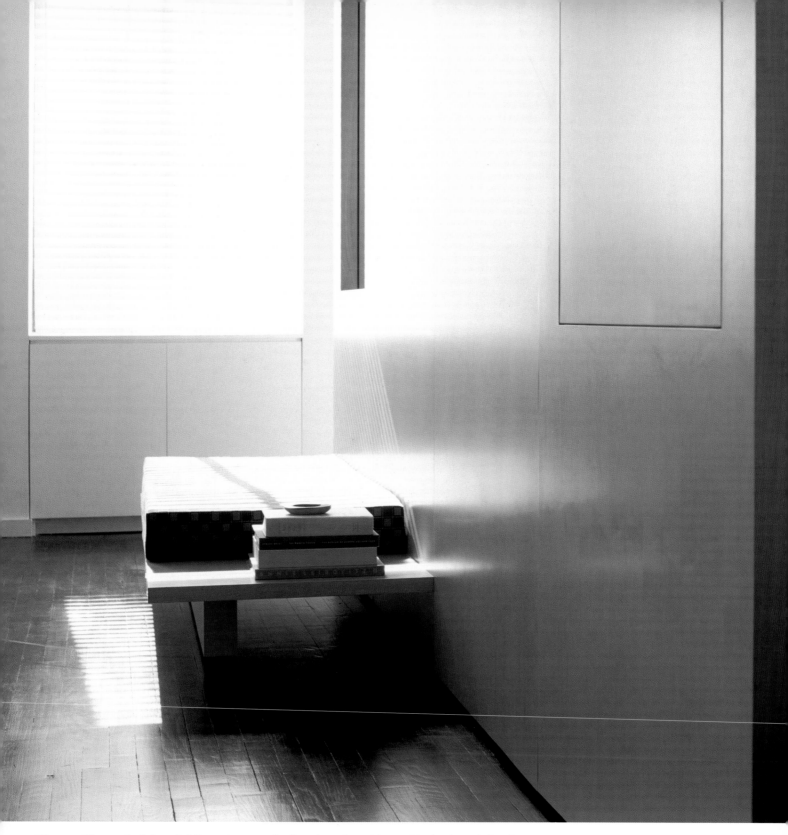

**Above:** *The wall of the dividing structure in the closed position with the bench in place*
**Left, clockwise from top:** *View of dining area with kitchen beyond; detail of wheels on the dining table legs that allow it to move into the workspace; view from the dining area to the living area*

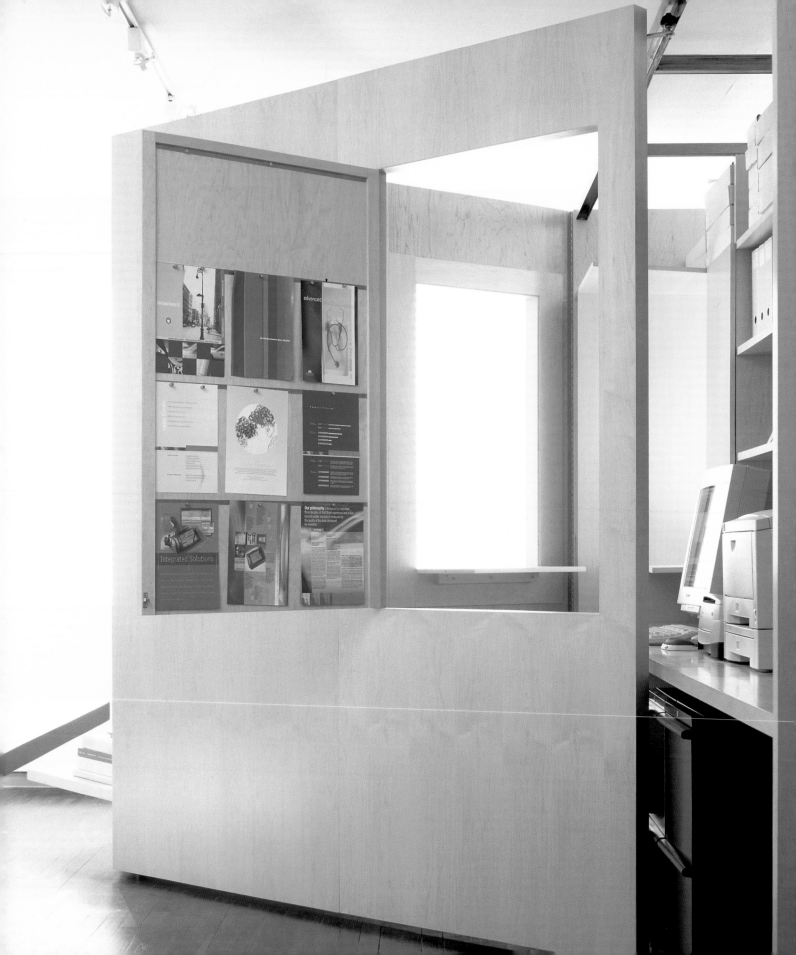

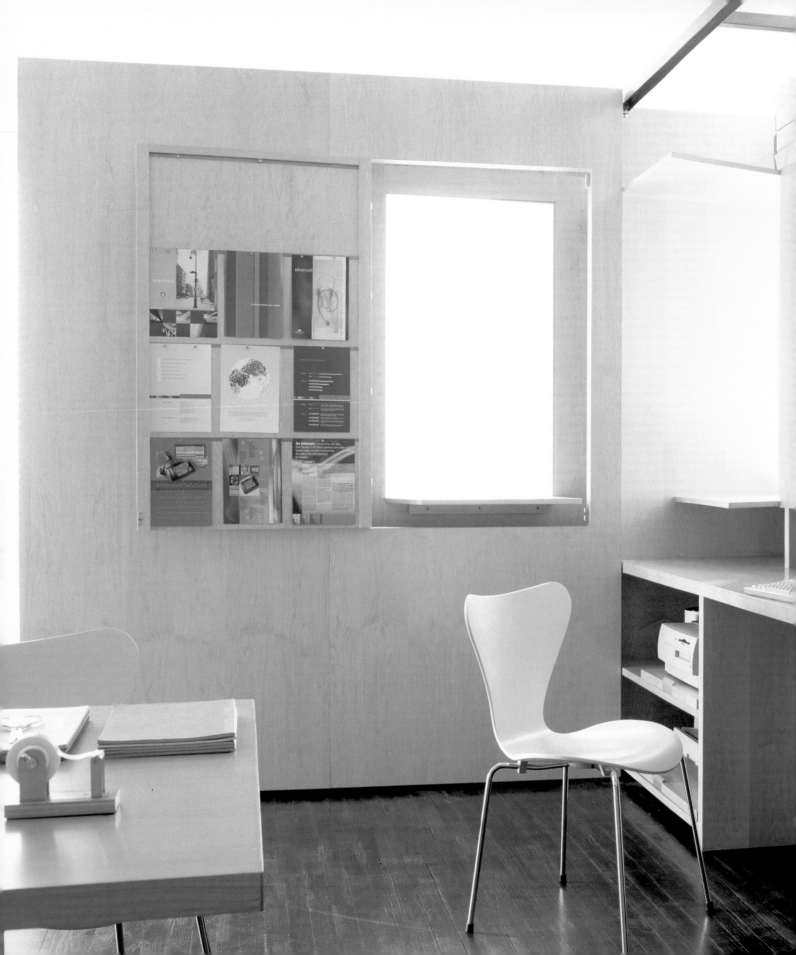

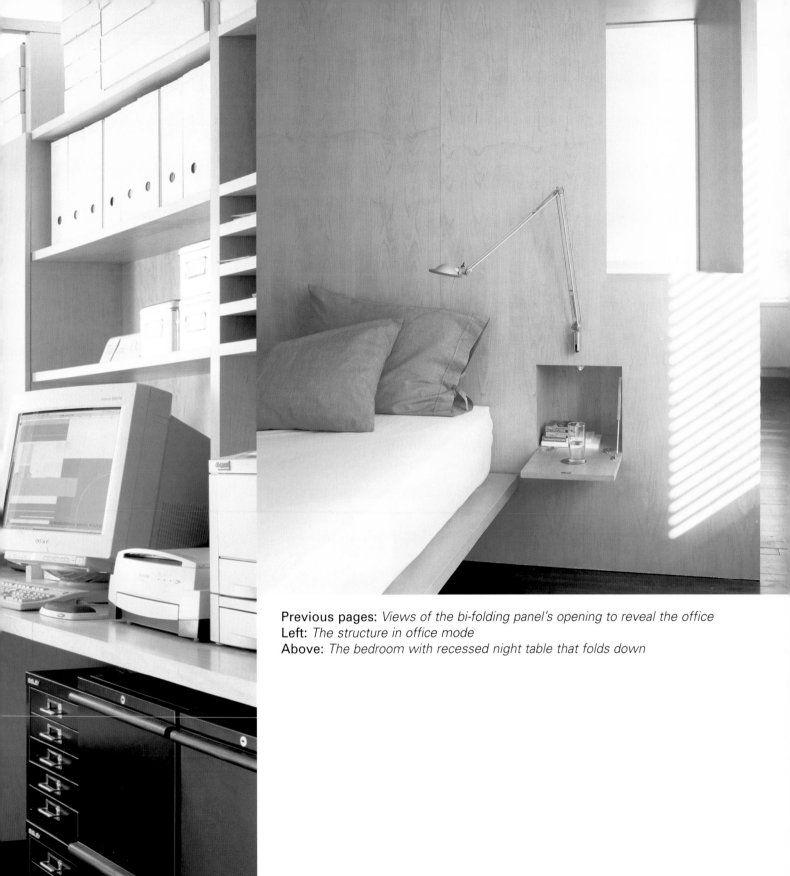

**Previous pages:** *Views of the bi-folding panel's opening to reveal the office*
**Left:** *The structure in office mode*
**Above:** *The bedroom with recessed night table that folds down*

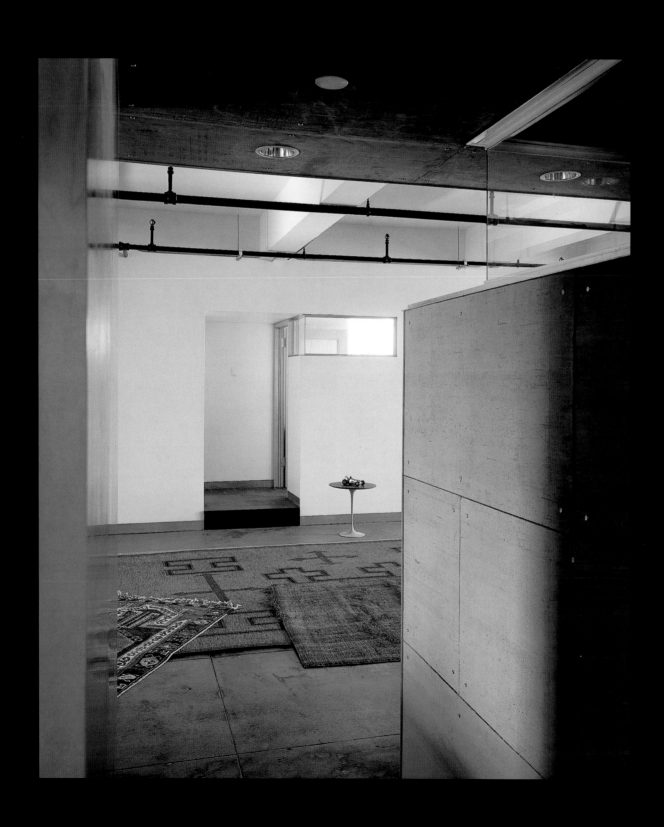

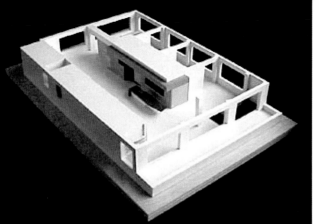

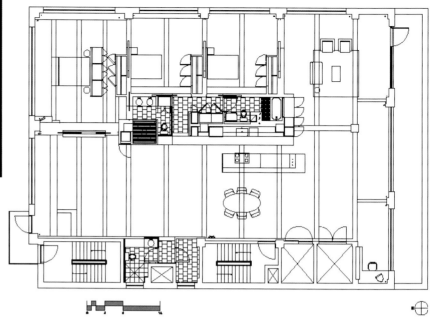

**Previous page:** *View of bathroom in living/dining area from bedroom*
**Above:** *Model*

## Sections

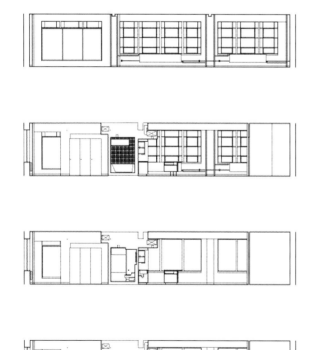

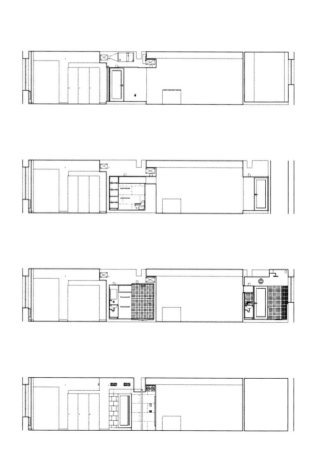

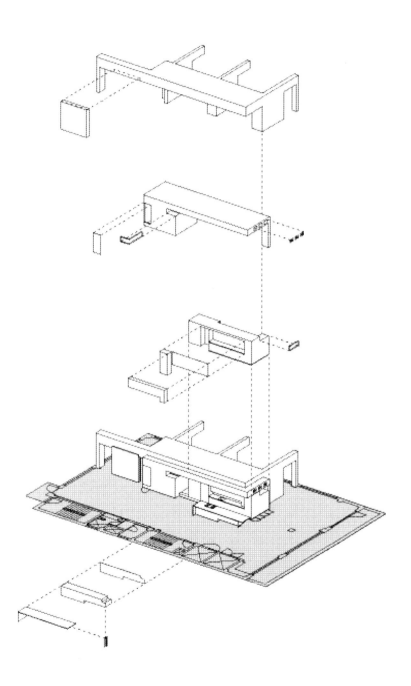

when open, returns the loft to the large, open space it once was. When closed, they extend to the exterior walls to close off all bedrooms for privacy.

**Resolution: 4 Architecture**
*New York, New York*

*Photography: Paul Warchol*

**Above:** *View from living area to entrance on the right to master bedroom on the left*
**Right:** *Bath*

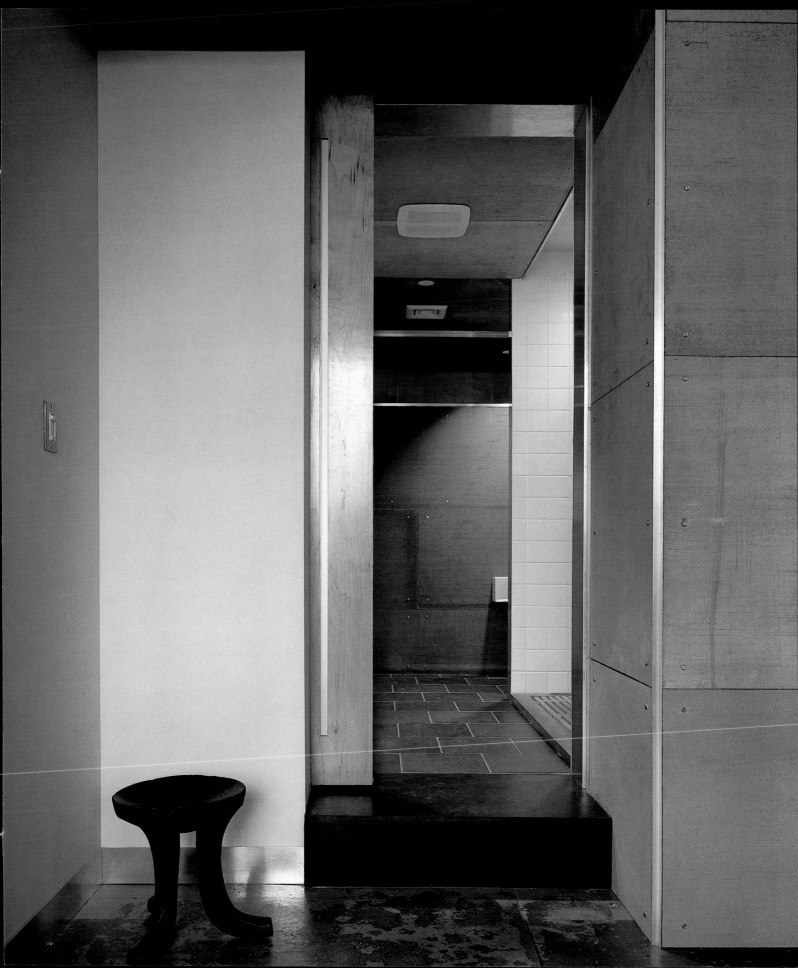

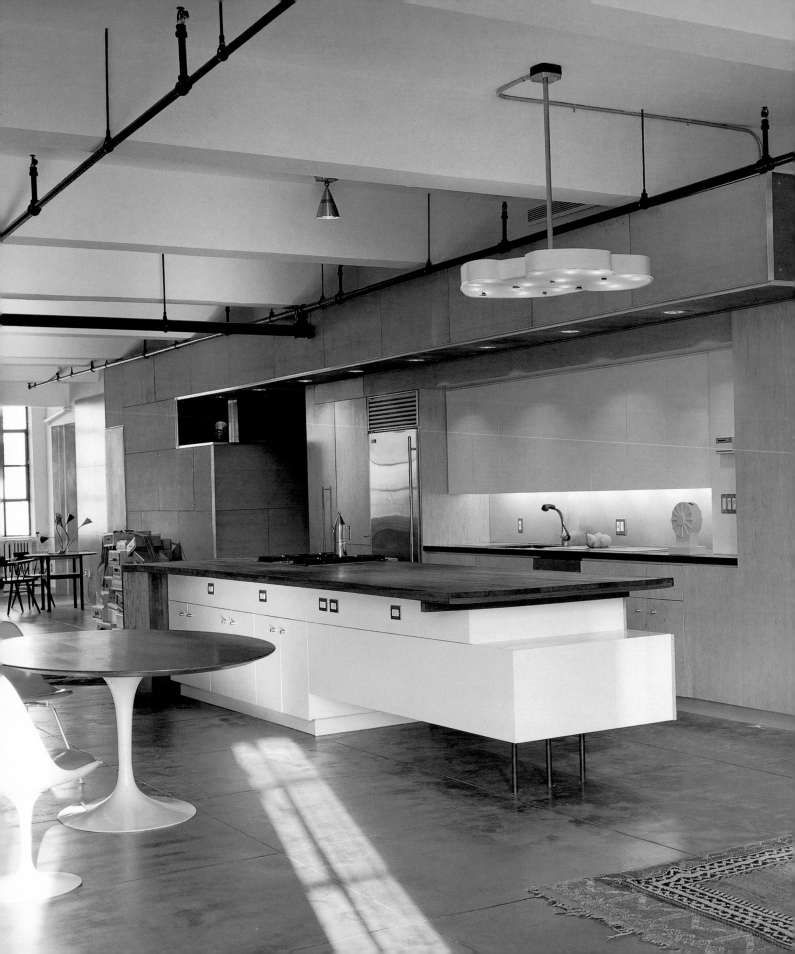

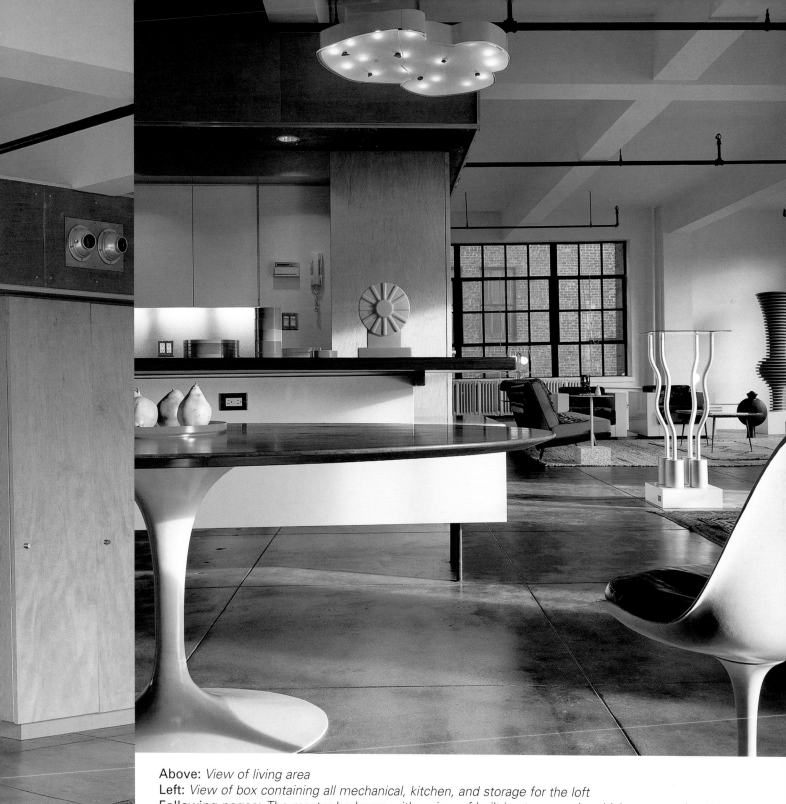

**Above:** *View of living area*
**Left:** *View of box containing all mechanical, kitchen, and storage for the loft*
**Following pages:** *The master bedroom with a view of built-in storage unit, which acts as a head-board; view of the other side of the storage unit*

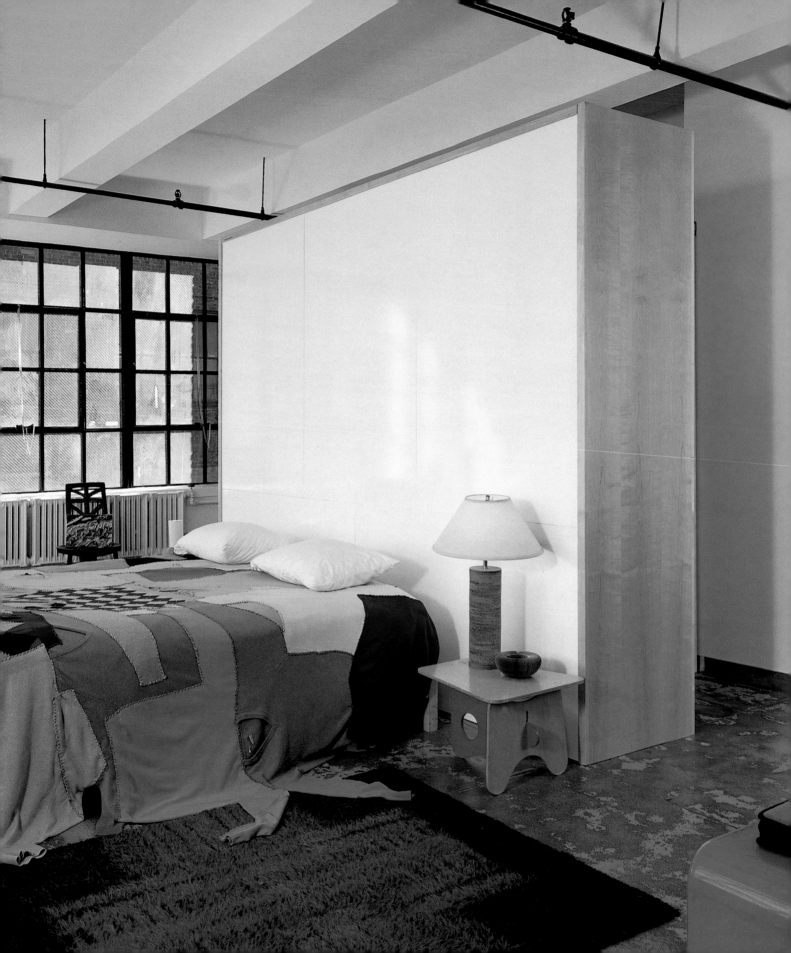

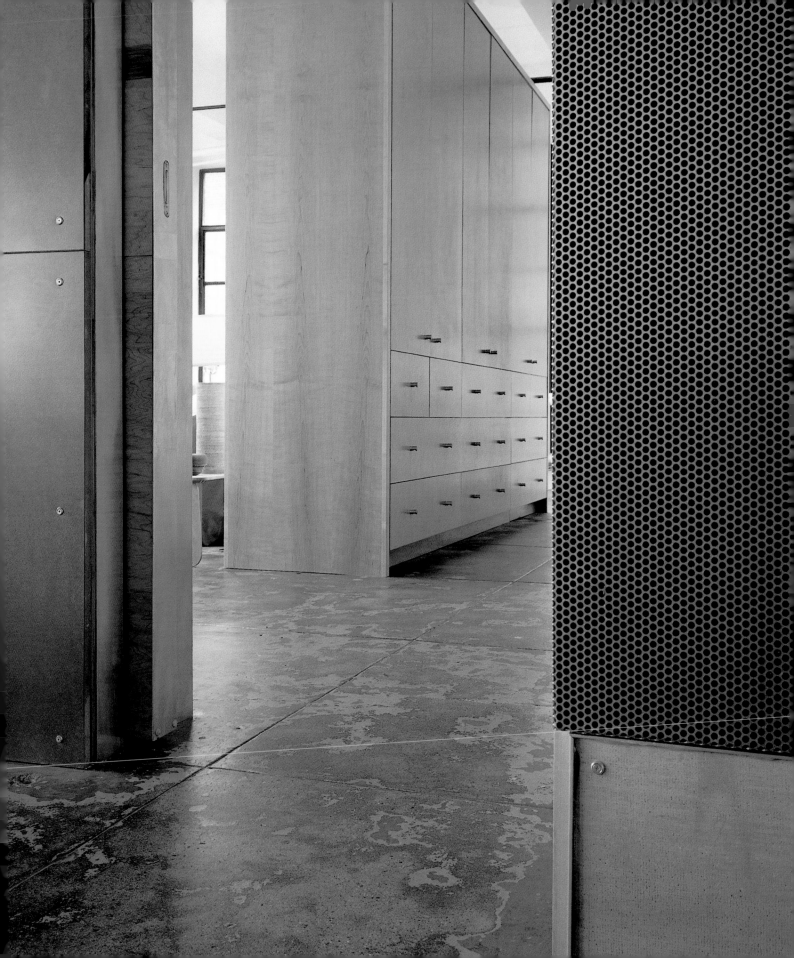

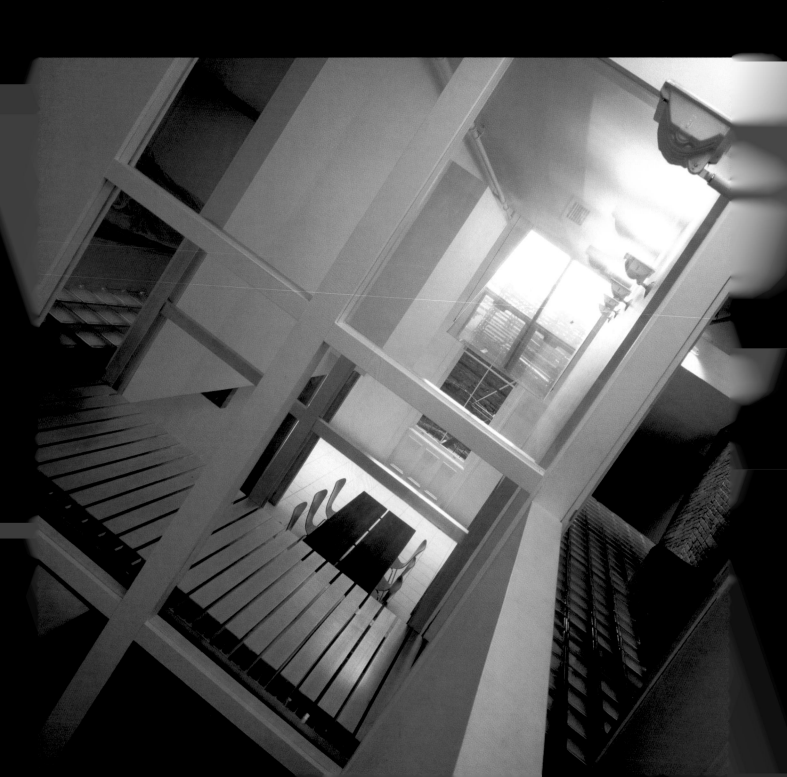

**For** a dark SoHo loft with a view of a brick wall, the architect hit

upon the idea of bringing the sky into the 1100-square-foot

space. He achieved this by installing a glass roof and then suspend-

ing a 6- by 10-foot one-way mirror beneath it at such an angle as to

reflect sunlight into the apartment's darkest reaches. When viewed

from the workspace, the mirror becomes a virtual window that par-

tially inverts the horizontal elevation (created by the skylight),

reflecting a picture-perfect view of the sky—clouds, birds, planes,

rain, and fog. Various computer programs were used to determine

which mirror angle would produce maximum reflected light.

Site plan

**Previous page:** *View from elevated bedrooms of the suspended mirror and glass block floors*

First-floor plan

Mezzanine-floor plan

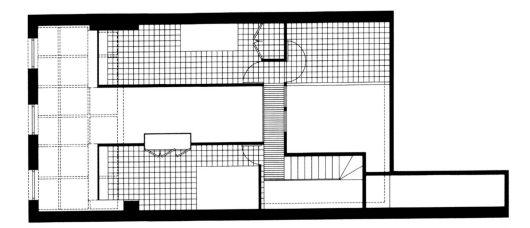

0   5   15

The loft's 16-foot ceilings allowed the two bedrooms to be elevated on glass block floors that allow light from the skylight to pass through to the living areas below. Privacy is controlled by a combination of diffused glass blocks and area rugs. Artificial light for the lower spaces is concealed below the bed platforms and is filtered by the color of the glass floors.

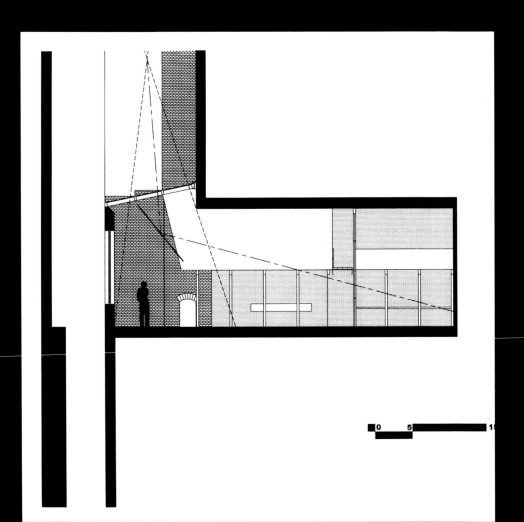

0    5         1

*Standing Architecture*
*New York, New York*

*Photography: Adam Fuss*

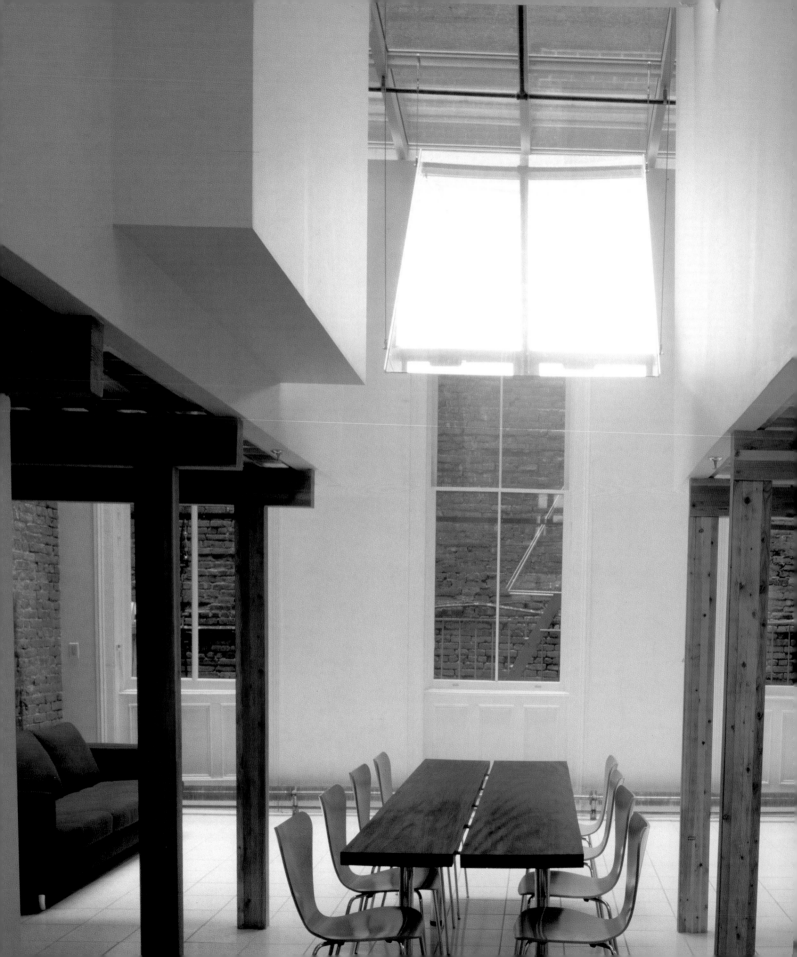

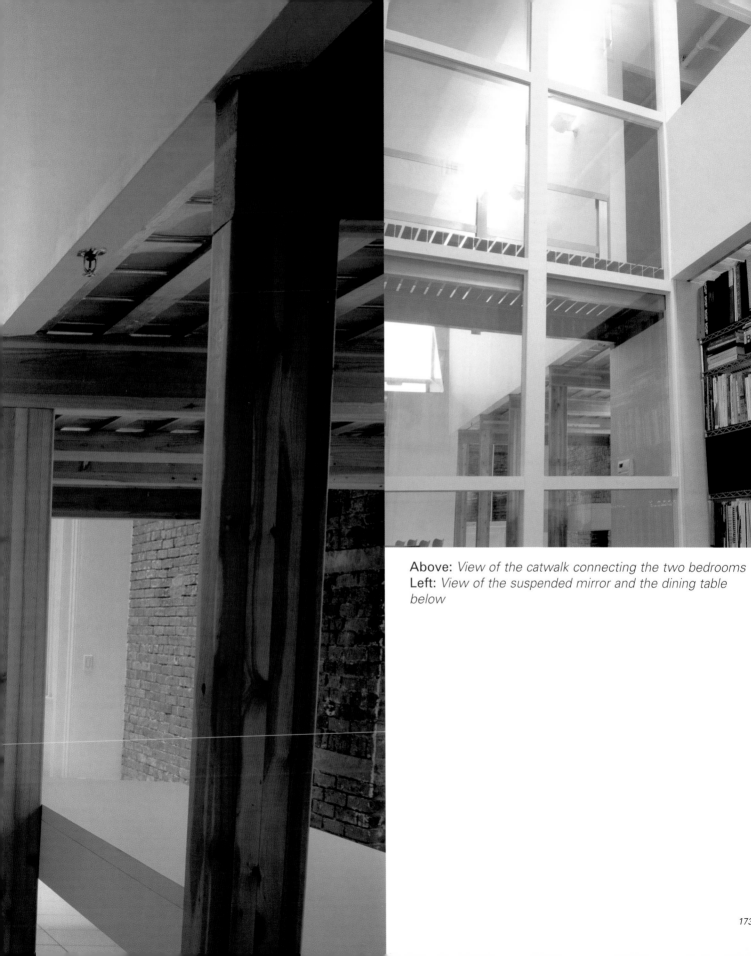

**Above:** *View of the catwalk connecting the two bedrooms*
**Left:** *View of the suspended mirror and the dining table below*

**Above:** *View of kitchen and dining area*
**Left:** *Mirror detail*

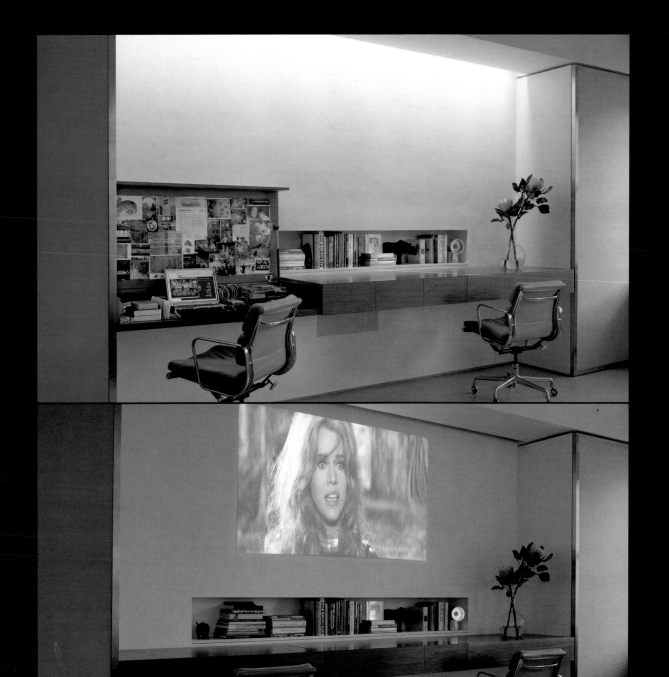

**For** the renovation of this 2000-square-foot residential loft, the clients wanted an open design incorporating materials and details that would complement their extensive collection of contemporary art, photography, and furniture.

A centrally located ebony wall houses a guest bed behind flush panels. The bed folds down and translucent curtains extend to create a private sleeping area for the guest.

A floating teak counter transforms into two individual work areas with flip-top desks and drawers between. When not in use, the simple counter helps to frame the large projection TV for viewing

**Previous page:** *Views of the floating teak counter being used as a work area and as a frame for the projection TV screen*
**Right:** *Guest nook elevation*

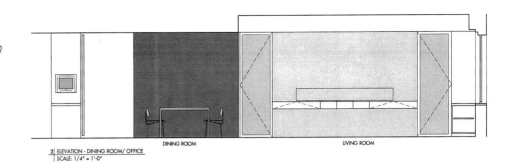

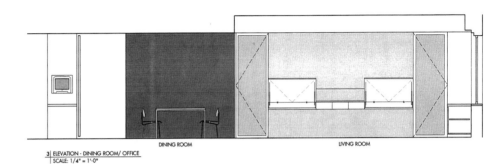

## Floor plan

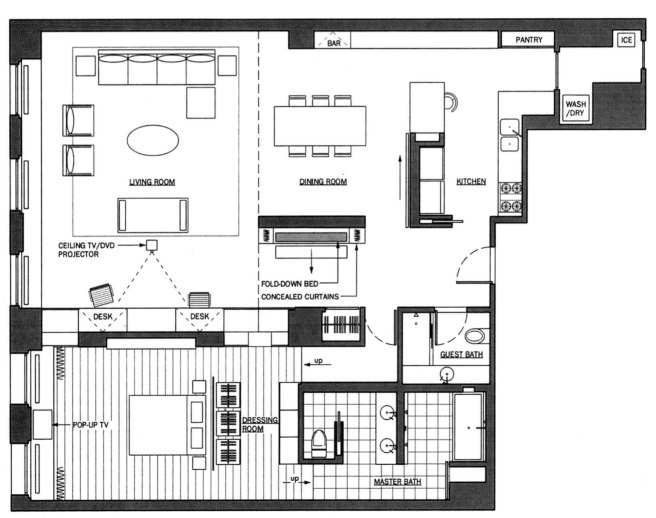

from the adjoining living room. In the modestly sized master bedroom, the length of the space is exaggerated by the long, flanking passageways on either side of the room. The dressing room is located behind the bed, and hanging clothes are housed in free-standing, fully enclosed towers. From the bedroom side, the etched glass wall defining the dressing room creates added depth, because the hazy images of the orange dressing room towers behind glow with color.

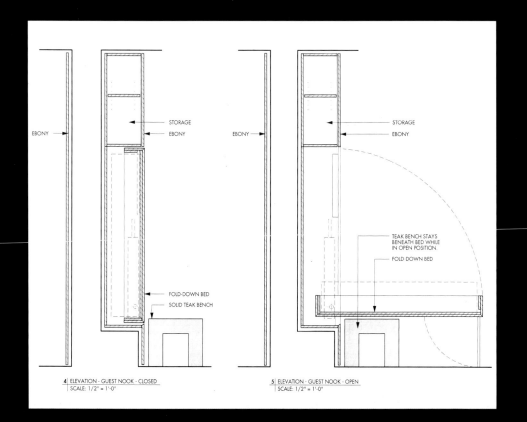

EBONY

STORAGE
EBONY

FOLD-DOWN BED
SOLID TEAK BENCH

4 ELEVATION · GUEST NOOK · CLOSED
SCALE: 1/2" = 1'-0"

EBONY

STORAGE
EBONY

TEAK BENCH STAYS
BENEATH BED WHILE
IN OPEN POSITION.
FOLD-DOWN BED

5 ELEVATION · GUEST NOOK · OPEN
SCALE: 1/2" = 1'-0"

*Roger Hirsch Architect*
*with Myriam Corti*
*New York, New York*

*Interior Design: Tocar, Inc.*
*New York, New York*
*Photography: Michael Moran*

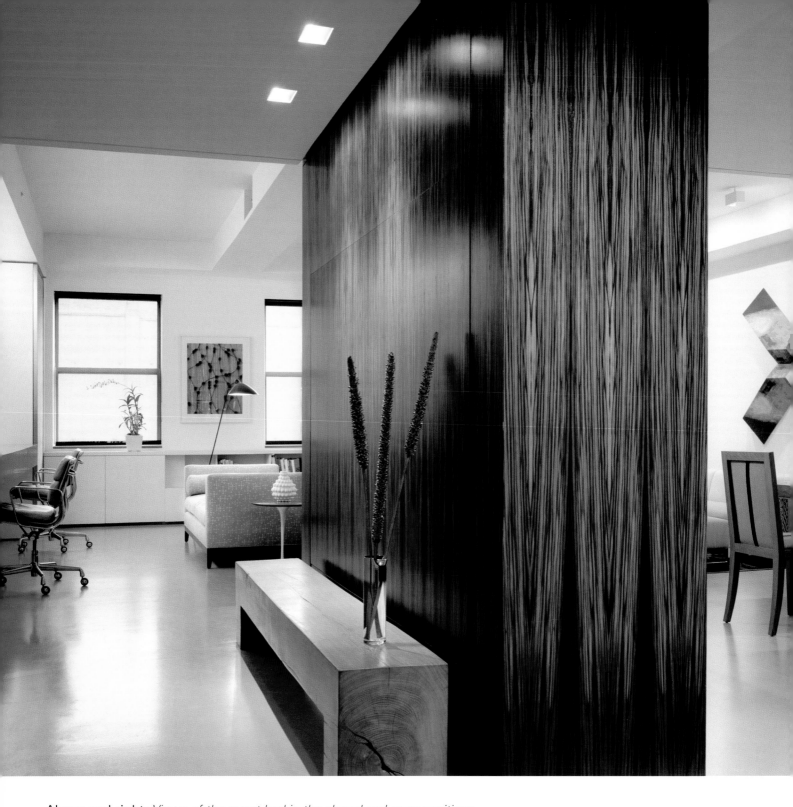

**Above and right:** *Views of the guest bed in the closed and open positions*

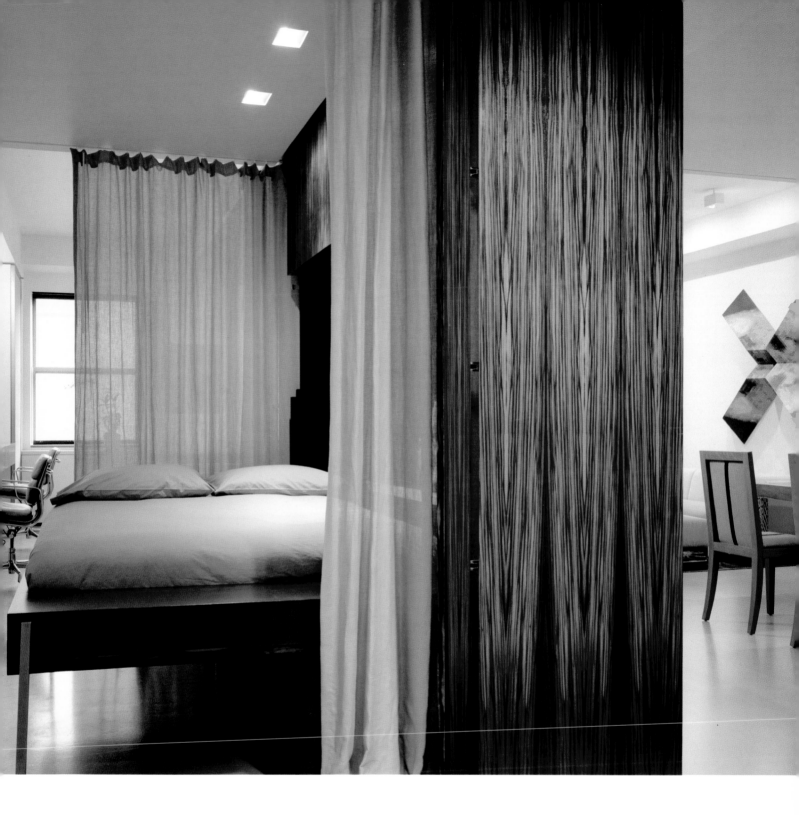

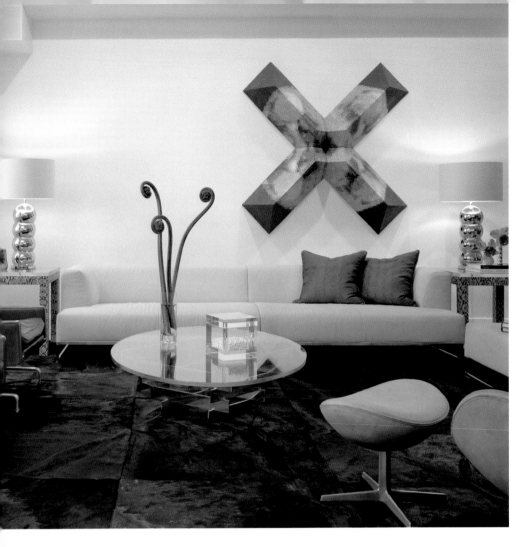

**Above:** *Living area*
**Right:** *Master bedroom with clothing towers glowing behind an etched glass wall*

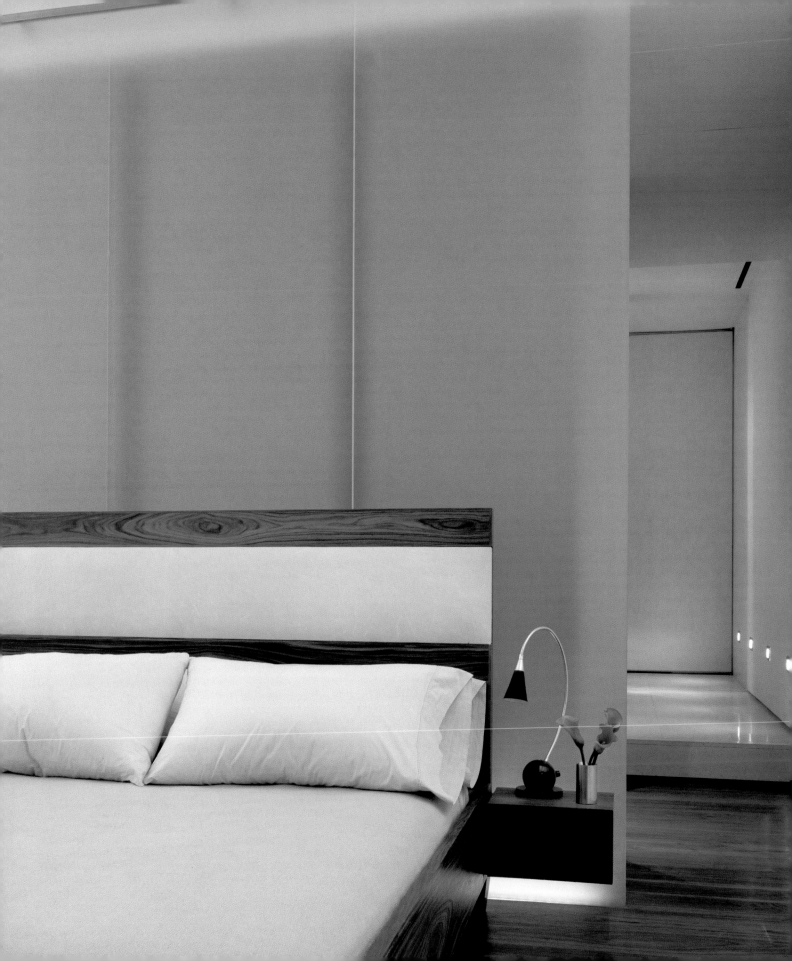

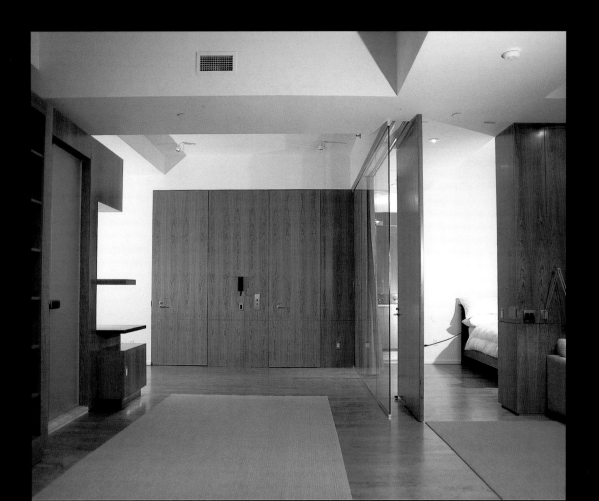

**Floating** nature best describes this loft, where the space is

defined by wood, glass, stone, steel, and light.

Cherry cabinetry and floors establish a landscape of deep reds,

interspersed with planes of glass, steel, and stone for this 5000-

square-foot loft renovation in Manhattan. Spaces revolve around a

central cherry cube, which is lit from below, making it appear to

float.

Entering the loft, one walks around this cube, past a plane of glass

that defines two guest bedrooms and a study, past a grove of bam-

boo contained in a sunken trough, and then to the living area. Here,

## Floor plan

one is bathed in natural light from a giant window wall with a perfectly framed view of the Empire State Building. A 10-foot-high wall of English sycamore panels mark the east wall of the living room. They pivot open to reveal the master bedroom beyond.

All other spaces in the apartment are cherry, with the exception of the master bedroom. This space is defined by sycamore as well, which lines this room as a "cabinet" of lighter wood, separate from the rest of the apartment.

Light permeates the space and, at the cube, creates a floating center of gravity for the apartment.

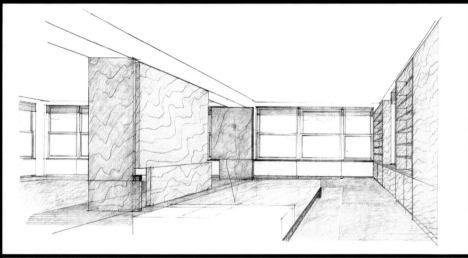

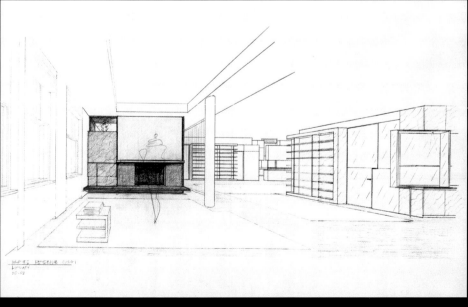

**HanrahanMeyers**
**Architects**
**New York, New York**

**Photography: Tom Hanrahan**

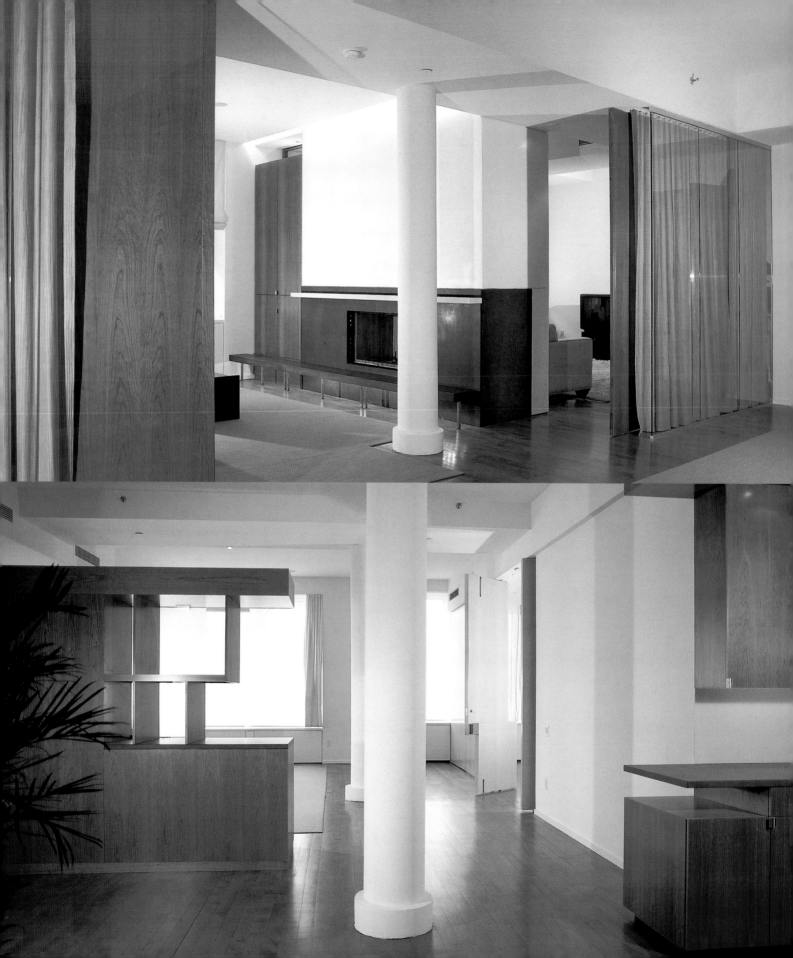

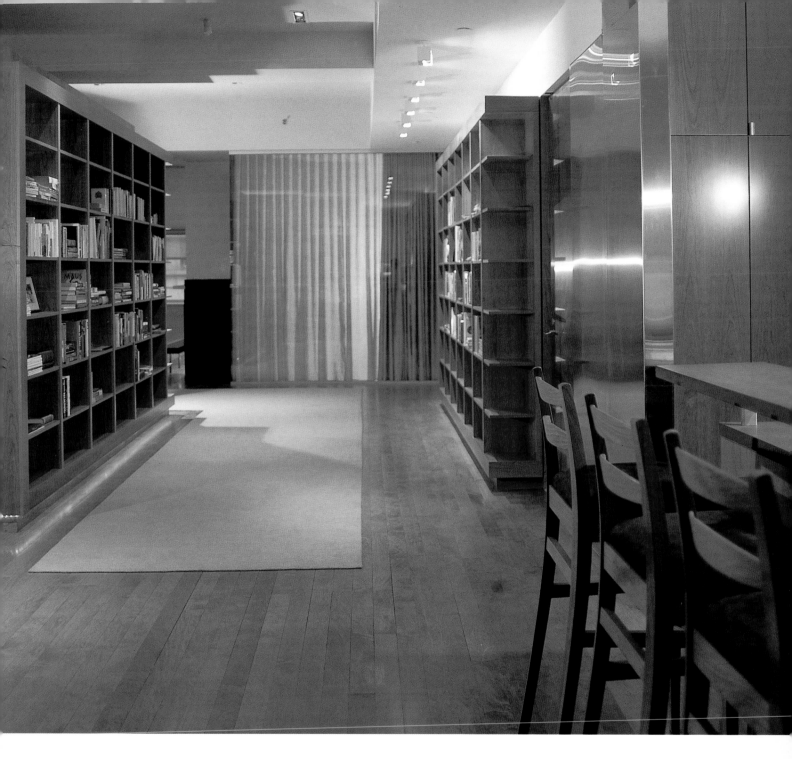

**Above:** *View of entry and library from kitchen*
**Left top:** *View of fireplace and guest bedroom beyond*
**Left:** *View of divider separating kitchen area from the living room*

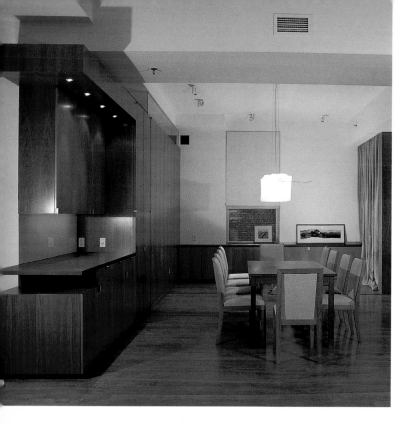

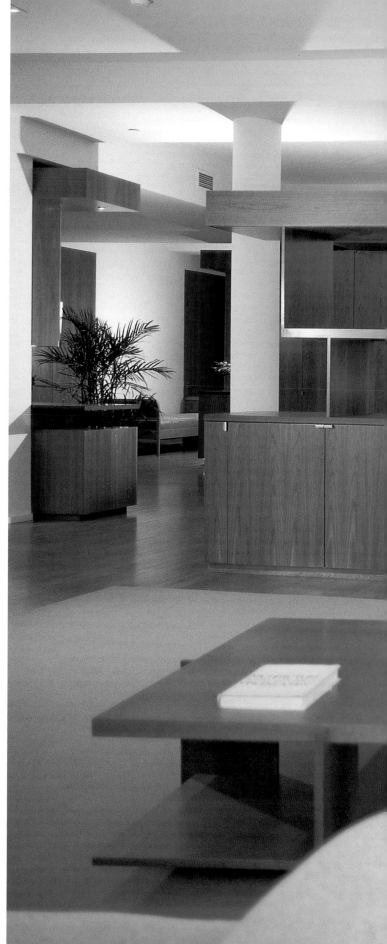

**Above:** *Dining area*
**Right:** *View of living room with kitchen beyond*

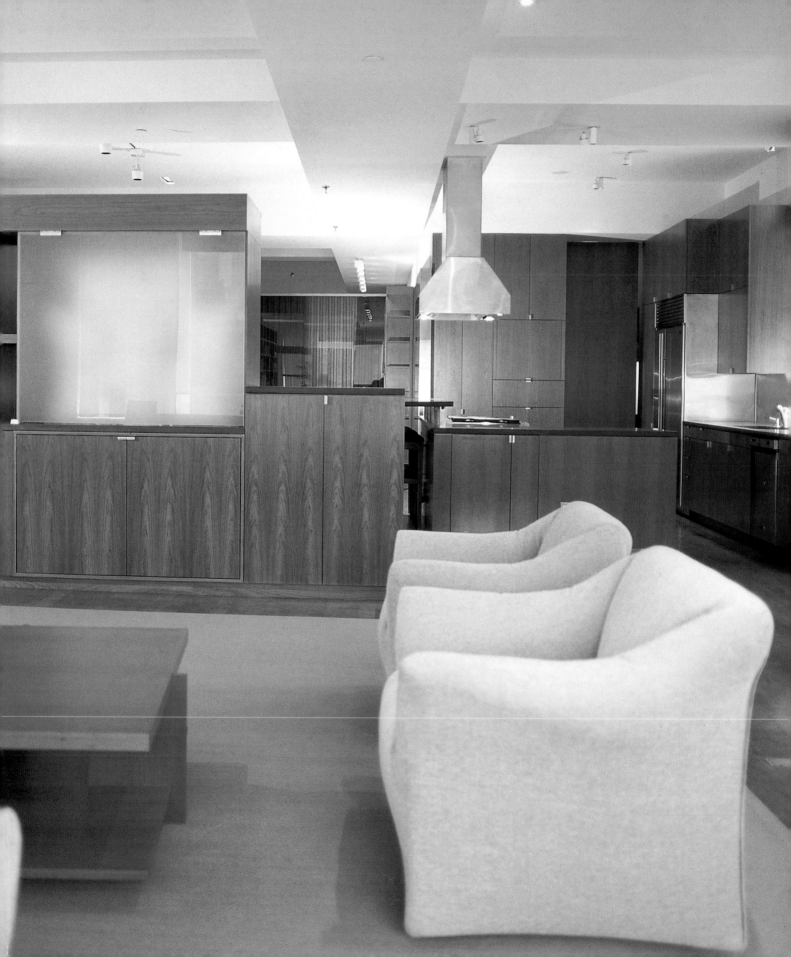

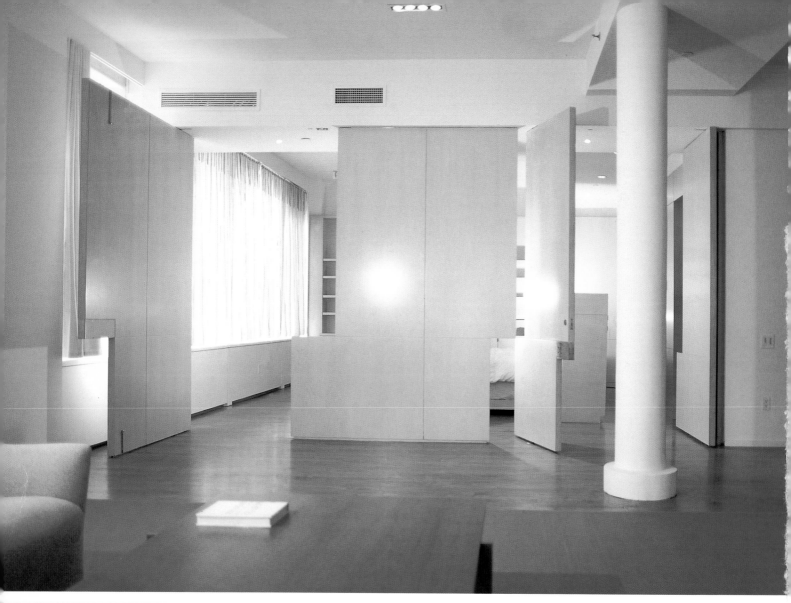

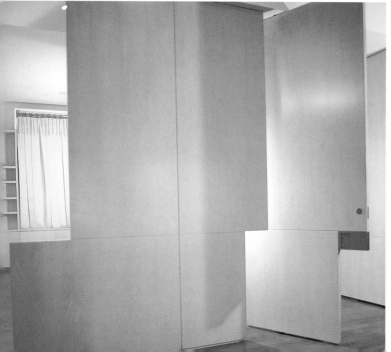

**Above:** *View from living room toward master bedroom*
**Left:** *Detail of pivoting English sycamore panels separating living room from master bedroom*